HISTORIC PHOTOS OF
CINCINNATI

The "Genius of Water" standing atop the Tyler Davidson Fountain is illuminated against the backdrop of the Carew Tower in the 1940's.

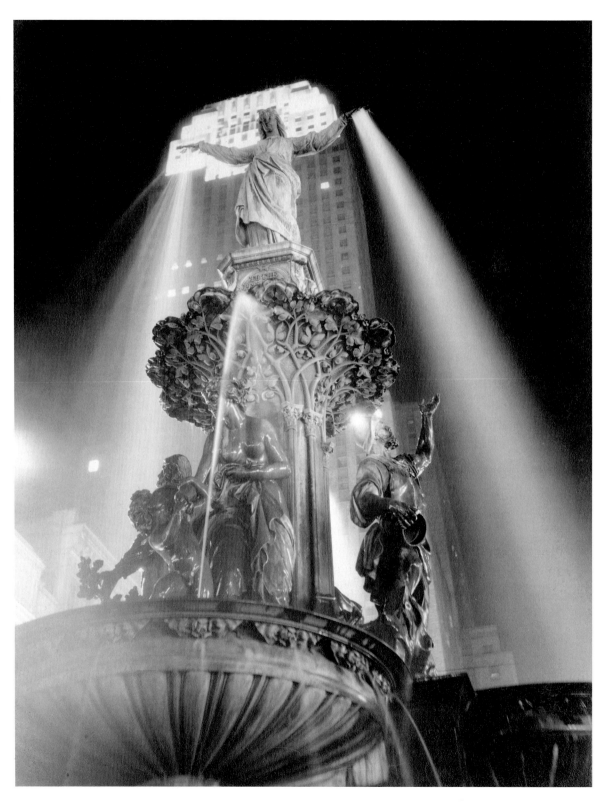

HISTORIC PHOTOS OF
CINCINNATI

TEXT AND CAPTIONS BY LINDA BAILEY

PHOTOS FROM THE COLLECTIONS OF

CINCINNATI MUSEUM CENTER

Turner®
Publishing Company
Nashville, Tennessee • Paducah, Kentucky

Turner Publishing Company
200 4th Avenue North • Suite 950 412 Broadway • P.O. Box 3101
Nashville, Tennessee 37219 Paducah, Kentucky 42002-3101
(615) 255-2665 (270) 443-0121

www.turnerpublishing.com

Library of Congress Control Number: 2006905291

ISBN: 1-59652-267-4

Printed in the United States of America.

0 9 8 7 6 5 4 3 2 1

CONTENTS

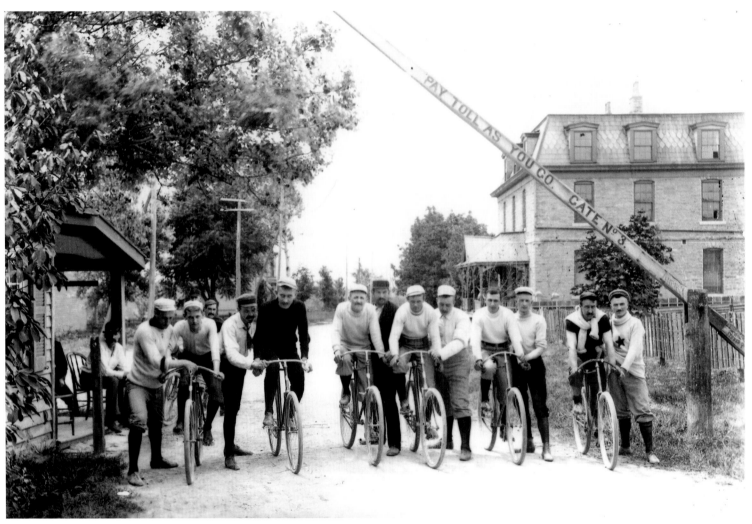

In the 1880's and 1890's, athletic and socially oriented bicycle clubs flourished.
Brighton Bicycle Club members are lined up for the start of a race from
Glendale to Hamilton in 1892.

ACKNOWLEDGMENTS

This volume, *Historic Photos of Cincinnati*, is the result of the cooperation and efforts of many individuals, organizations, institutions, and corporations. It is with great thanks that we acknowledge the valuable contribution of the following for their generous support:

Cincinnati Museum Center
Taft, Stettinius & Hollister LLP
US Bank

We would also like to thank the following members of the staff of Cincinnati Museum Center for their valuable contribution and assistance in making this work possible:

Daniel Hurley-Assistant Vice President for History
Scott Gampfer-Director of History Collections-Chapter Essays
Tina Bamert-Scanning Technician-Scanning
Ruby Rogers-Library Director-Fact Checking and Proofreading
M'Lissa Kesterman-Reference Librarian-Fact Checking and Proofreading
Anne Shepherd-Reference Librarian-Fact Checking and Proofreading
Laura Chace-Reference Librarian-Fact Checking and Proofreading

PREFACE

Cincinnati has thousands of beautiful and important historic photographs. This book began with the observation that, while those photographs are of great interest to many, they are not easily accessible. During a time when Cincinnati is looking ahead and evaluating its future course, many people are asking how do we treat the past? These decisions affect every aspect of the city - architecture, public spaces, commerce and infrastructure - and these, in turn, affect the way that people live their lives. This book seeks to provide easy access to a valuable, objective look into the history of Cincinnati.

The power of photographs is that they are less subjective in their treatment of history. While the photographer can make decisions regarding what subject matter to capture and some limited variation in its presentation, photographs do not provide the breadth of interpretation that text does. For this reason, they provide an original, untainted perspective that allows the viewer to interpret and observe.

This project represents countless hours of review and research. The researchers and authors have reviewed thousands of photographs from the Cincinnati Museum Center Archives. We greatly appreciate the generous assistance of the archivists listed in the acknowledgments of this work, without whom this project could not have been completed.

The goal in publishing this work is to provide broader access to this set of extraordinary photographs that seek to inspire, provide perspective and evoke insight that might assist people who are responsible for determining Cincinnati's future. In addition, the book seeks to preserve the past with adequate respect and reverence.

With the exception of touching up imperfections caused by the damage of time, no other changes have been made. The focus and clarity of many images is limited to the technology and the ability of the photographer at the time they were taken.

The work is divided into eras. Beginning with some of the earliest known photographs of Cincinnati, the first

section records photographs from pre-Civil War through the end of the nineteenth century. The second section spans from the beginning of the twentieth century through the years following World War I. Section three moves from the roaring twenties to World War II. The last section covers from World War II to the 1960's.

In each of these sections we have made an effort to capture various aspects of life through our selection of photographs. People, commerce, transportation, infrastructure, religious institutions and educational institutions have been included to provide a broad perspective.

We encourage readers to reflect as they go walking in Cincinnati, along the Ohio riverfront or stroll along Vine Street, or through parks and neighborhoods hidden in the hills. It is the publisher's hope that in utilizing this work, longtime residents will learn something new and that new residents will gain a perspective on where Cincinnati has been, so that each can contribute to its future.

Todd Bottorff
Publisher

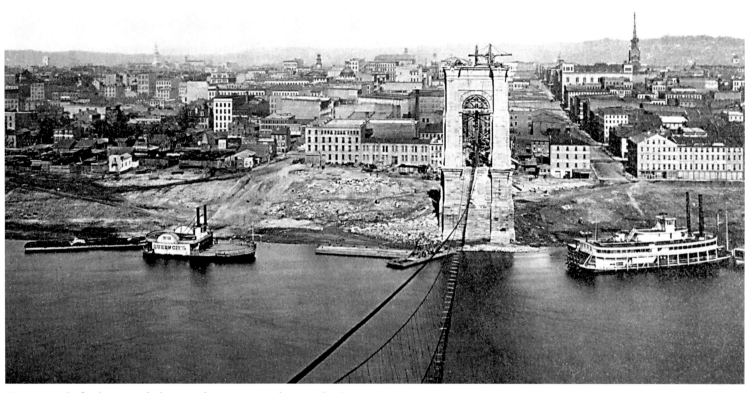

Center panel of a three-panel photographic panorama showing the Covington and Cincinnati Suspension Bridge under construction in 1865. Designed by master engineer John A. Roebling, the bridge was a prototype for New York's Brooklyn Bridge.

From Civil War to the
Dawn of a New Century

1860-1899

Between the outbreak of the Civil War and the turn of the twentieth century, powerful forces sweeping America and its cities transformed Cincinnati and the people who called it home.

The outbreak of sectional violence in the spring of 1861 initially hurt the city whose major economic ties were still with the South. But as the war ground on, Cincinnati's critical position on the border and its manufacturing capacity allowed it to recover quickly. It would become one of the major industrial centers and supply depots for the Union cause.

The rise of railroads not only drove the explosive growth of cities like Chicago and Kansas City, but it set in motion a long, slow shift of the traditional activity center of the city from the riverfront to Third and Fourth Streets.

No longer America's fastest growing city, Cincinnatians invested in creating a series of enduring landmarks and institutions that made their city a national cultural leader—the Cincinnati & Covington Suspension Bridge (1866), the Cincinnati Reds (1869), the Tyler Davidson Fountain (1871), the May Festival (1873), the Cincinnati Zoological Gardens (1873), Music Hall (1876), the Art Museum and Art Academy (1884, 1885) and the Symphony Orchestra (1895).

Aided by transportation innovations like inclines and electric streetcars, hundreds of thousands moved out of the basin onto the surrounding hilltops, sorting themselves out by economic class, religion and ethnicity. At the same time the traditional family-owned, craft-based workshops gave way to the industrial factory. The result was confusion and anger that found many expressions, including a terrible riot in March 1884 that left 56 people dead and the Hamilton County Court House, the symbol of justice, in ashes.

By 1900, Cincinnati was a fundamentally different place than the city of mid-century.

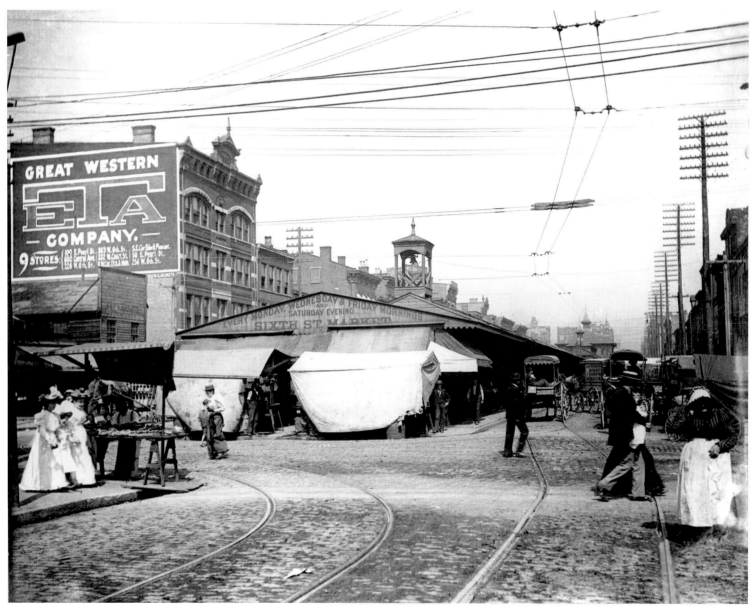

The Sixth Street market stretched from Central to Vine Street from 1826 to 1959. The huge market consisted of two market houses, one for meat, poultry and dairy products, and the other was filled with colorful flower stalls. Both were surrounded by fruit and vegetable stands that lined both sides of the street.

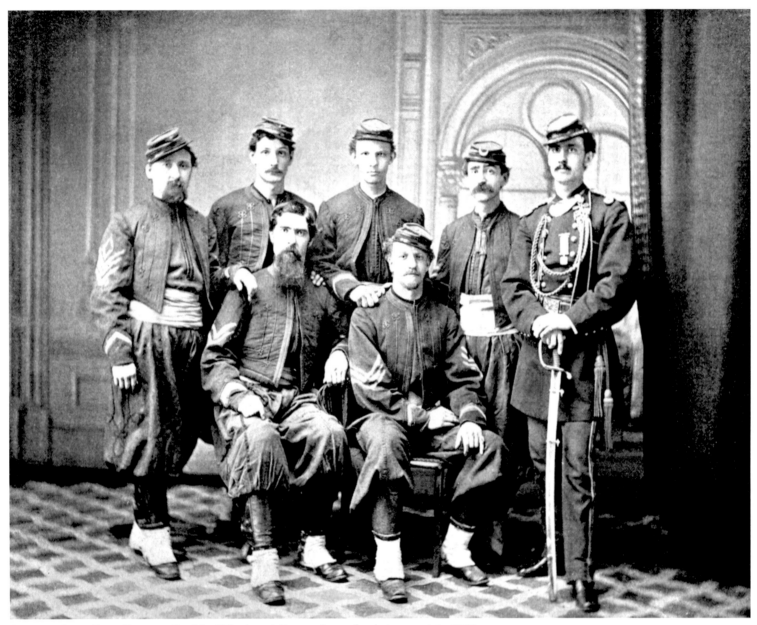

A group of men from Company B of the "Cincinnati Zouaves" pose for their portrait in 1868. An independent military organization, the Zouaves were known for their colorful uniforms consisting of dark blue jackets, scarlet baggy flannel trousers, and red fatigue caps.

Smartly attired Cincinnatians read the daily newspaper on the Commercial Gazette Building at Fourth and Race Streets in 1882. The area was known as "Ladies Square" for its fashionable shops.

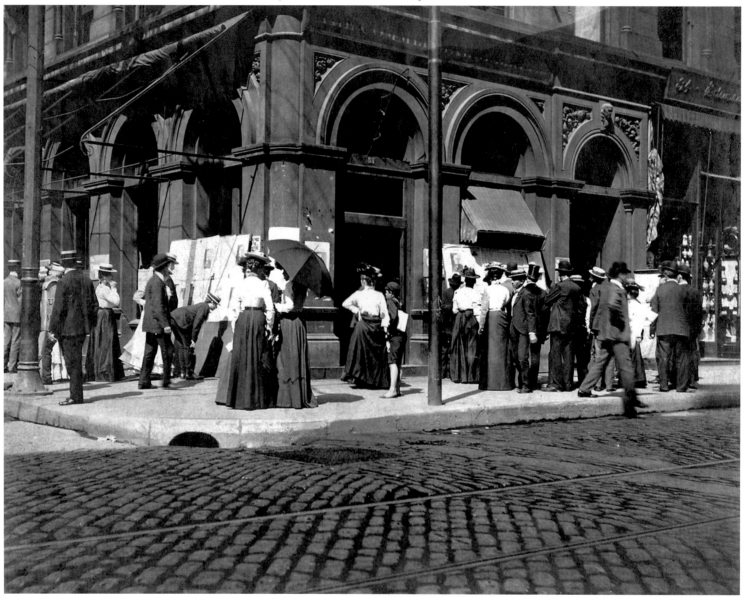

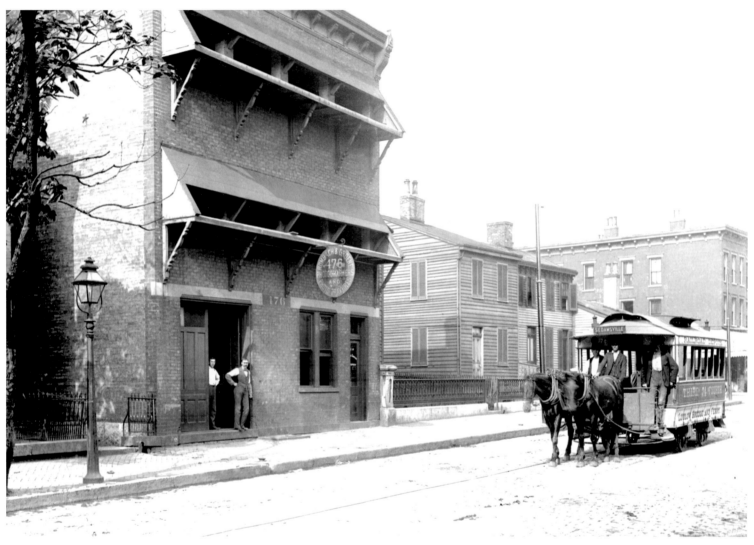

The last horse-drawn streetcar on Fourth Street passes in front
of the Rombach and Groene photograph studio about 1892.

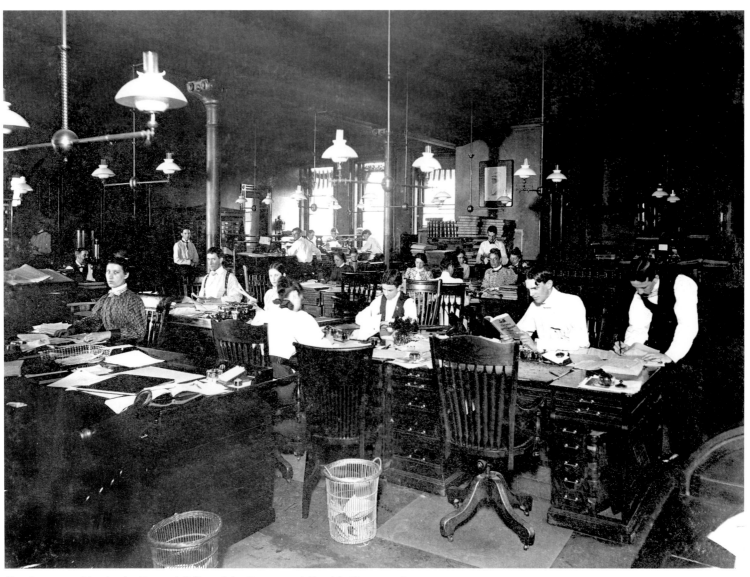

Employees working in the General Office of the Procter and Gamble Company in 1892. This office was located on an upper floor of the United Bank Building at Third and Walnut Streets.

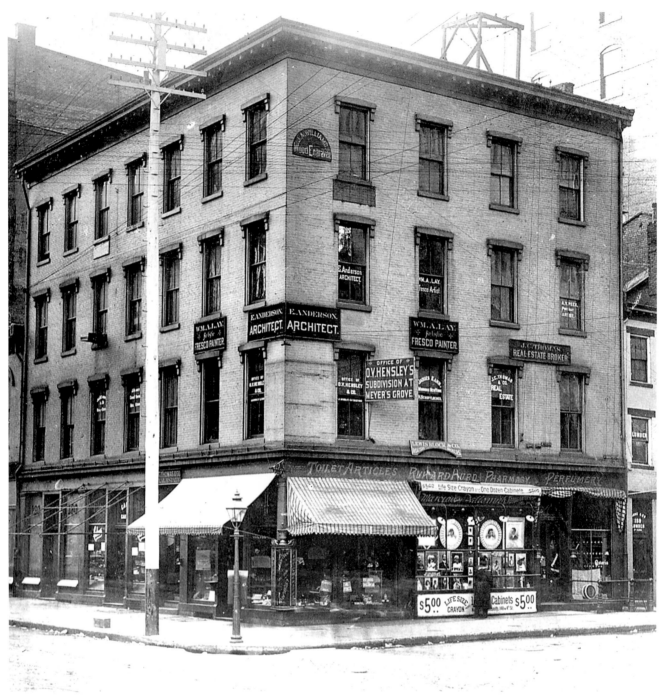

This multi-function office building stood on the northwest corner of Fourth and Race Streets.
It housed offices of the architect Edwin Anderson, fresco painter, William Lay, and realtor J. C.
Thomas, as well as Hurd's Pharmacy and the studio of photographers Marceau and Bellsmith.
The building was replaced by the Neave Building in 1891.

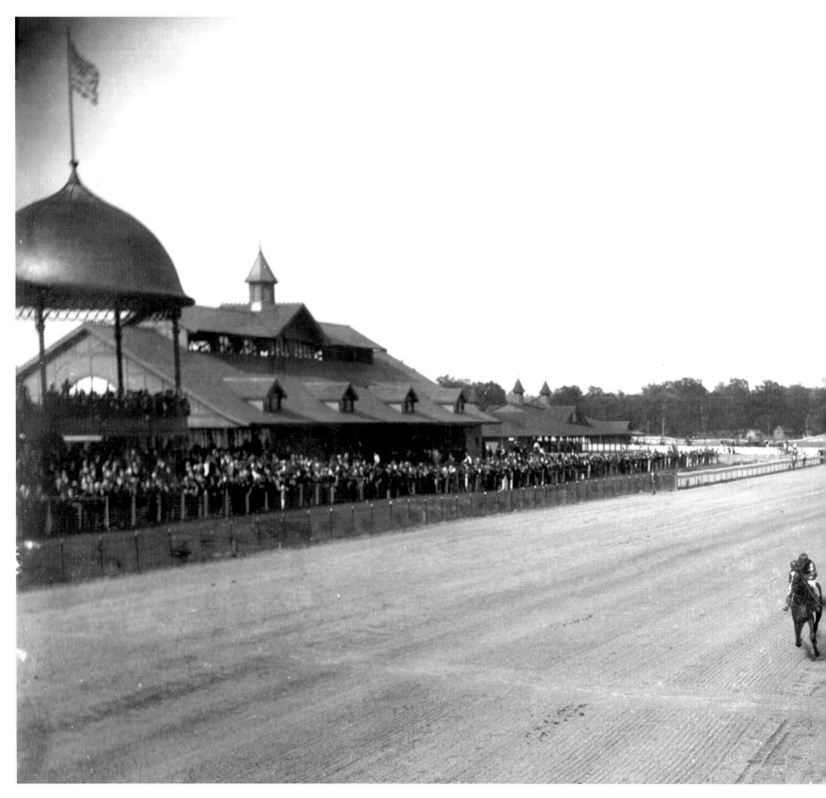

In the 1890's thoroughbred races replaced trotting at the Oakley Race Track. This photo shows the finish of the "Prince Leaf" race in 1896. Eventually, allegations of crooked gambling forced the track to close.

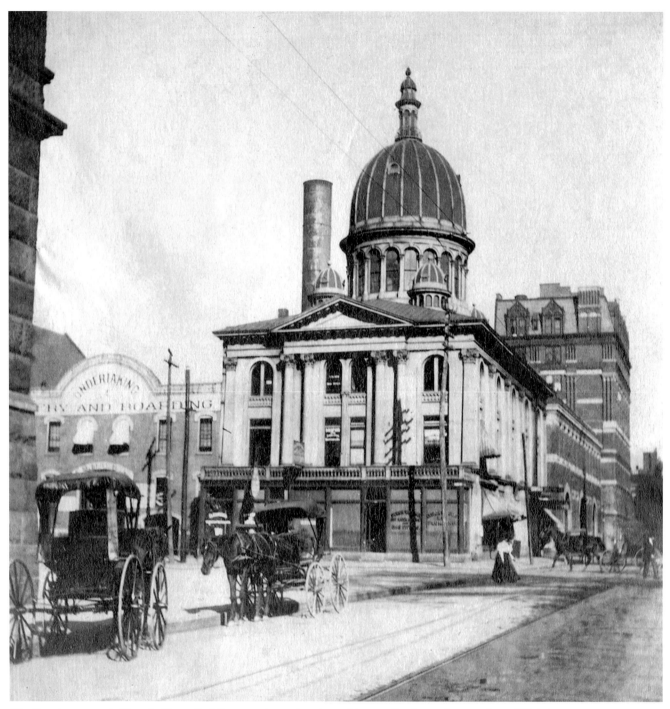

The Renaissance-style Temple Court Building was situated at the architecturally diverse intersection of Eighth and Plum Streets. Originally built in 1869-70 as the First Congregational Church (Unitarian), the building was remodeled for business use about 1890. In 1946 it was razed to make way for a gasoline service station.

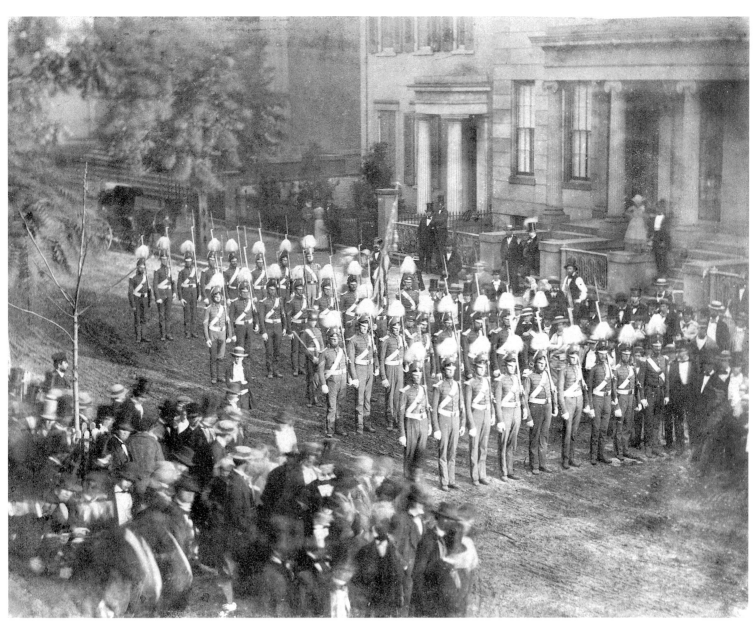

The Guthrie Grays stop in front of the St. Nicholas Hotel as they parade along Fourth Street. This independent militia unit became the nucleus of the Sixth Ohio Volunteer Infantry during the Civil War.

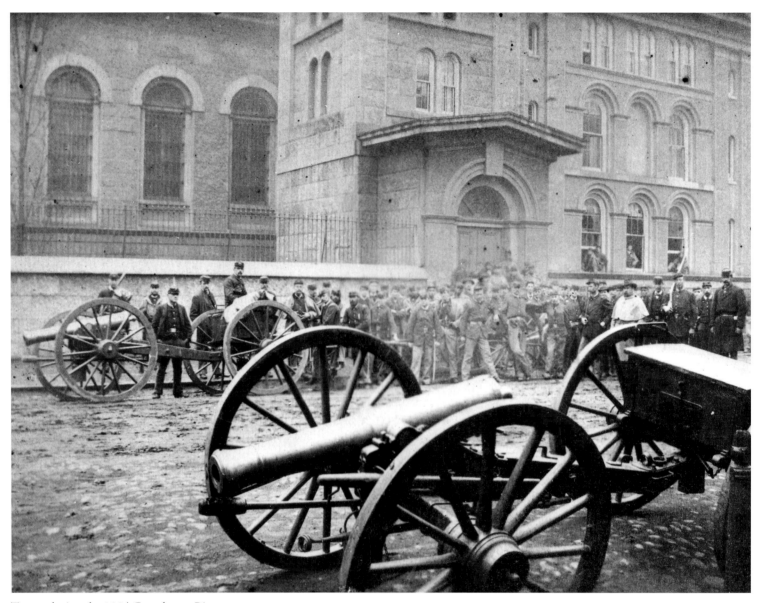

Troops during the 1884 Courthouse Riot.

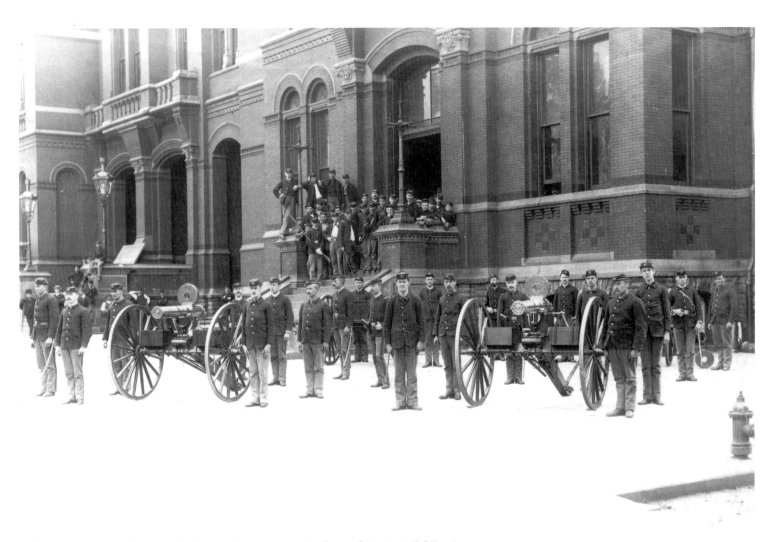

Ohio National Guardsmen with their Gatling guns pose in front of Music Hall following the Courthouse Riot in March 1884. The mere presence of the Gatling gun tended to have a calming effect on the frenzied mobs.

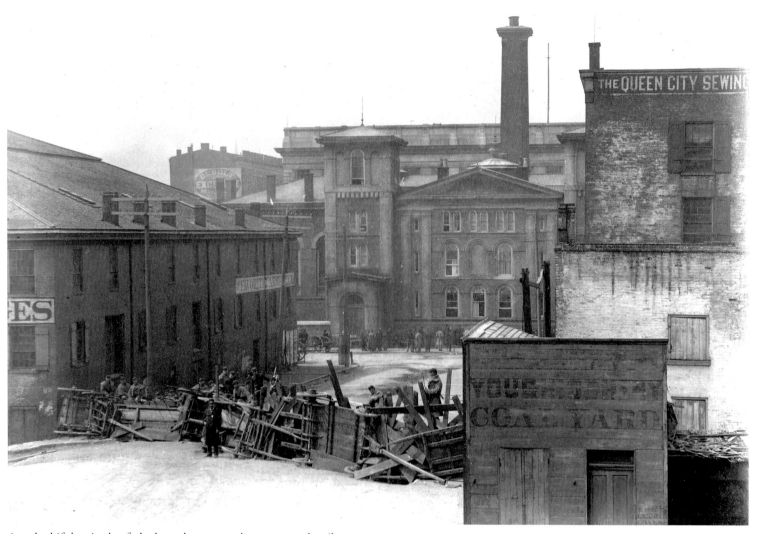

A makeshift barricade of planks and overturned wagons was hastily thrown together during the 1884 Courthouse Riot to protect the Hamilton County Jail.

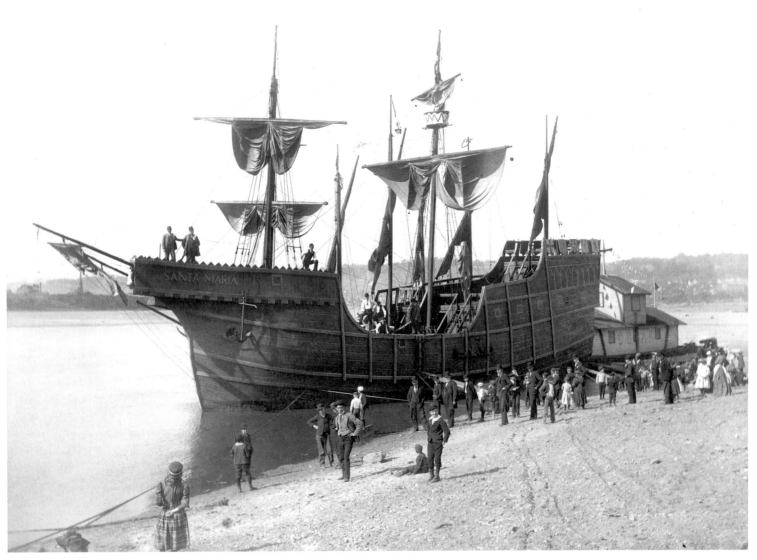

A replica of the Santa Maria took part in a river pageant on October 21, 1892 in honor of the 400th anniversary of Christopher Columbus' voyage to the new World.

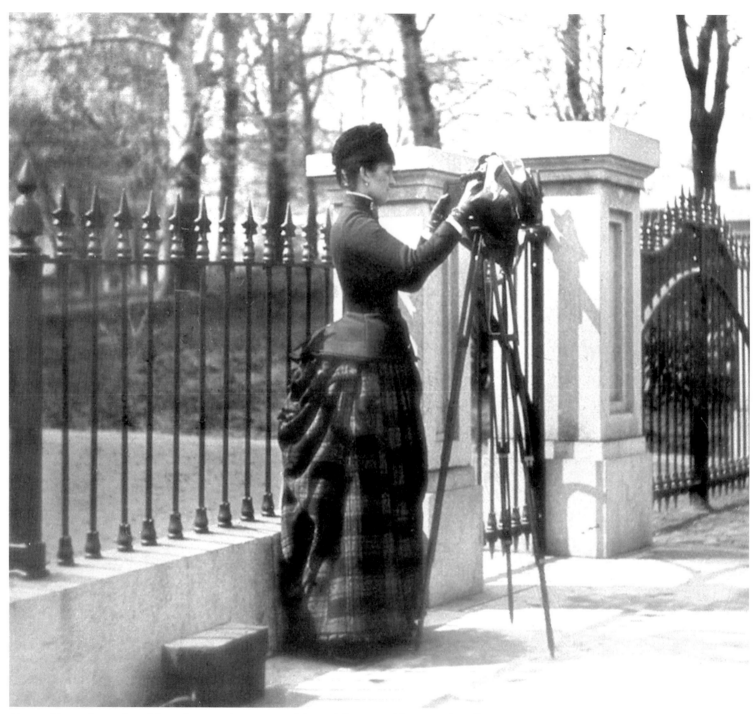

Along with nursing and teaching, photography was one of the socially acceptable occupations for women in the late 19th century. Most women photographers learned the basics of photography from their family and often inherited the photo studio from their father or husband.

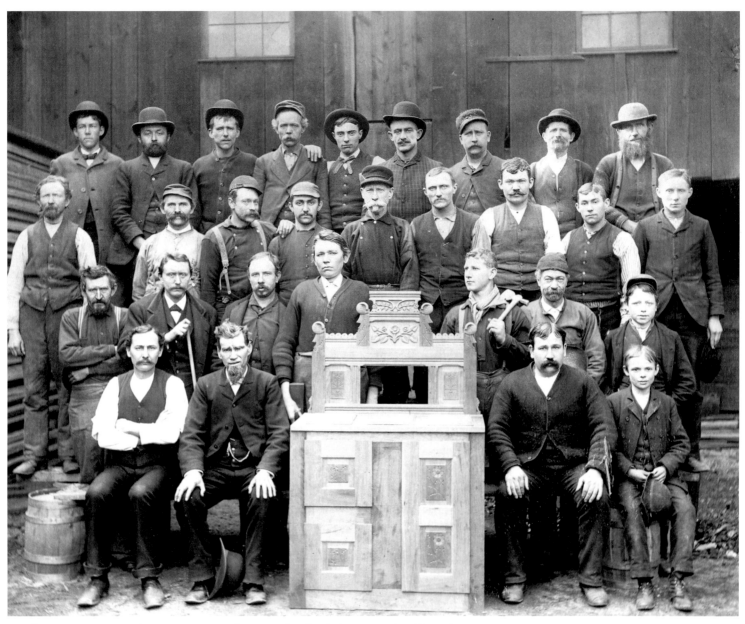

Joseph W. Wayne was the western manufacturer of Schooley's patented self-ventilating refrigerators which kept perishable items fresher. Besides refrigerators, they also manufactured wash-boards, folding tables, beer coolers and roller skates from 1866-1898.

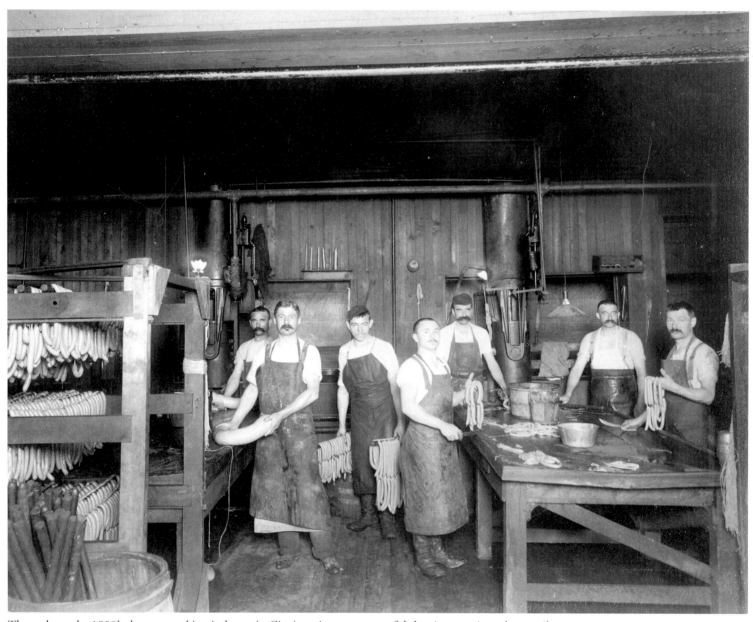

Throughout the 1800's the meatpacking industry in Cincinnati was so successful the city was given the moniker "Porkopolis". In 1880 there were sixty-eight pork and beef packers and twenty-five sausage makers in the city.

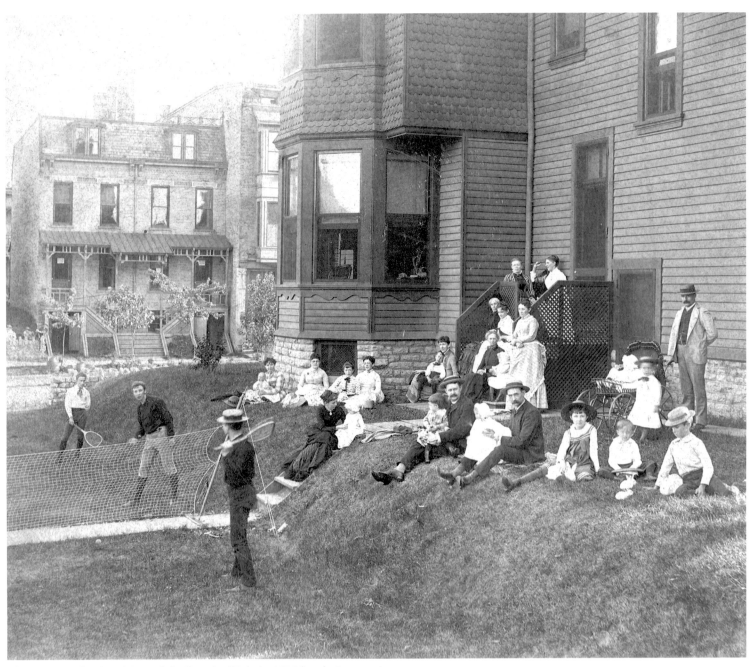

The Hargrave family celebrated the Fourth of July in 1885 by playing tennis in their side yard.

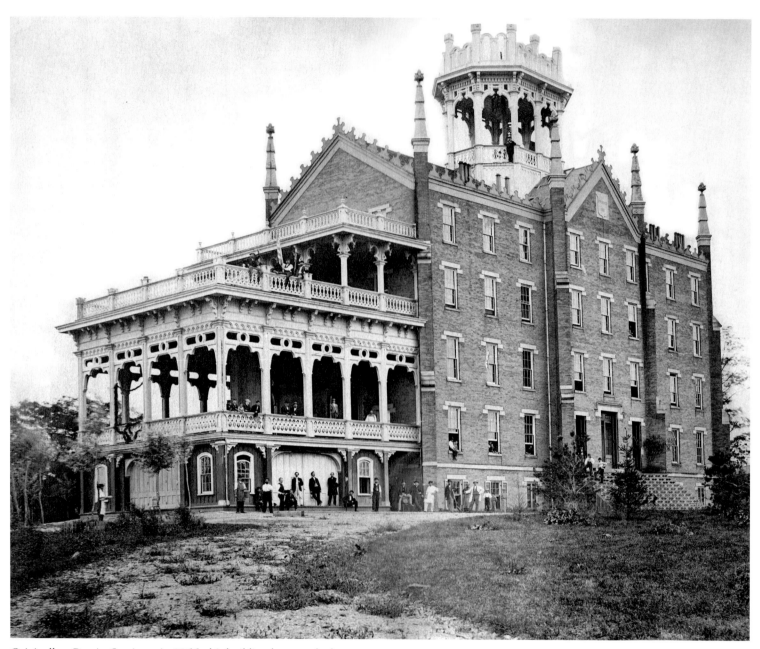

Originally a Baptist Seminary in 1866, this building became the home of the Schuetzen Verein, the German Shooting Society. In 1868 a beer garden, picnic grounds and bowling alley were added. It was driven out of business by other hilltop venues accessible by inclines.

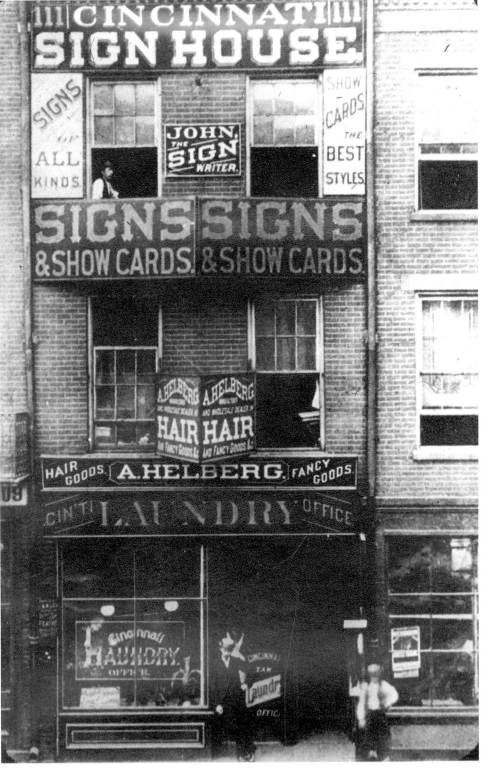

An 1880's storefront on West Fifth Street housed several business establishments including Cincinnati Laundry, Cincinnati Sign House and A. Helberg's Fancy Goods, manufacturers of hair goods and wholesale dealers in ladies' fancy notions.

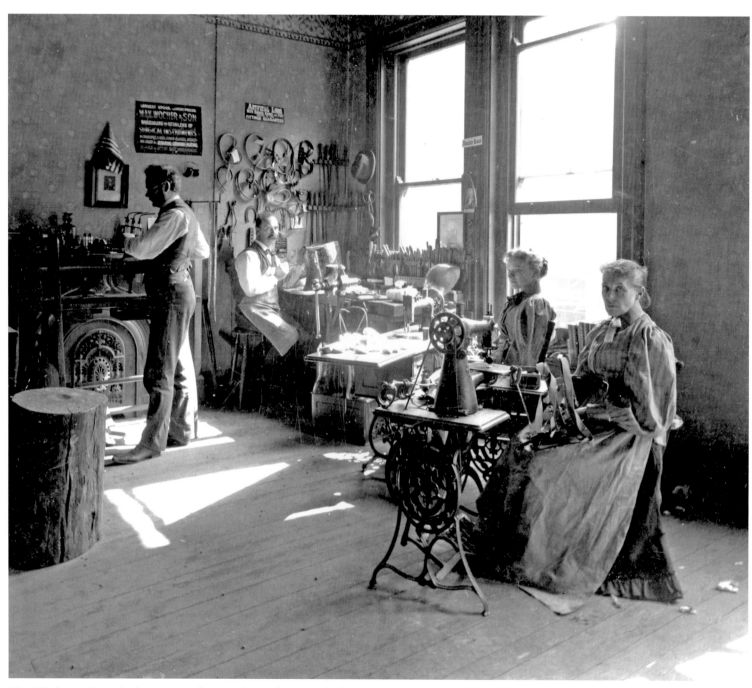

Max Wocher & Sons Co. began manufacturing bowie knives and other cutlery. They grew into one of the largest suppliers of hospital furniture, surgical instruments and orthopedic appliances. Seen here is the sewing room about 1896.

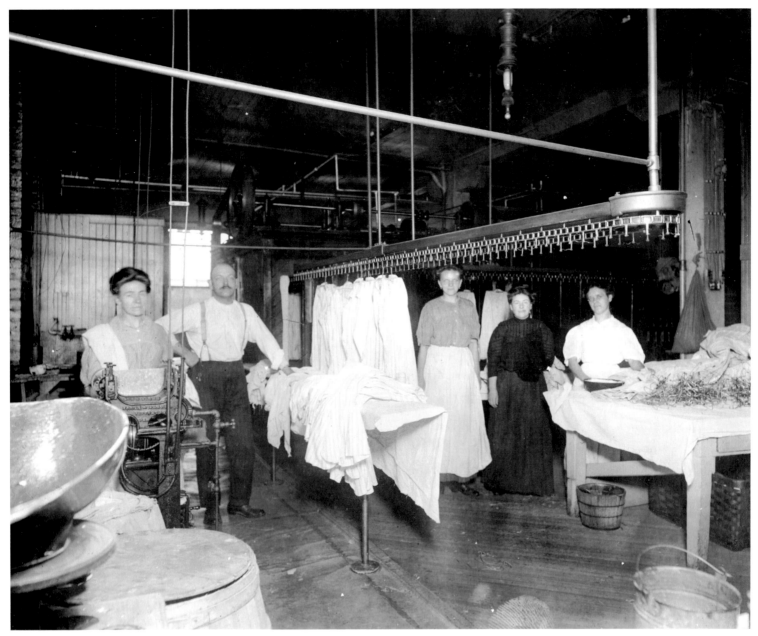

The White Star Laundry at Ninth and Sycamore employed 50 people in 1886 using the finest equipment known. In 1888 they received the only medal ever given to a laundry.

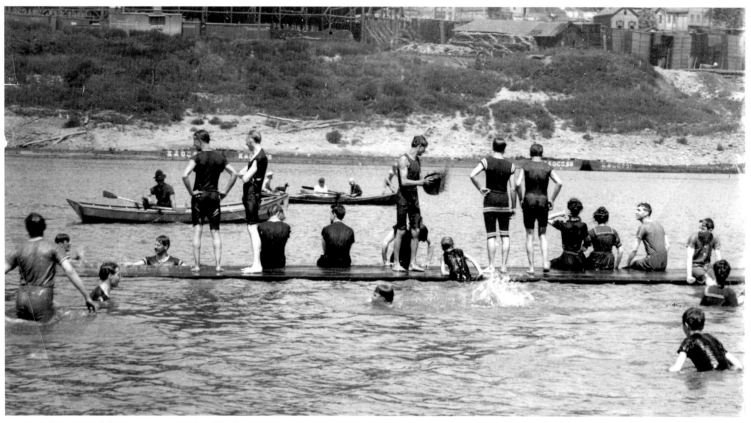

Around the turn of the Century crowds of bathers on the beaches of Dayton and Bellevue, Kentucky could be seen from the Cincinnati shore of the Ohio River.

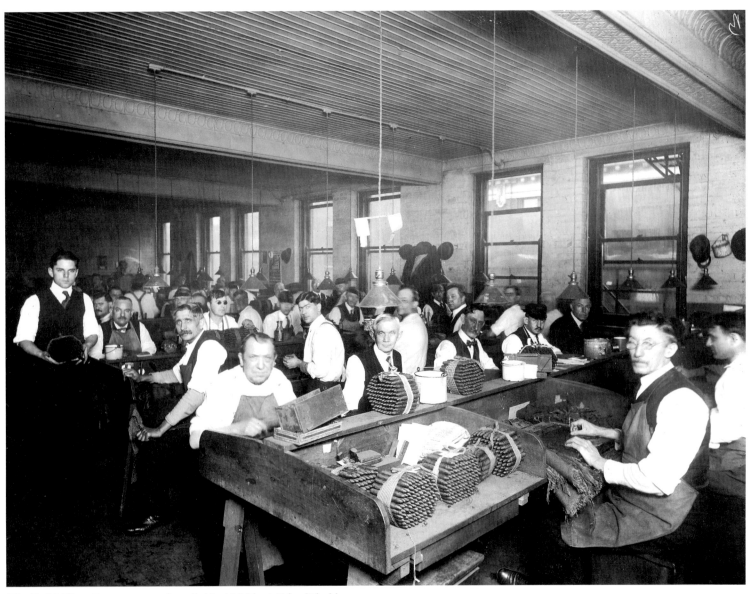

The Ibold Cigar Company was founded in 1884 by Michael Ibold.
The company was the nation's second largest broadleaf cigar maker.
These men would each make an average of 250 cigars in an eight-
hour day at the turn of the twentieth century.

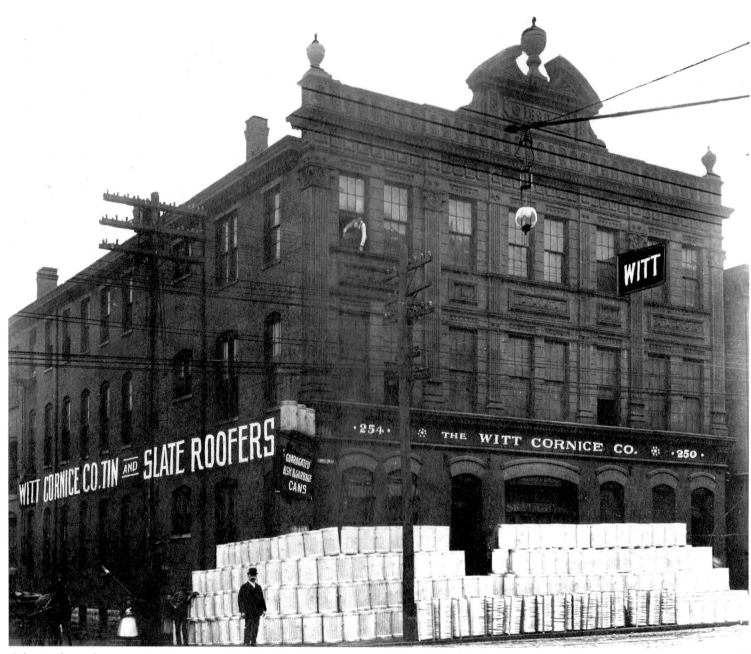

Galvanized metal cans await shipment to the U.S. War Department in 1899. Originally manufacturers of roofing and cornices, the Witt Cornice Company expanded into the business of making fireproof cans to safely and sanitarily hold hot ashes and other garbage.

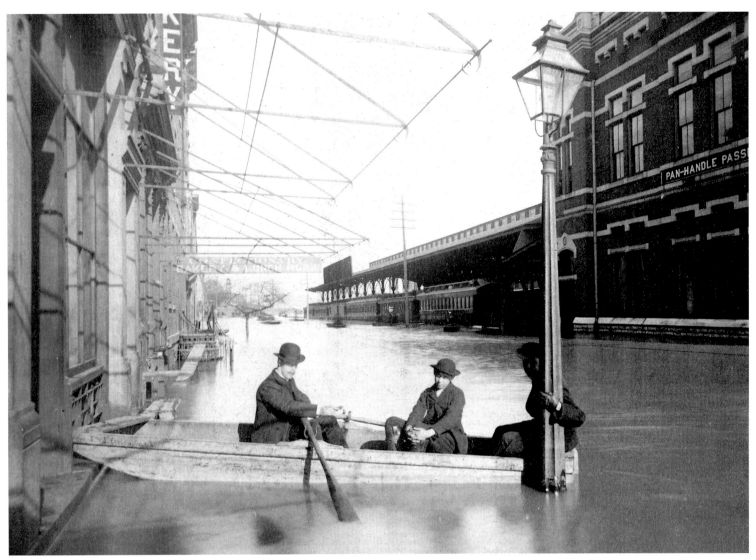

The view on Pearl Street as it looked facing east from Butler in 1884 during the second devastating flood in a year. The Ohio River crested at 71.1 feet.

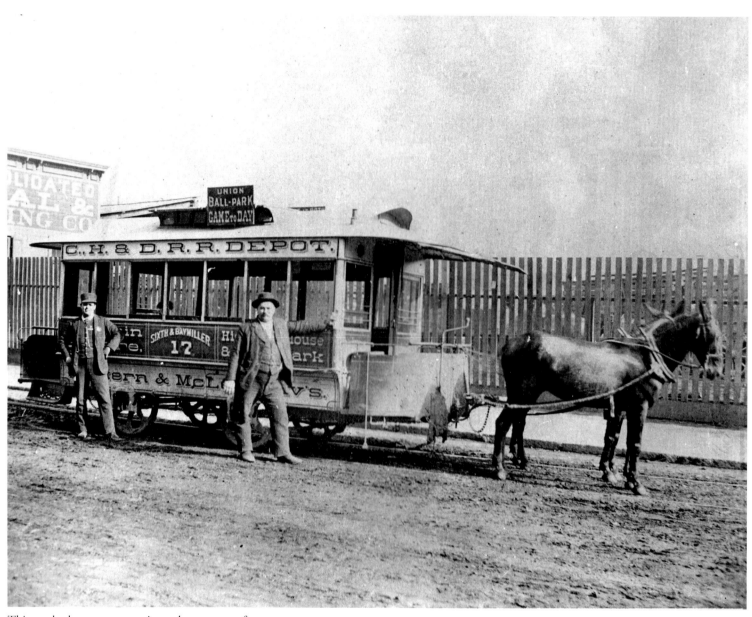

This mule-drawn streetcar is ready to escort fans to a
baseball game at Union Park in 1883.

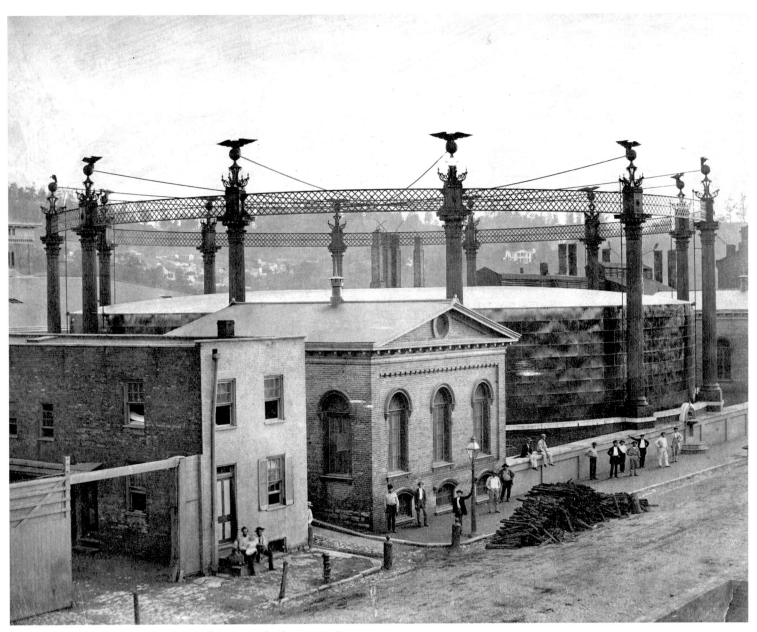

The Gas Works on Front Street west of Rose was built circa 1860 on
the site called Hobson's Choice where General "Mad" Anthony Wayne
trained his army in 1793.

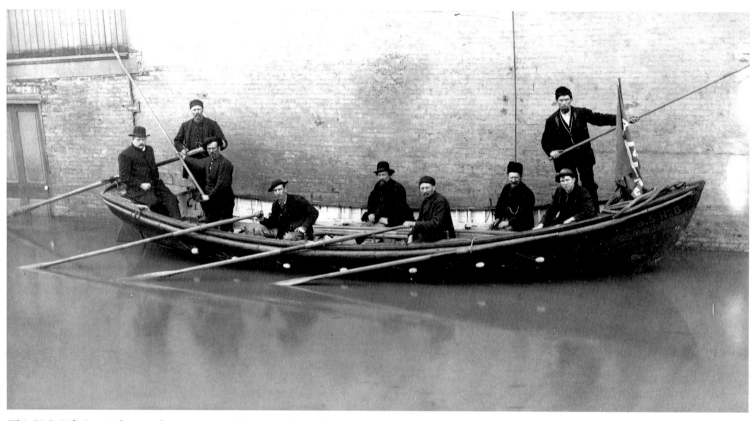

This U.S. Life Service boat and crew came to Cincinnati from Cleveland to assist with flood relief in 1883. They worked under the auspices of the Masonic Relief Committee of Cincinnati.

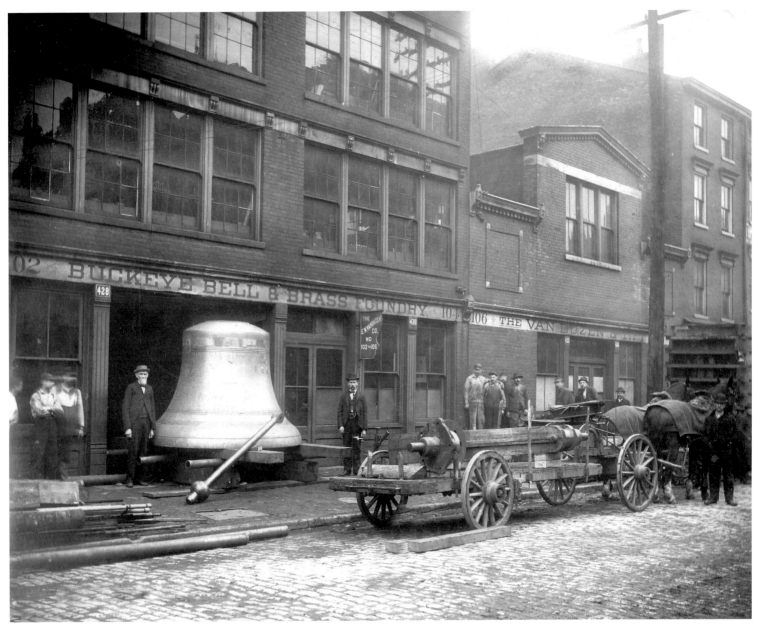

"Big Joe" is shown leaving the Buckeye Bell and Brass Foundry in 1895 en route to its home in the steeple of St. Francis de Sales Church. The massive bell was rung only once because the E-flat peal was so deafening it shattered windows and shook surrounding buildings.

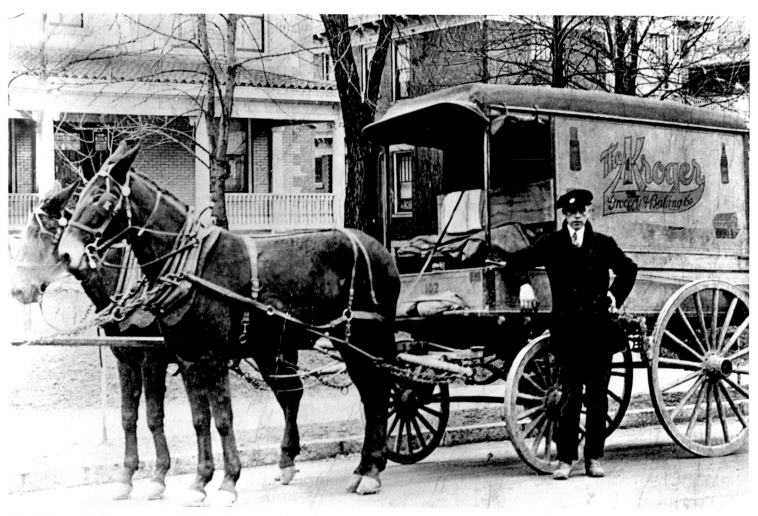

The bright red delivery wagons with the firm name lettered in gold were an early form of advertising for the Kroger Grocery and Baking Company in the 1880's.

Pneumatic or air-filled tires provided a more comfortable ride for bicyclists but were more prone to punctures. Members of the Brighton Bicycle Club became experts at changing tires.

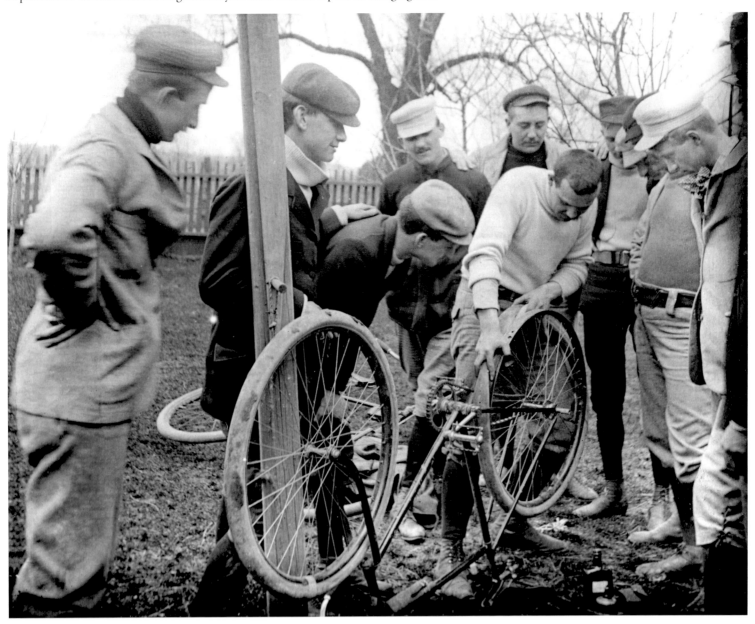

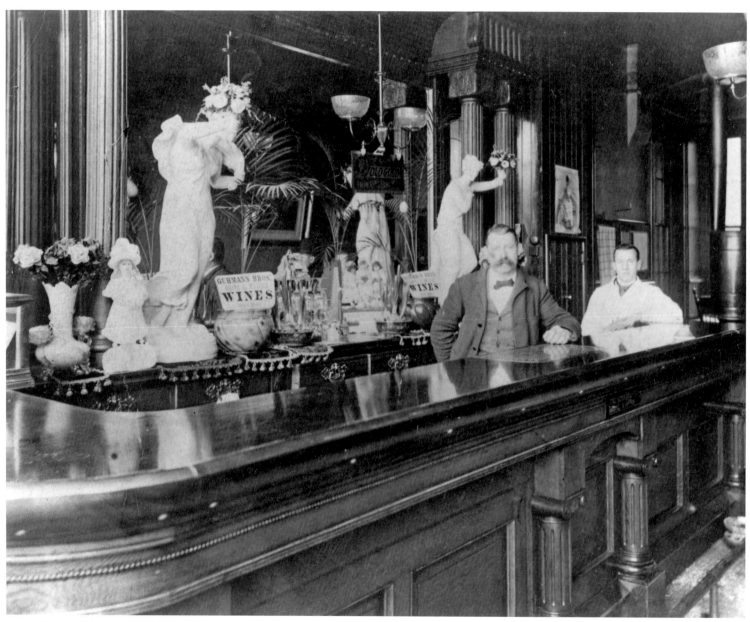

The Schwartz Saloon on McMicken Avenue was typical of the many neighborhood saloons that dotted the city in the late nineteenth century. In 1890 there were more than 1,800 saloons listed in the Cincinnati City Directory.

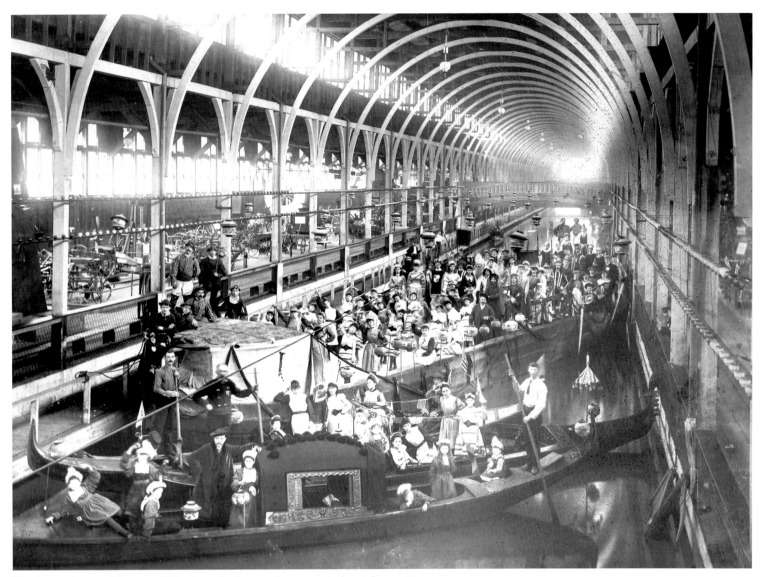

The last and most elaborate of Cincinnati's nineteenth century industrial expositions was the Centennial Exposition of the Ohio Valley and Central States in 1888. With the Miami and Erie Canal converted into a Venetian waterway complete with gondolas, the exposition featured a spectacular production of the *Carnival of Venice*. Here, members of the cast pose for a photograph.

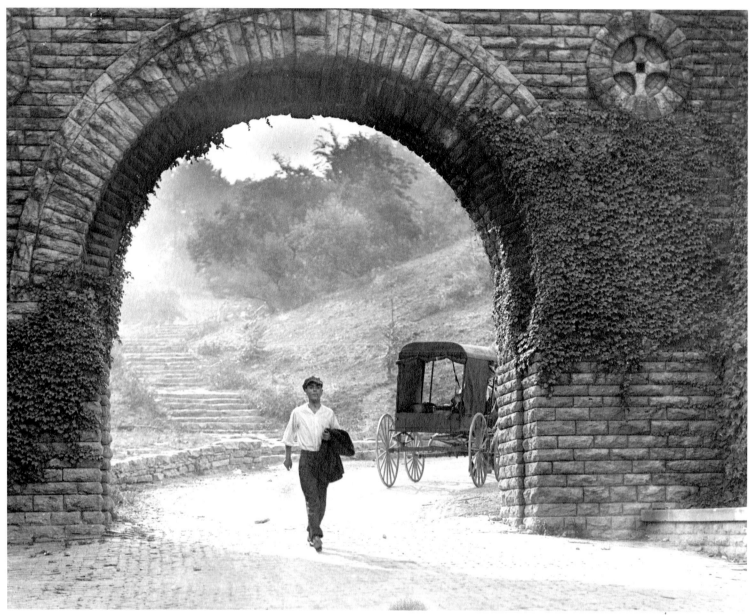

The archway of the Elsinore Tower once served as an entrance to Eden Park. Inspired by the castle in Shakespeare's *Hamlet*, the Elsinore Tower was built in 1883 as a valve house for use by the city waterworks to control the flow of water from the Eden Park Reservoir to the city below.

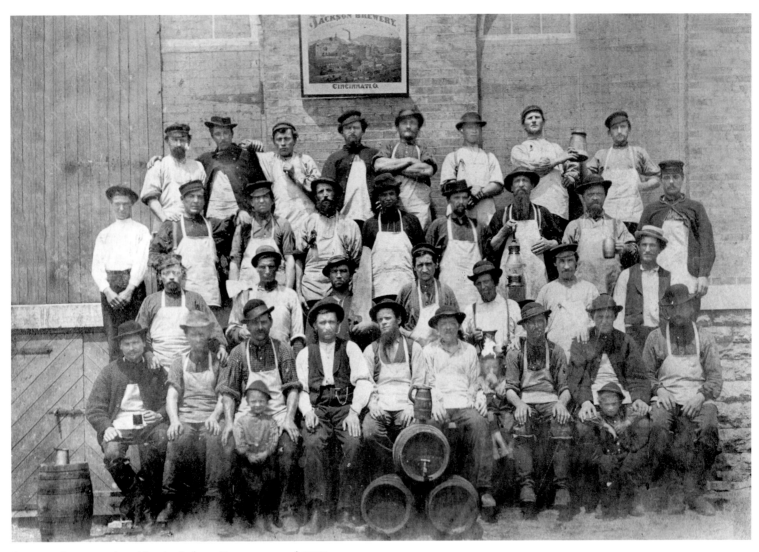

A group of men employed by the Jackson Brewery around 1870.
In 1871 this brewery was the fifth largest in Cincinnati.

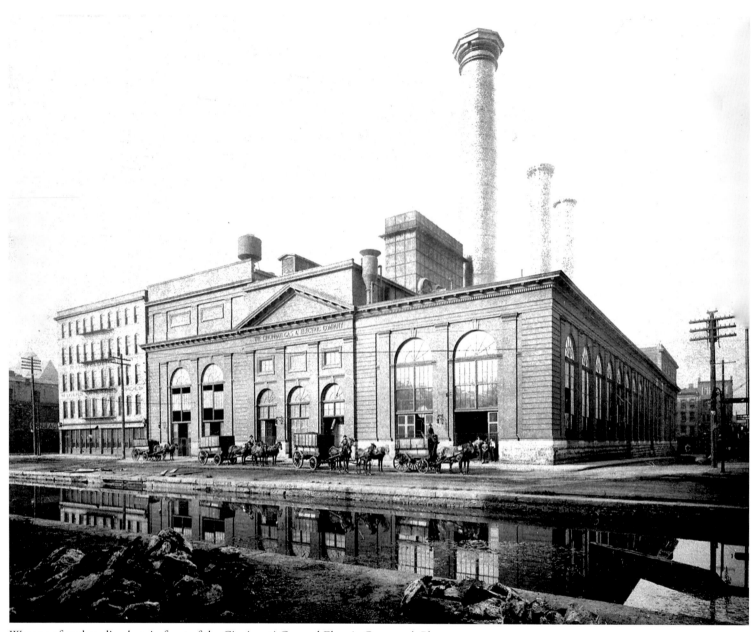

Wagons of coal are lined up in front of the Cincinnati Gas and Electric Company's Plum Street Power Station in the early 1900's. Located along the Miami and Erie Canal, this station had a generating capacity of 4,000 kilowatts when it first opened in 1899.

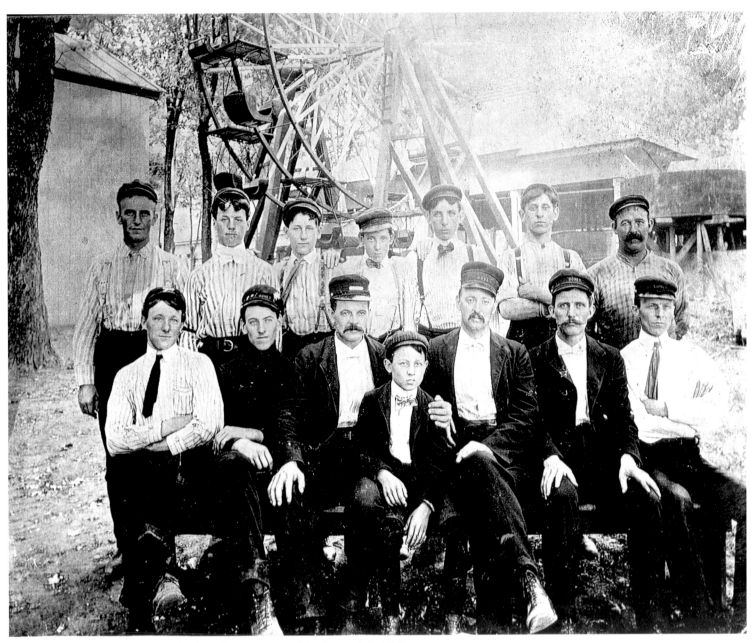

Taken about 1888, this Coney Island work crew is posed in front of the Flying American. This Ferris wheel type amusement park ride predates George Ferris' famous wheel, which made its debut at the Chicago World's Fair in 1893.

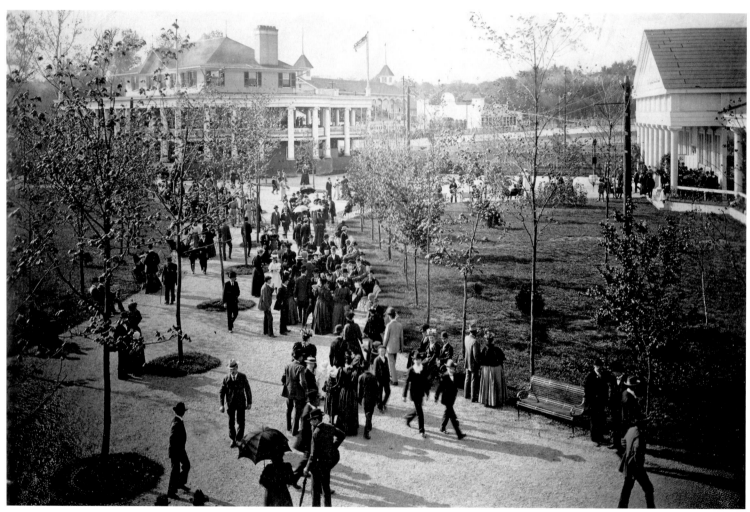

Adults and children alike enjoy a leisurely afternoon at Chester
Park about 1898. This popular local amusement park opened
in 1875; however, it was unable to survive the Great Depression
and was forced to close in 1932.

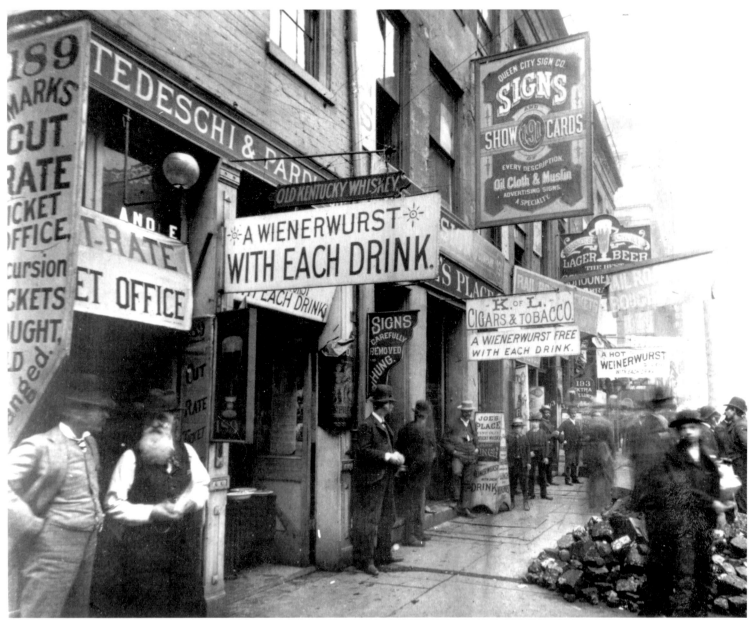

"Nasty Corner" was the name given to the southwest corner of Fifth and Vine Streets in the 1890's because of the large number of saloons concentrated on that corner. The German influence in the city can be seen in the signage. The Carew Building and later Carew Tower were constructed on this site.

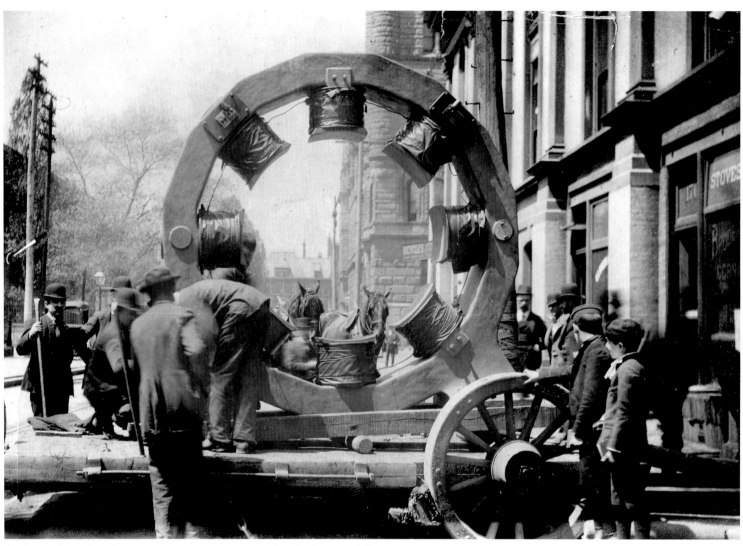

Workmen delivering electric generating equipment to the Ninth Street Substation of the Cincinnati Gas and Electric Company. In 1904 City Council fixed the maximum rate for electricity at 11 cents per kilowatt-hour.

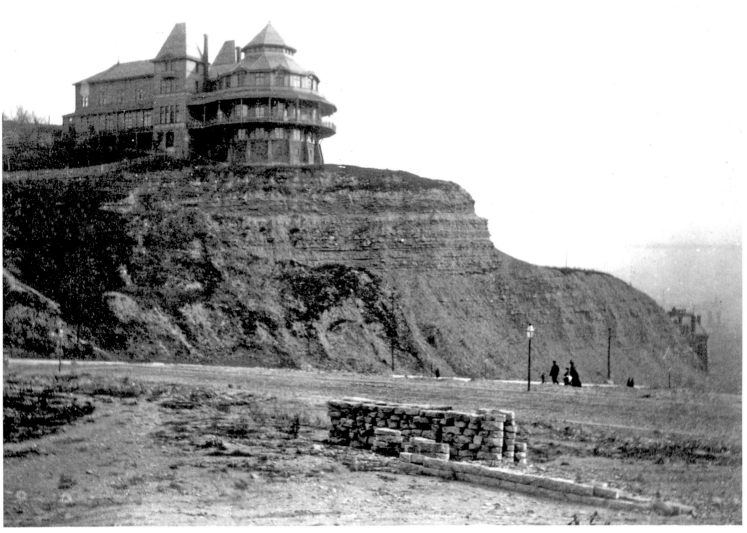

Designed by prominent local architect James W. McLaughlin and
erected in 1876, the Bellevue House was located adjacent to the
Bellevue Incline, high above the smoke and heat of Cincinnati's basin
area. This ornate hilltop resort provided its customers with food, drink,
entertainment, and a sweeping view of the city until it finally went out
of business around 1895.

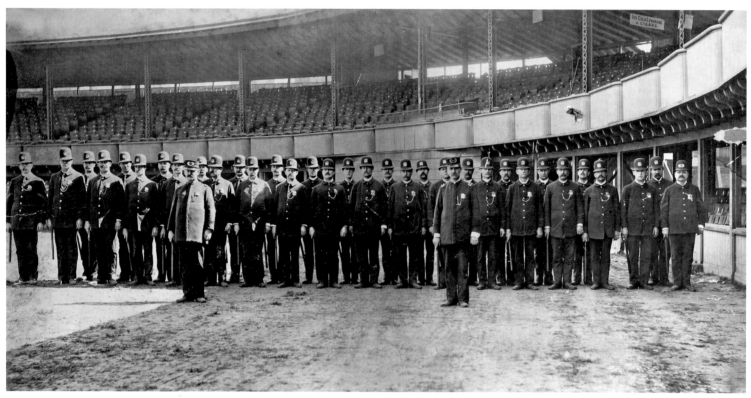

Beginning in 1887 the Cincinnati Police Force began staging an
annual inspection, review, and parade to which the public was
invited. Up until 1901, this yearly event was often held at League
Park, which was the home of the Cincinnati Reds Baseball Club.

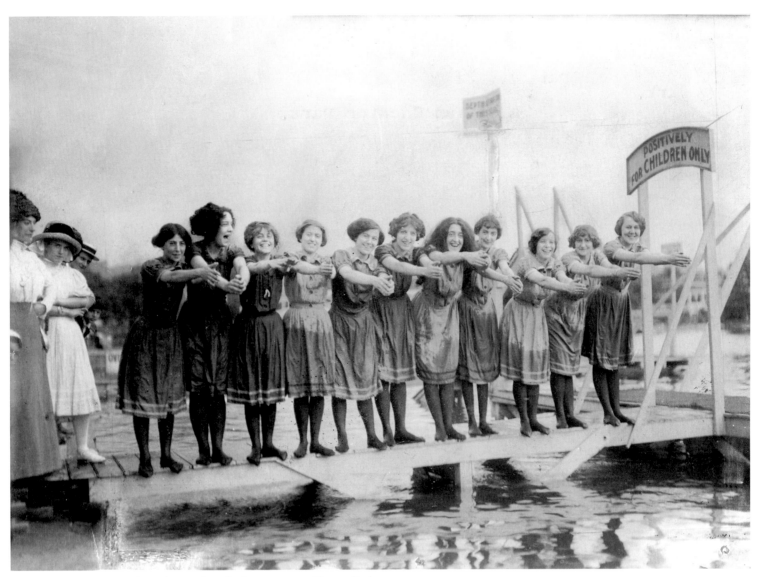

Bathing beauties line up for a dive in the refreshing water at Chester Park.

This bustling intersection at Fifth and Walnut Streets was the scene of the Drach explosion in 1896. Escaping gasoline fumes caused a terrific explosion that resulted in the collapse of several buildings and a number of deaths.

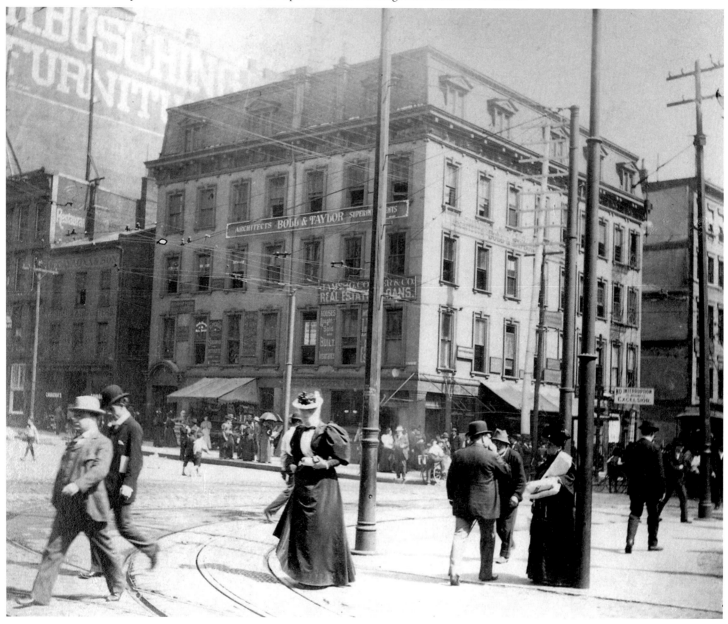

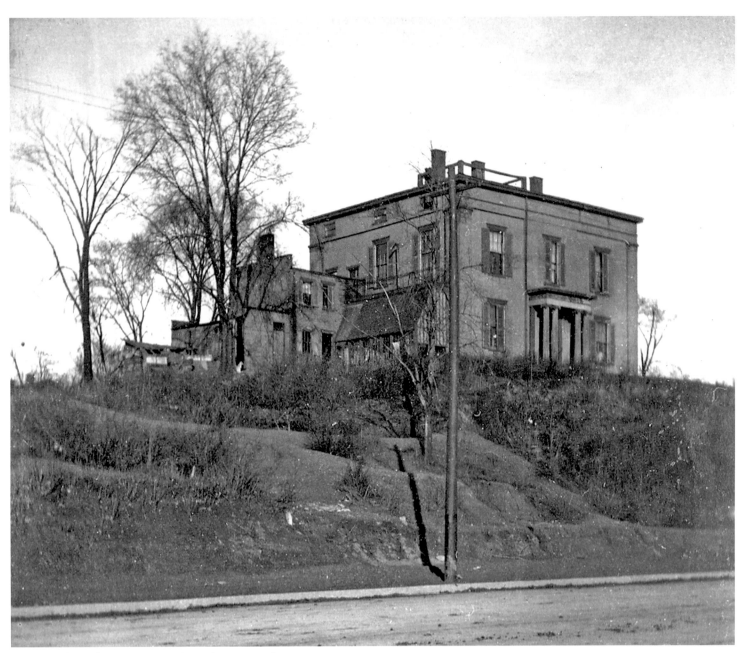

The Hopple residence on Spring Grove Avenue was home to the family who owned a large part of the land on which Spring Grove Avenue was built. The home was torn down in 1900.

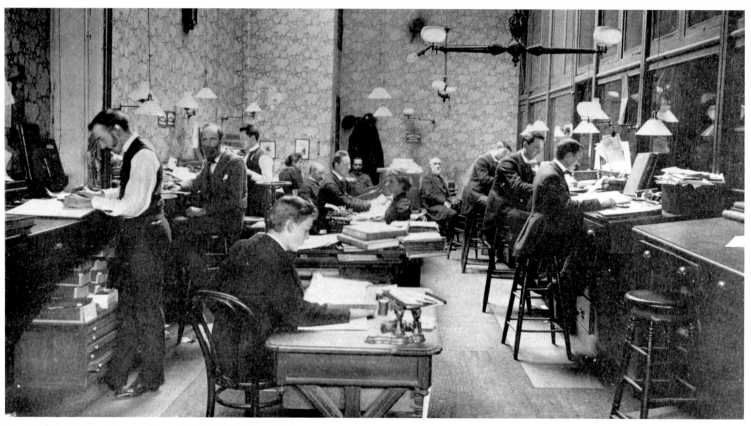

Clerks in the Walnut Street office of D. H. Baldwin and Company, piano manufacturers, are busy at work in September 1891. Business partners sat at the center rear of the room.

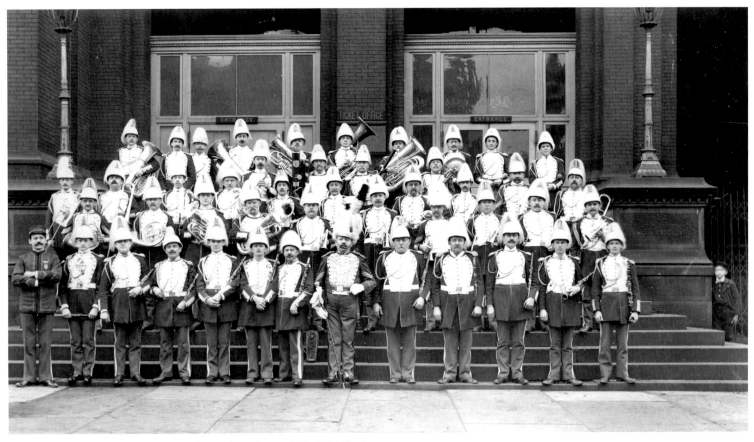

Smittie's Band, led by George G. Smith stands in front of Music Hall. Four
generations of Smith's have led the band in major parades, inaugurations,
fairs and concerts in the city.

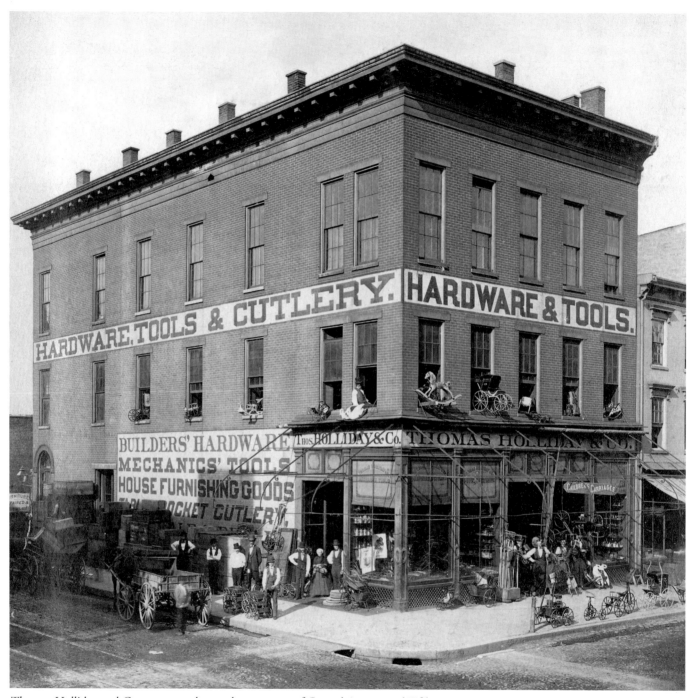

Thomas Holliday and Company on the northeast corner of Central Avenue and Fifth Street manufactured children's carriages and hobby horses as well as hardware and tools. In 1873 indoor photography outside of studios was difficult, so merchants set their wares on the street or hung them from windows to be photographed.

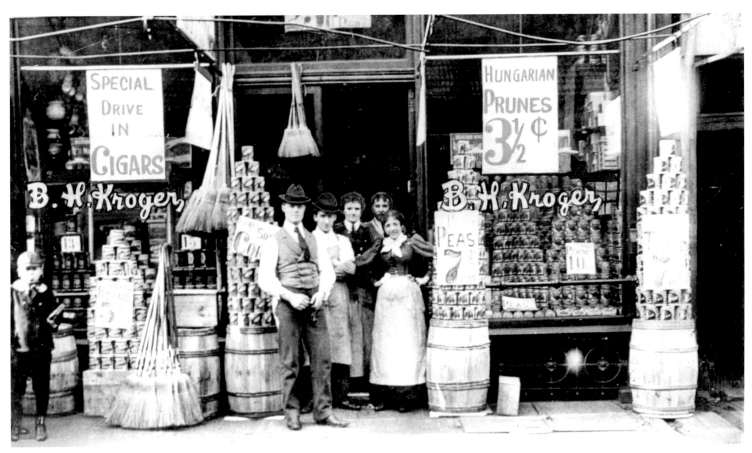

A large selection of canned goods is displayed in front of Barney Kroger's original grocery store location. This store opened in 1883 at 66 Pearl Street, just opposite the Pearl Street Market House.

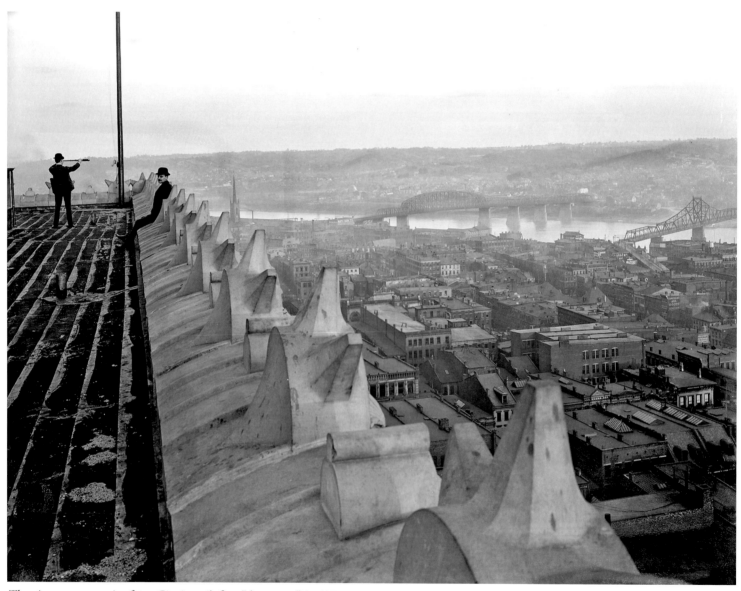

The view was expansive from Cincinnati's first "skyscraper" in 1901.
From the top of the Union Savings Bank and Trust Company Building
at Fourth and Walnut, you could look down into the smoky basin of the
city or across to the rolling hills of the Bluegrass State.

THE EXPANDING CITY:
CINCINNATI ENTERS THE NEW CENTURY

1900-1920

During the first two decades of the twentieth century, the City of Cincinnati undertook an aggressive program of annexation. By absorbing more than a dozen suburban communities from Mount Washington to Sayler Park, city leaders brought the middle-class tax base and talent pool back within city boundaries. In a parallel burst of energy, developers transformed the basin into a modern downtown, marked by signature skyscrapers and massive department stores.

Though unable to extricate itself from the grip of corrupt and inefficient political bossism, Cincinnati took some steps towards a better city. In 1907 the City commissioned George Kessler to develop a parks and parkways plan that guided the development of greenspace for over five decades.

The entrance of the United States into World War I against Germany in April 1917 had far-reaching consequences. The school board terminated the extensive German language program in the elementary schools, City Council changed the names of 13 streets with German-sounding names, and many families of German descent felt pressured to anglicize their names. The adoption of wartime prohibition of alcohol and the 18th Amendment in 1920 just piled on additional adjustments for a city of breweries and saloons.

As the city mobilized and local men signed up for military service, their places were taken in factories by women and by African Americans who were migrating north in large numbers. By the time the war ended in November 1918, over 1,300 local soldiers had given their lives.

The first twenty years of the new century drew to a close with the city starting one of its most ambitious, and ultimately controversial projects, the construction of a 16-mile rapid transit loop, including a subway system in the bed of the old Miami and Erie Canal.

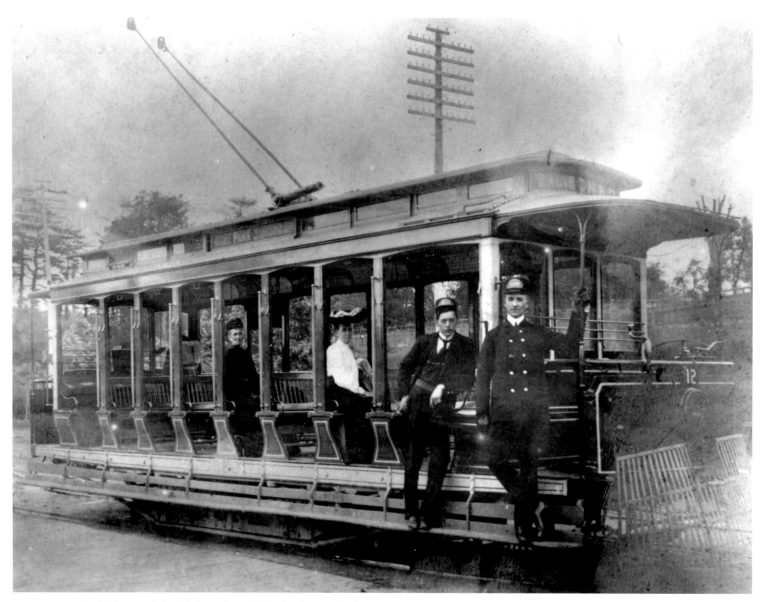

Summer car 12 which served the Madison Road-Hyde Park route had nine
benches with a seating capacity for 45 passengers. Open-sided streetcars
such as this one provided a pleasant way to climb the hills of the Queen
City on a hot summer day in the early 1900's.

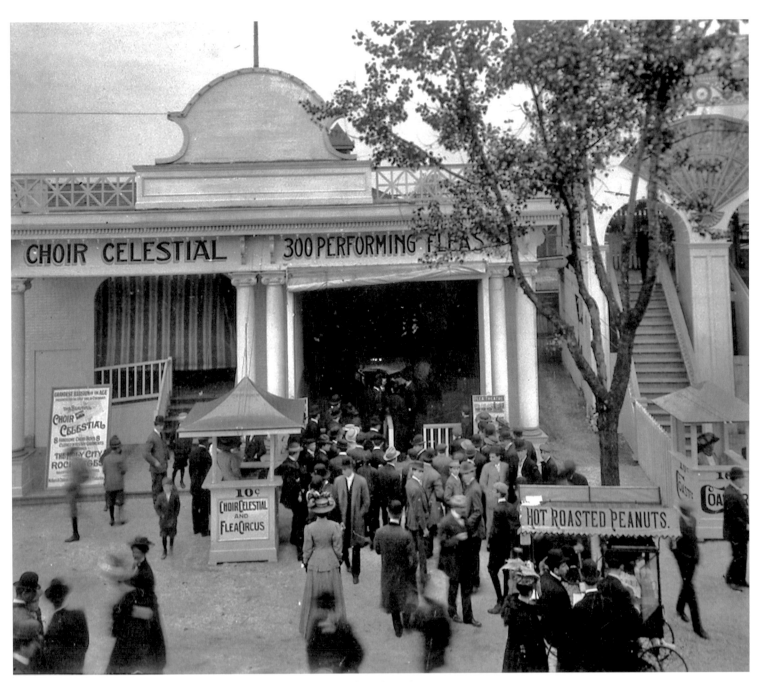

Three hundred fleas and eight handsome choir boys performed side-by-side in the theater on the Coney Island midway at the turn of the century.

Roman Catholic faithful kneel to pray at the crucifixion shrine after climbing the 120 hillside steps to the Church of the Immaculata in Mt. Adams in the early 1900's. This Good Friday tradition has continued for close to 150 years.

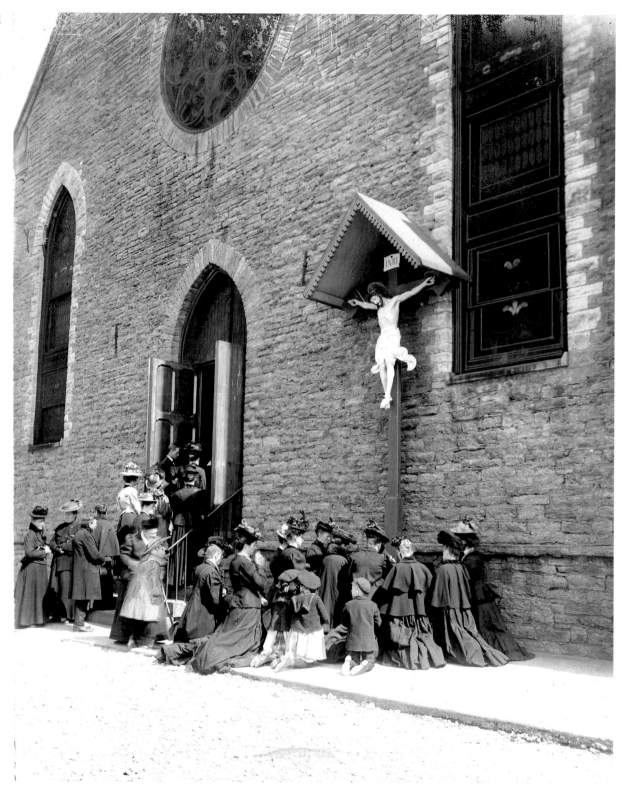

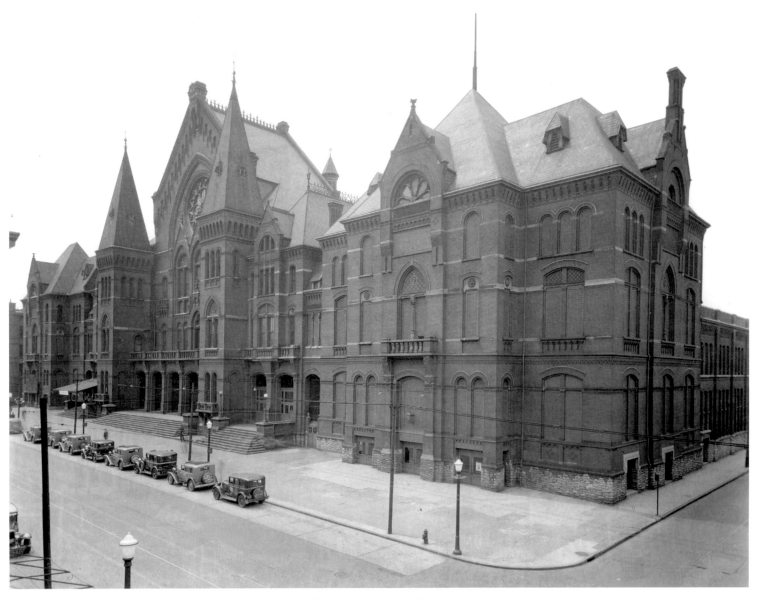

In 1878 Cincinnati celebrated the completion of one of the finest and most beautiful music and exhibition halls in the world. Since that time Music Hall has been home to the Cincinnati Symphony Orchestra and its stage has been graced by the leading opera, ballet and theater companies, as well as performances by musical artists and orators.

The Ingalls Building designed by architects Alfred O. Elzner and George M. Anderson is under construction in 1903. It was the first reinforced concrete skyscraper in the country. Some period skeptics of the construction technique predicted confidently that the building would collapse of its own weight.

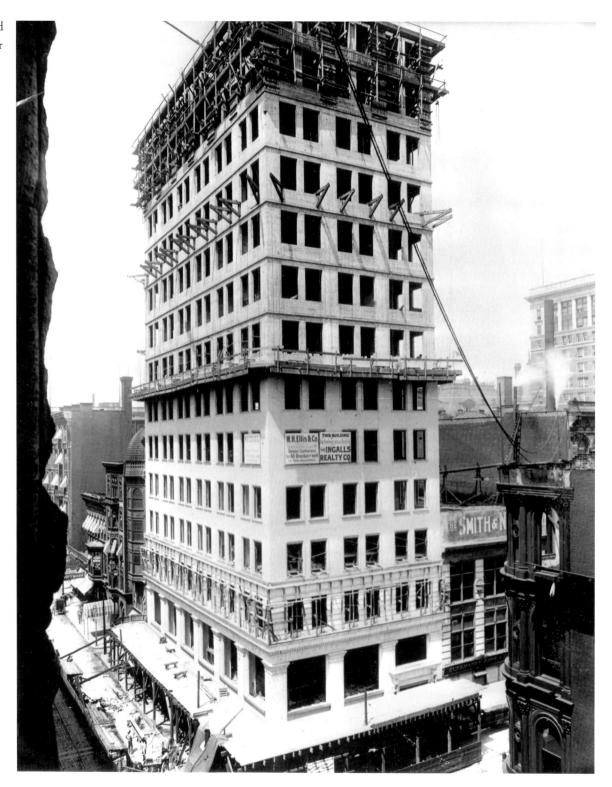

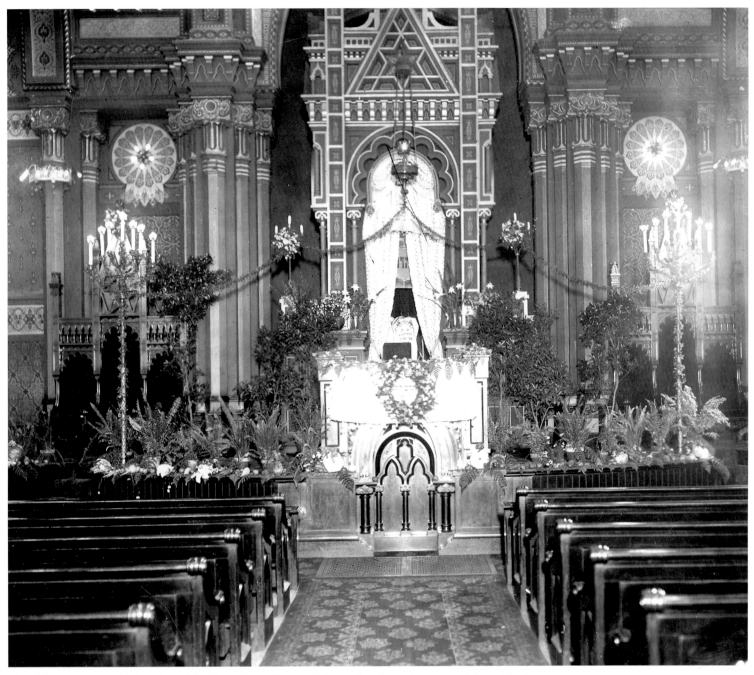

The elaborate neo-gothic interior of the Plum Street (Isaac M. Wise) Temple retains many of the original features such as the flooring, pews, and pulpit furnishings. Chandeliers and other lighting fixtures, converted from gas to electricity, remain in use today. Completed in 1866 by the B'nai Yeshurun reformed congregation, this interior view shows the temple as it appeared in the early 1900's.

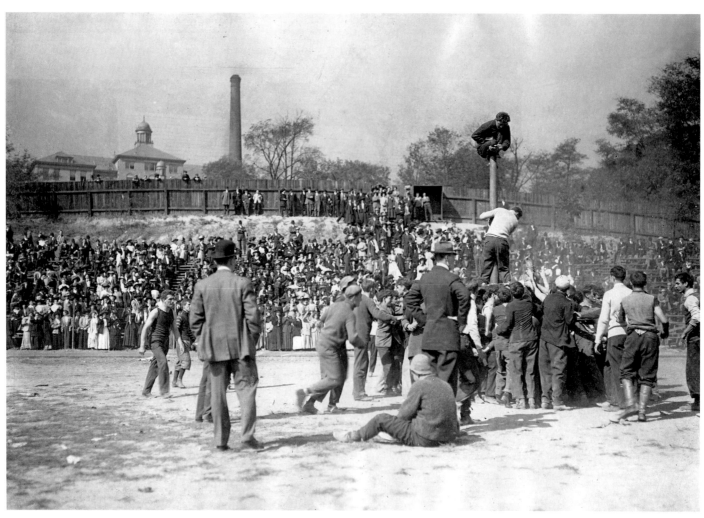

Flag Rush took place annually between freshman and sophomores at the University of Cincinnati to determine physical superiority. The event was discontinued in 1913 because it was deemed too dangerous.

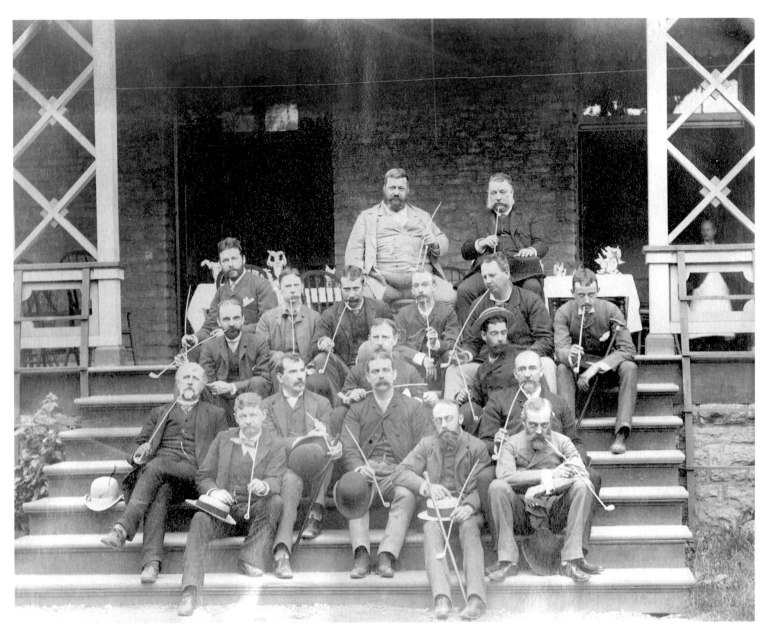

Four young lawyers began daily meetings over lunch at Hengstenberg's Restaurant in 1872. Other prominent Cincinnatians joined them and the group became known as the Hengstenberg Lunch Table. Anywhere from two to twelve men would meet daily for lunch and for a yearly formal meeting.

From 1900 to 1928 the Bode Wagon Company supplied wagons to all the major circuses to carry calliopes, animals, bands and general equipment. Albert W. Bode stands next to a motorized circus wagon prior to World War I.

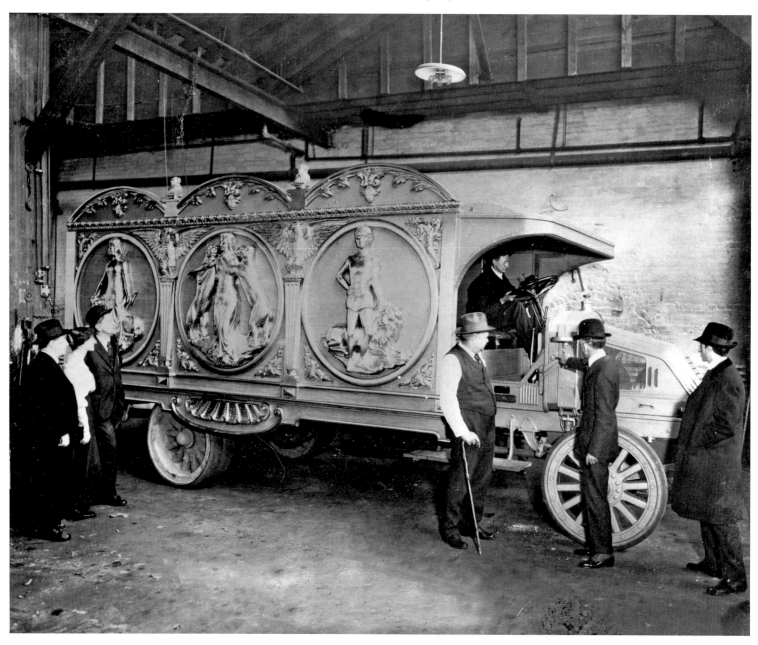

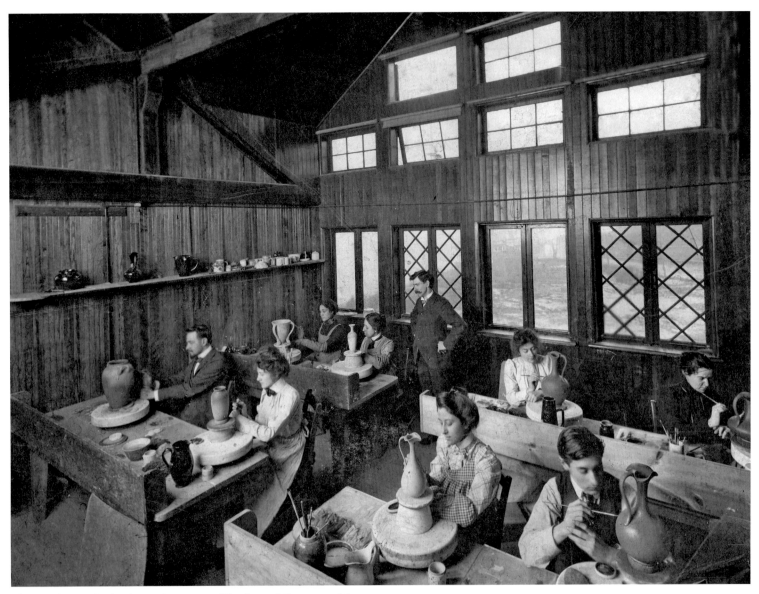

These artists are in the decorating room of Rookwood Pottery on Mount Adams. This picture was posed for use in the Paris Exposition of 1900. Today Rookwood is considered one of America's most collectible makers of art pottery.

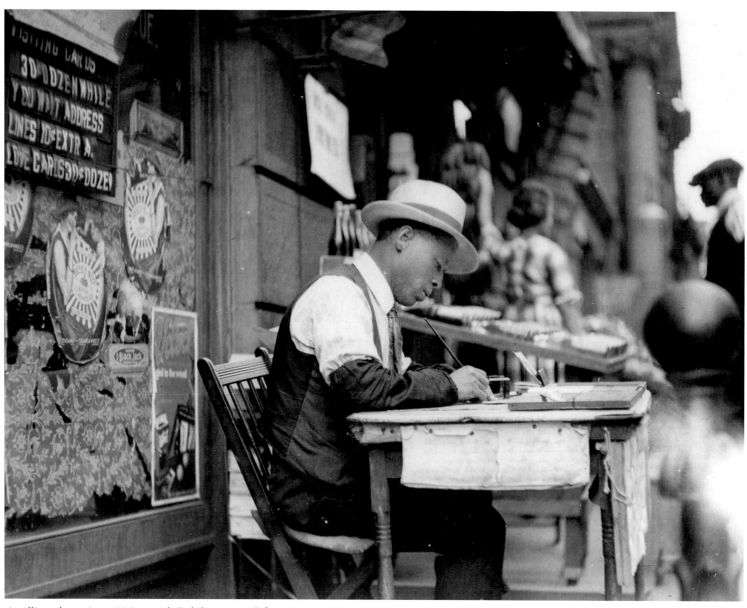

A calligrapher prints visiting cards "while you wait" for 30 cents a dozen
with an additional 10 cents for addressing them in the early 1900's.

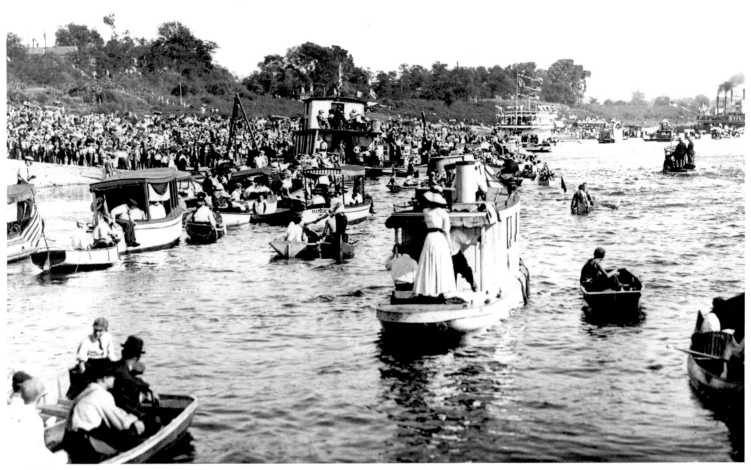

Colorful regattas attracted hundreds of spectators to the Ohio River at the turn of the century. Throngs lined the banks of the river, while others boarded small craft of their own to watch or participate in the race.

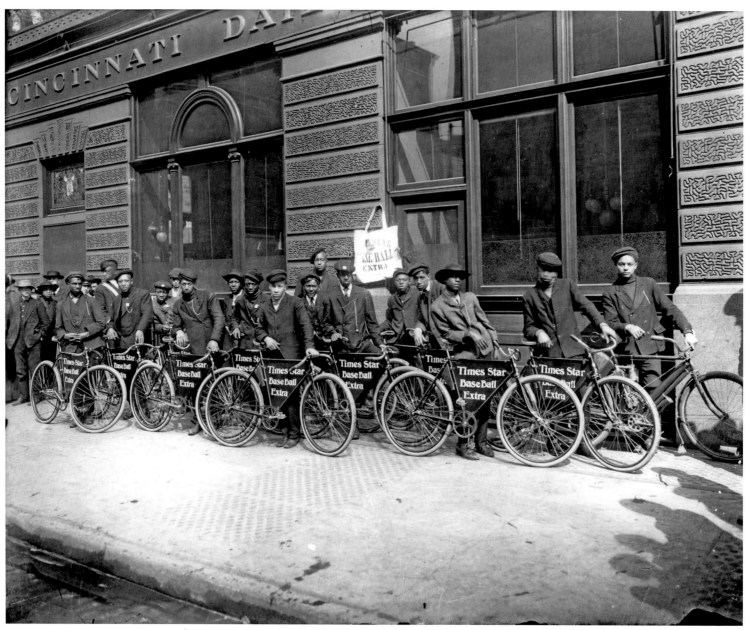

In the early twentieth century selling newspapers on the street was one of the main jobs available to young boys. These newsboys await the baseball edition of the *Cincinnati Times-Star* to deliver on their bicycles.

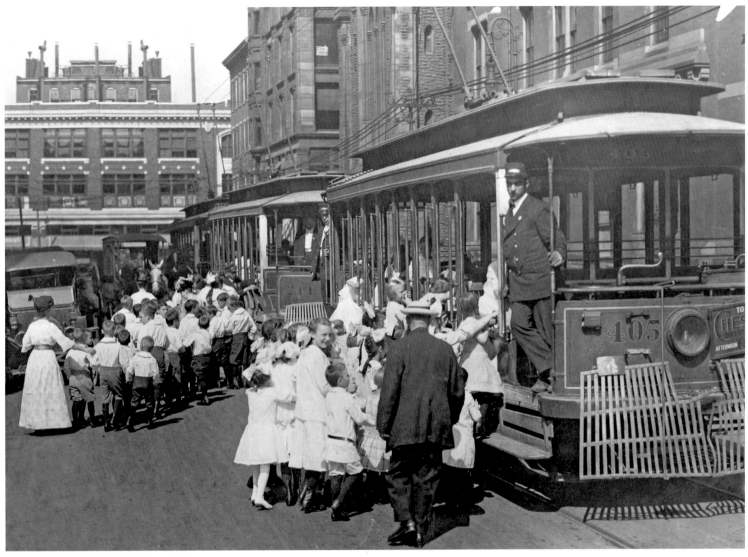

Residents of the Children's Home board
streetcars for a day at the zoo.

Located at Fourth and Walnut Streets, the First National Bank Building sits in the heart of the city's financial district around 1915. This building was completed in 1904, and it was one of four skyscrapers designed by Chicago architect Daniel Burnham that was built in Cincinnati in the early 1900's.

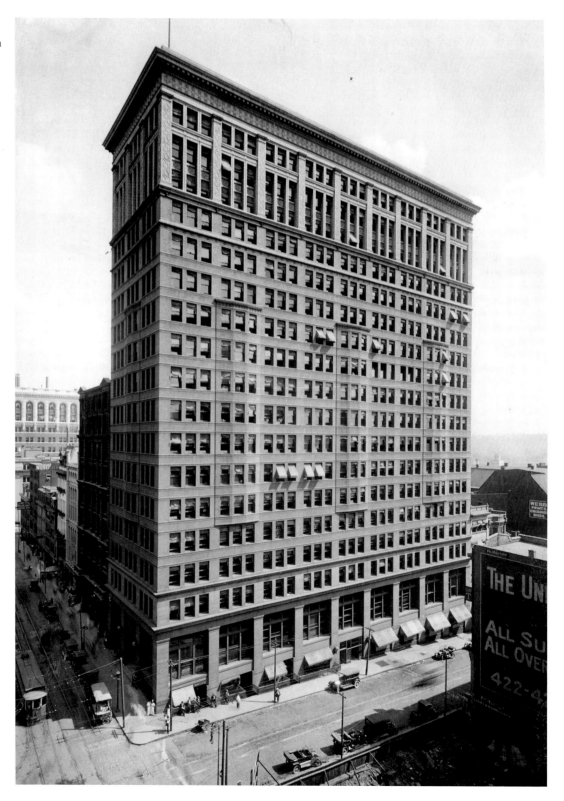

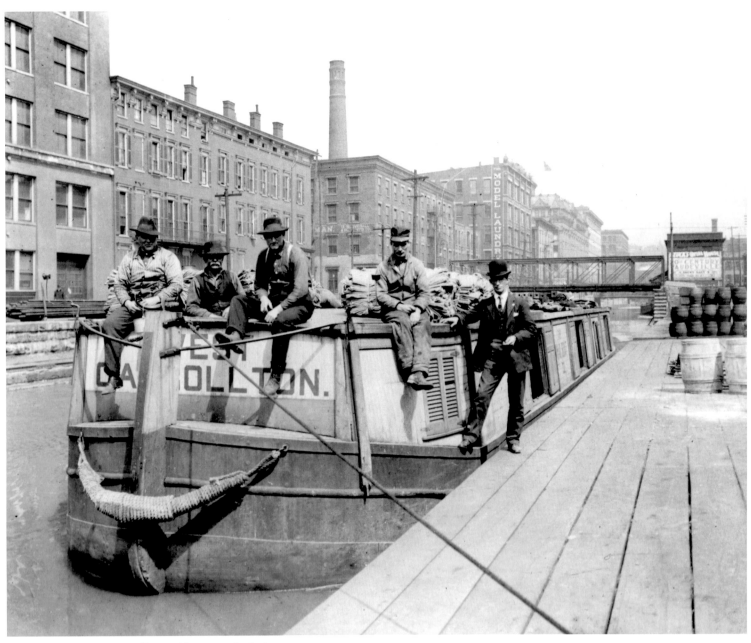

The canal boat *West Carrollton* and her crew docked
along the Miami and Erie Canal about 1905. This
section of the canal later became Central Parkway.

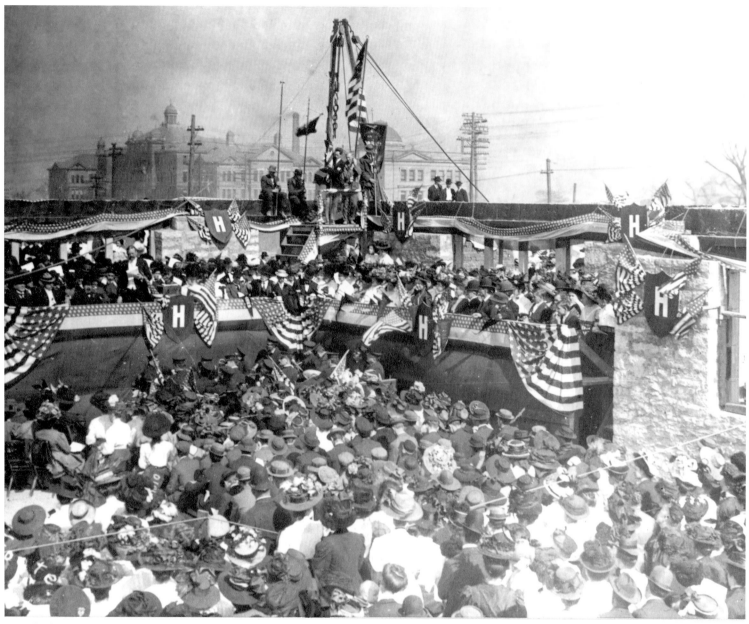

Hundreds watch the laying of the cornerstone of the new Hughes High School on October 16, 1908. This school as well as its predecessor was named for Thomas Hughes, a cobbler, who died in 1824 leaving his estate for the purpose of public education.

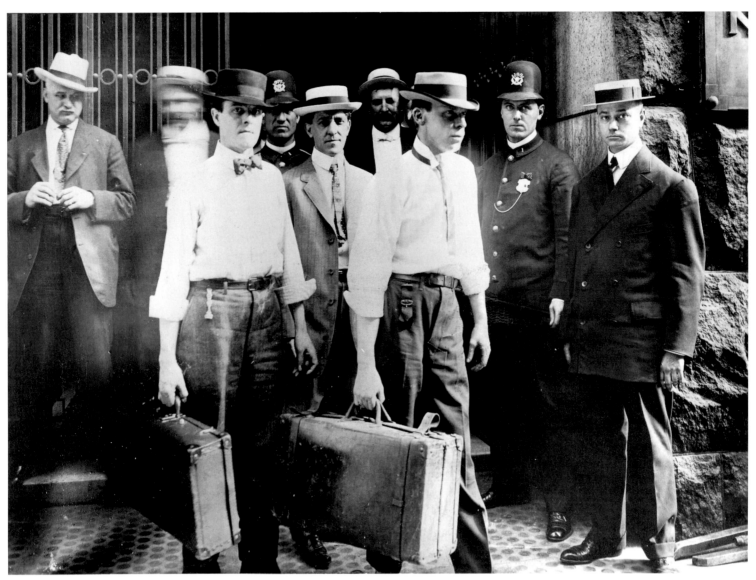

The Third National Bank and the Fifth National Bank consolidated under the name Fifth Third National Bank in 1908. Bank employees are seen here moving out of the Fifth National Banks' old headquarters shortly after the merger.

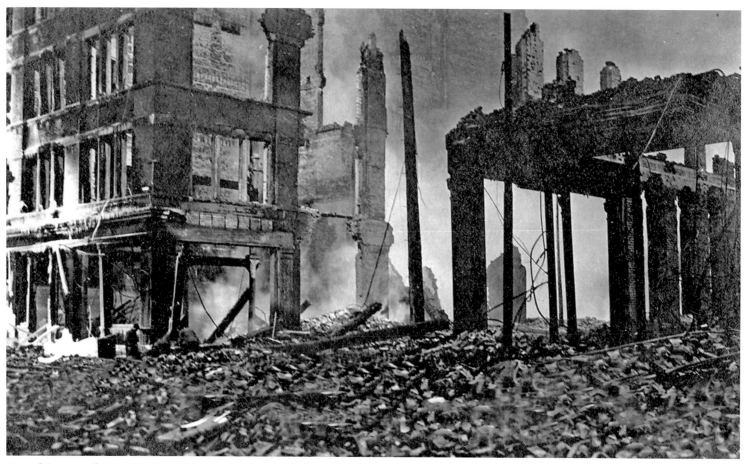

One of the worst fires in Cincinnati history swept a two-block area on Sycamore Street in December, 1910. The fire burned for 222 hours and 49 minutes destroying three shoe factories and several other manufacturers. Three Cincinnati fire fighters died in the blaze.

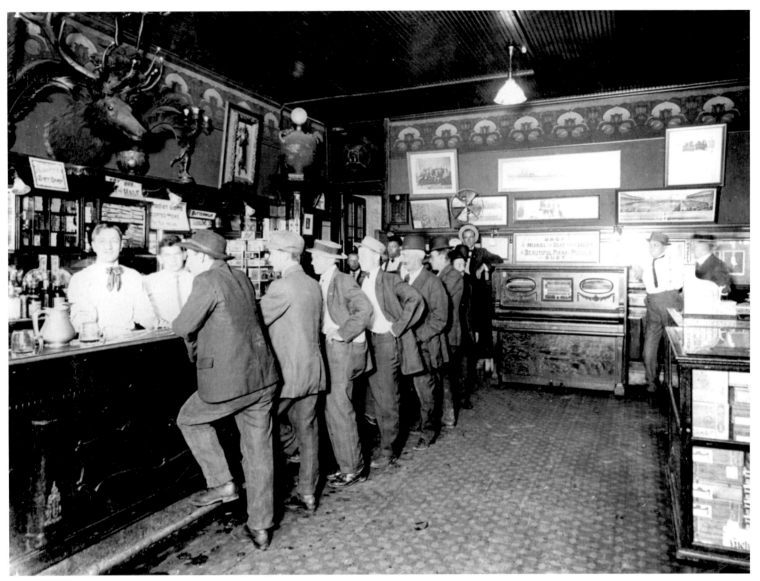

In 1910 you could drop a nickel in the slot of the nickelodeon and hear "a beautiful piano-piccolo duet" at the Garfield Cafe at Eighth and Vine Streets.

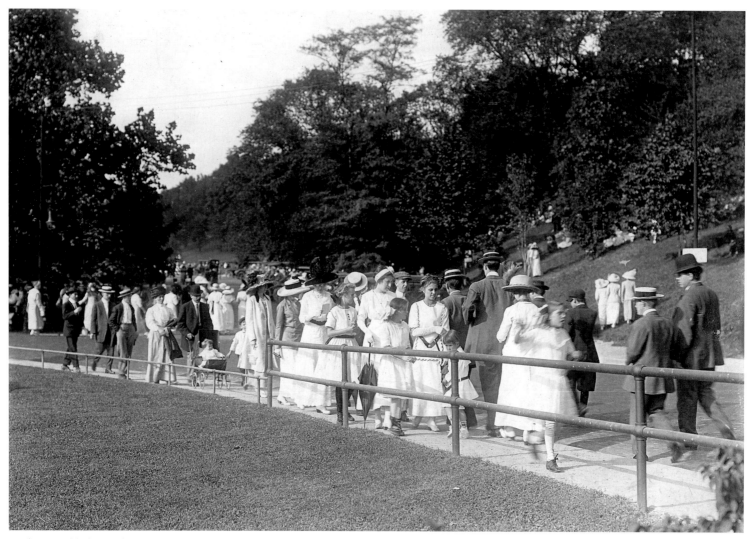

Finely attired ladies and gentlemen promenade through Eden Park about
1910. Conveniently located near the downtown district, Eden Park was
a popular weekend destination that offered its visitors rolling landscaped
hills and an impressive view of the Ohio River.

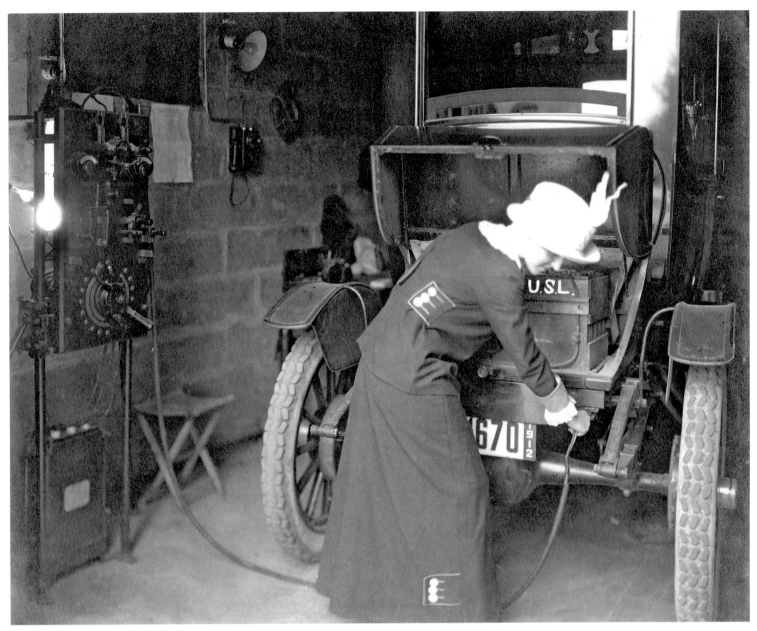

Charlotte Shipley charges up her car for a day's outing in 1912. Electric vehicles were popular in the early 1900's especially for women because they didn't need to be cranked for starting or have their gears shifted.

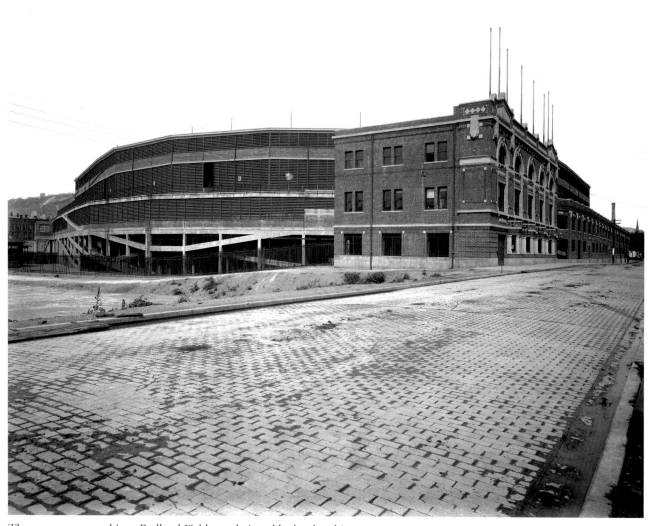

The new cement and iron Redland Field was designed by local architect
Harry Hake and boasted the largest playing area in the major leagues when
it opened in 1912. In 1934 the ballpark's name was changed to Crosley
Field when radio magnate Powel Crosley, Jr. acquired control of the
Cincinnati Reds.

An ice cream vendor is waiting for business at the playground on
Reading Road near Elsinore Place in 1913.

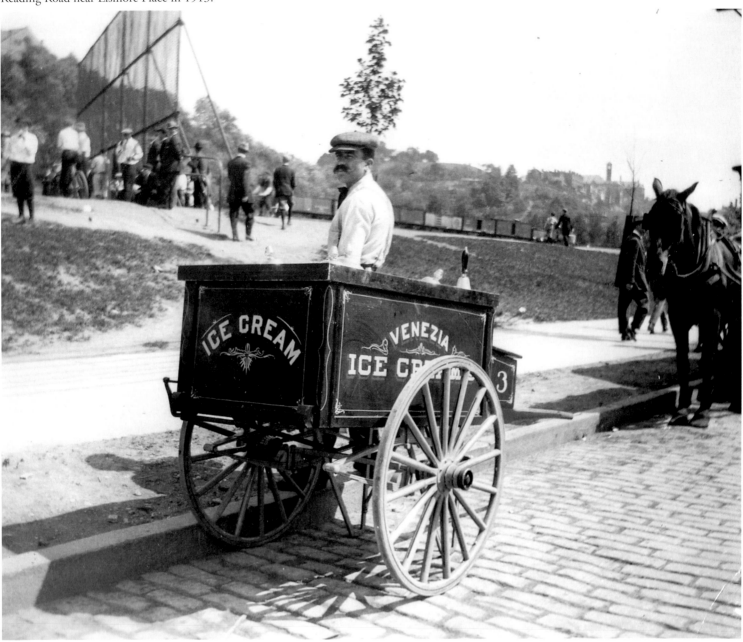

Conductors stand in front of a car on the Highland
Avenue Streetcar line in 1913.

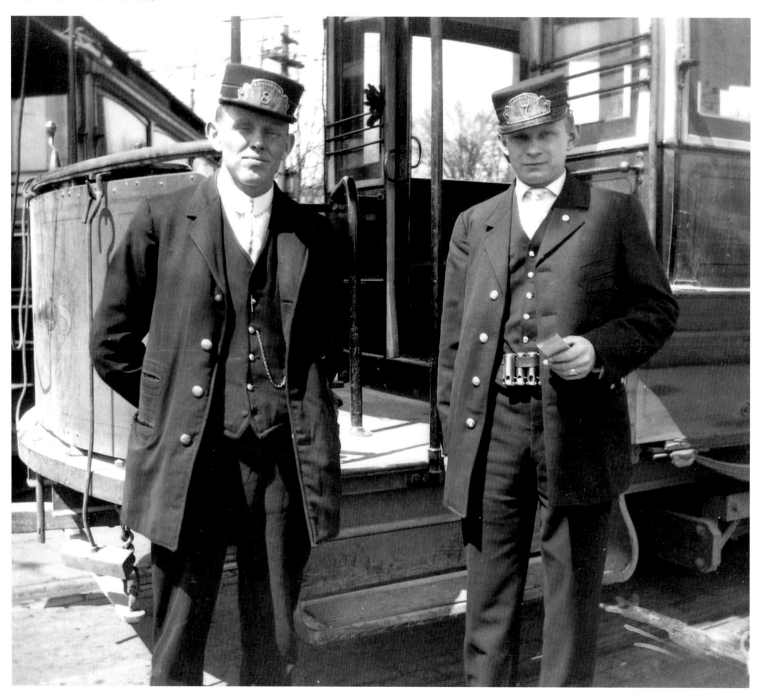

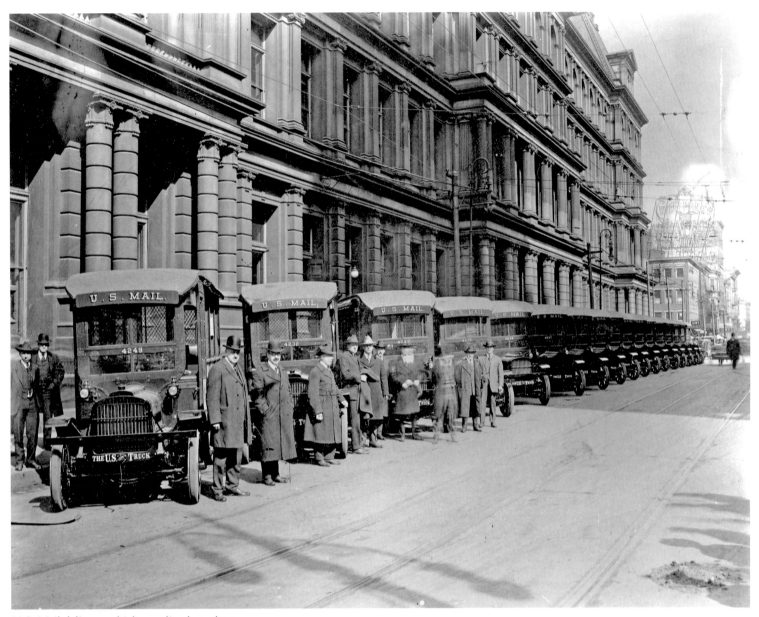

U.S. Mail delivery vehicles are lined up along
the Fifth Street side of the Federal Office
Building. Government owned and operated
vehicle service began in 1914.

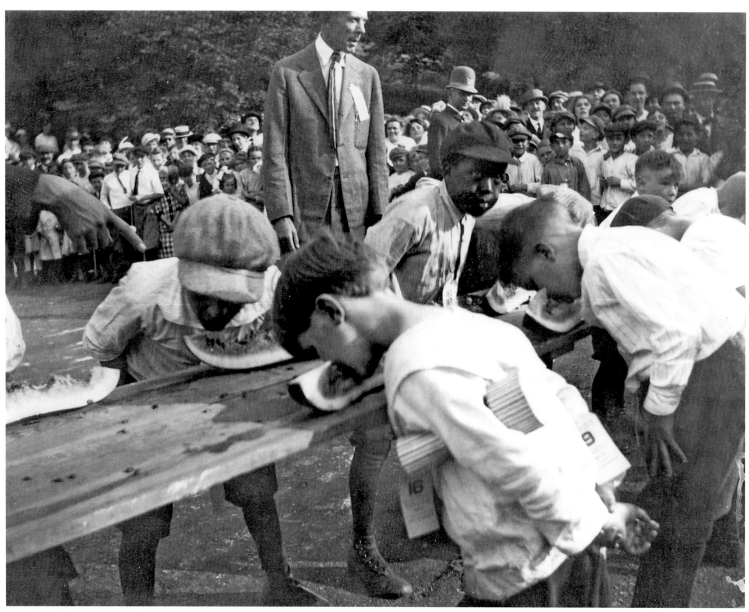

While the reservoir in Eden Park was drained and cleaned in 1915, a great municipal dance and picnic was held in the empty shell. Crowds watch the watermelon-eating contest.

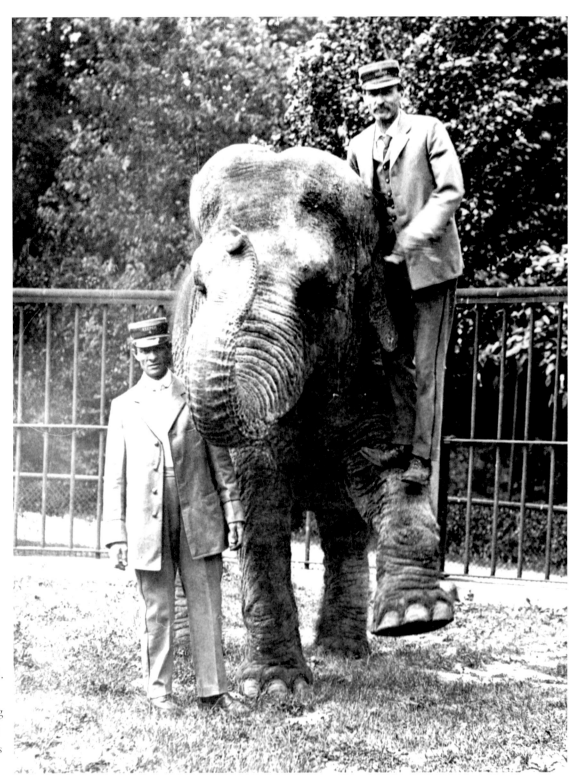

Ed Coyne is standing atop an elephant at the Cincinnati Zoological Garden about 1915. One of the zoo's most popular keepers, Coyne started working at the zoo at the age of ten and continued for the next 65 years until his death in 1942.

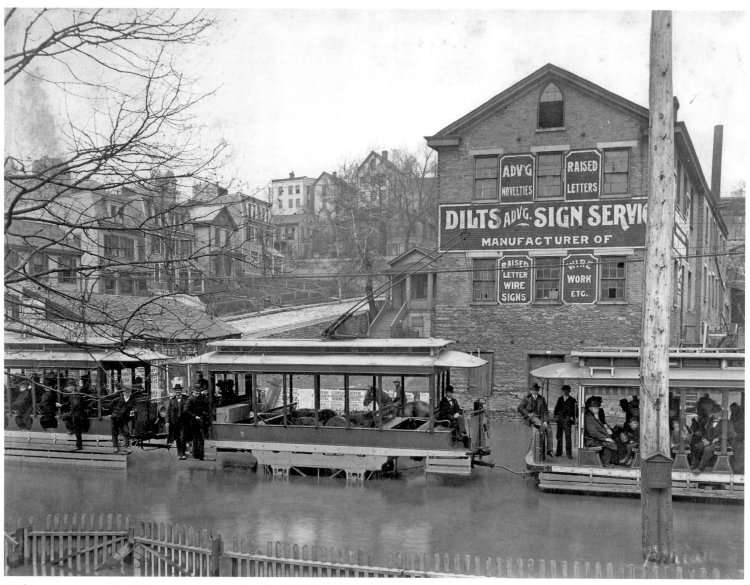

High-water streetcars had their motors mounted up in the body
of the car that was elevated from the tracks seen here in 1915 on
Queen City Avenue.

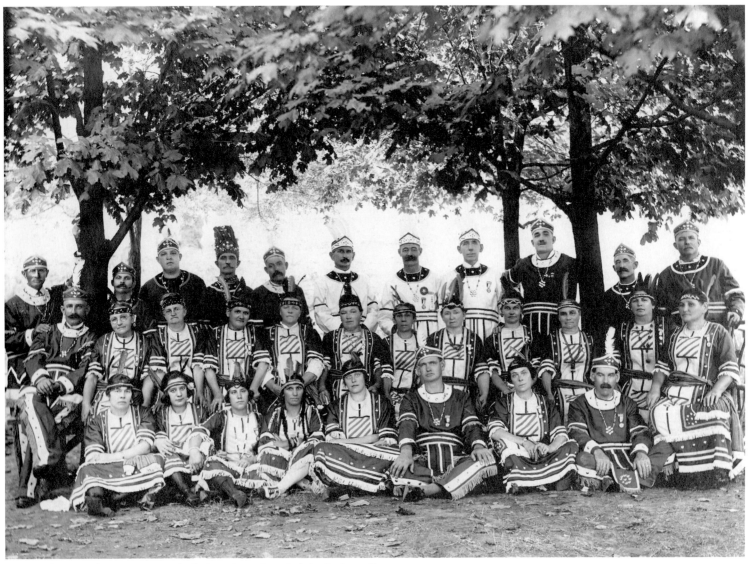

During the War of 1812 some patriotic Americans founded the Society of Red Men. They took their symbolism from Native American life and on festive occasions dressed in Native American costumes. This is one of the Cincinnati "tribes" of the Improved Order of Red Men about 1916.

Looking east on Canal Street in 1916, now Central Parkway. The German community referred to crossing the canal as going "over the Rhine."

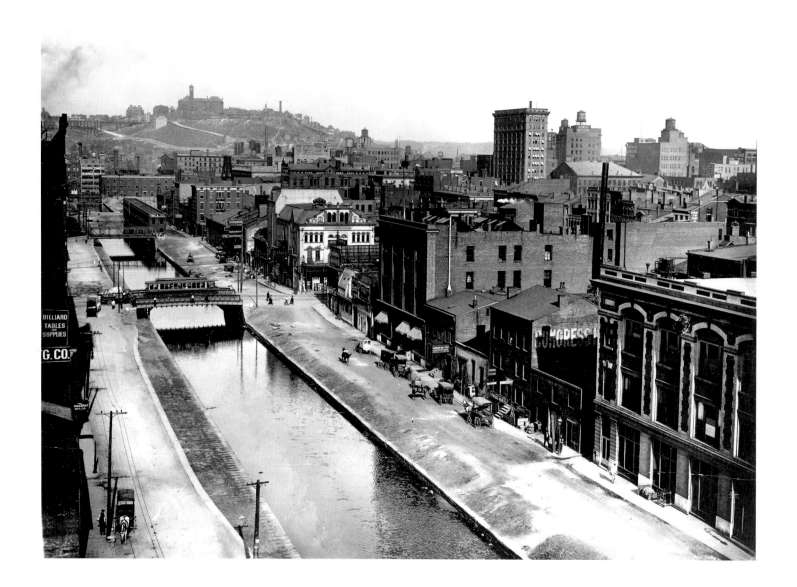

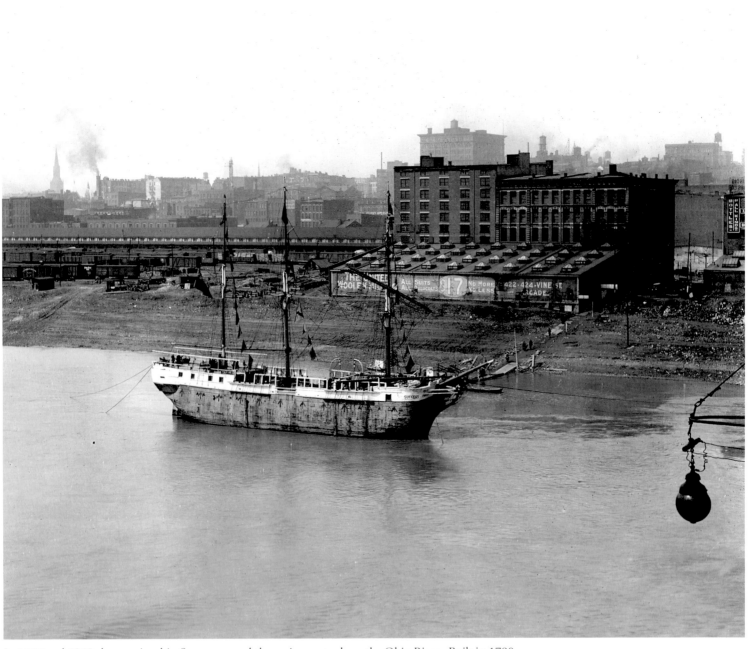

In 1917 and 1918 the convict ship Success toured the major ports along the Ohio River. Built in 1790, the Success transported felons from England to Australia. The exhibit was an object lesson in prison reform showing the barbaric conditions the prisoners endured.

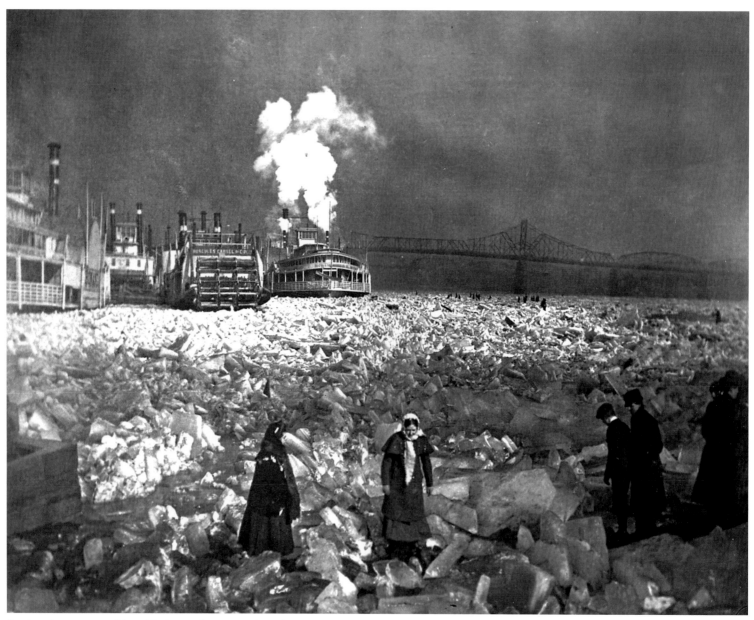

During the unseasonably cold winter of 1917-18 the Ohio River
froze from shore to shore making it possible to walk across it. The ice
gorge broke up, battering small boats and crushing and sinking larger
steamboats.

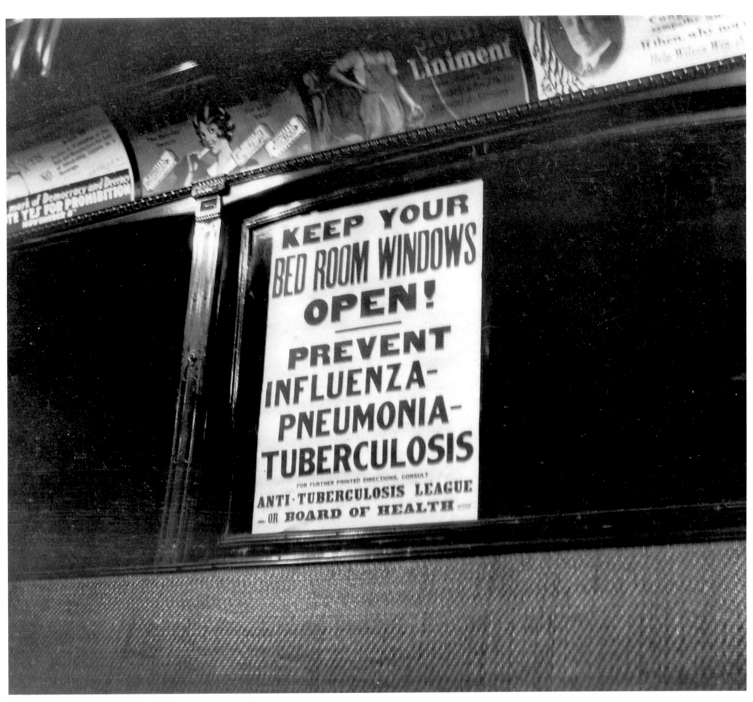

As the nation mobilized for war in 1918, a deadly influenza epidemic hit the country.
Before the year was out, over 600,000 fell victim to the contagious illness. Lacking a
reliable cure, public health groups concentrated on prevention as seen in this poster by the
Anti-Tuberculosis League.

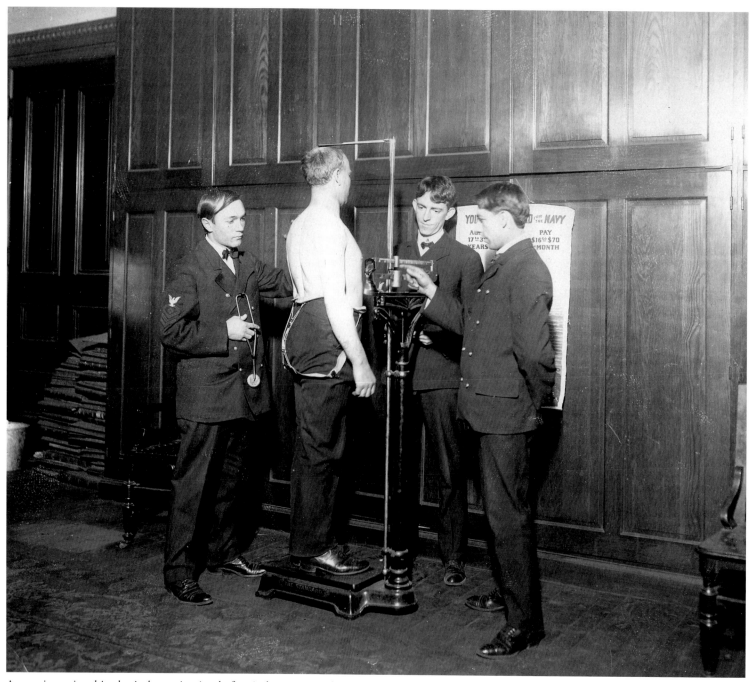

A recruit receives his physical examination before induction into the U.S. Navy following passage of the Selective Service Act in 1917. He could expect to make $16-$70 a month.

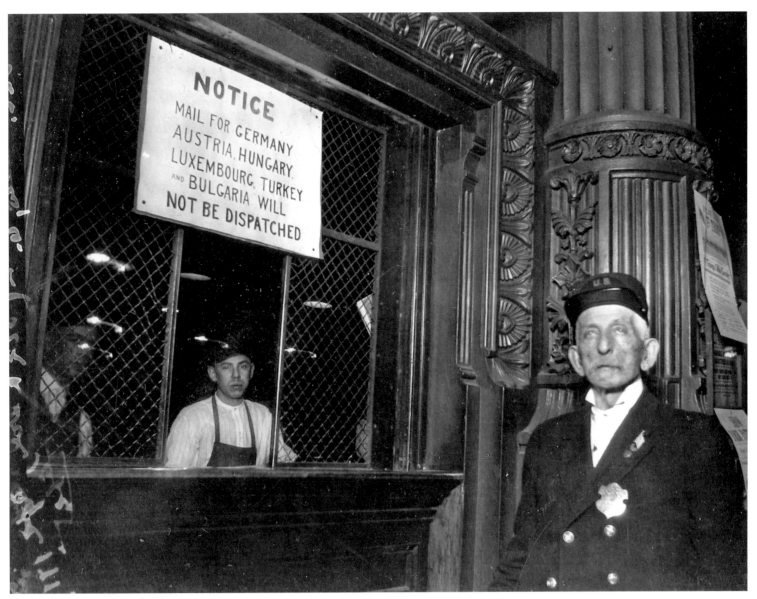

A sign in the Federal Building Post Office gives notice that
mail service was suspended to the Central Powers in 1917.

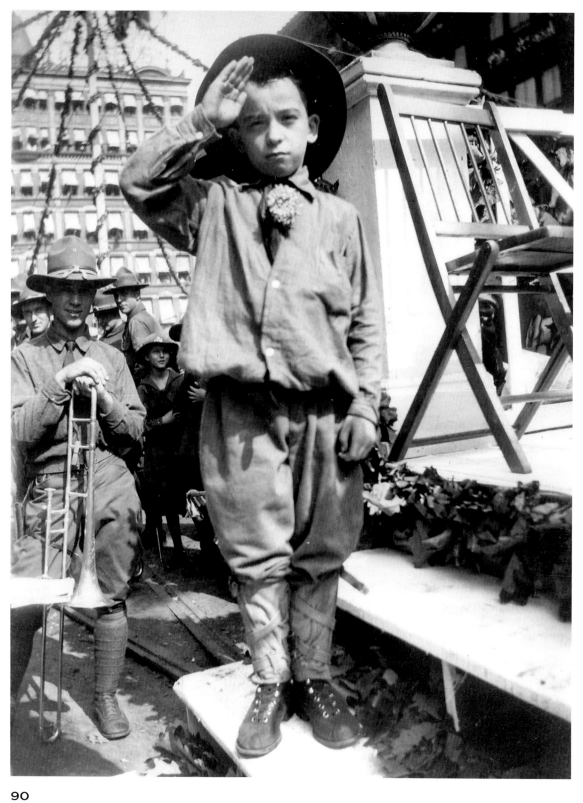

Albert Neal, young mascot of the Third Ohio Ambulance Corps., bids farewell to the troops in August, 1917.

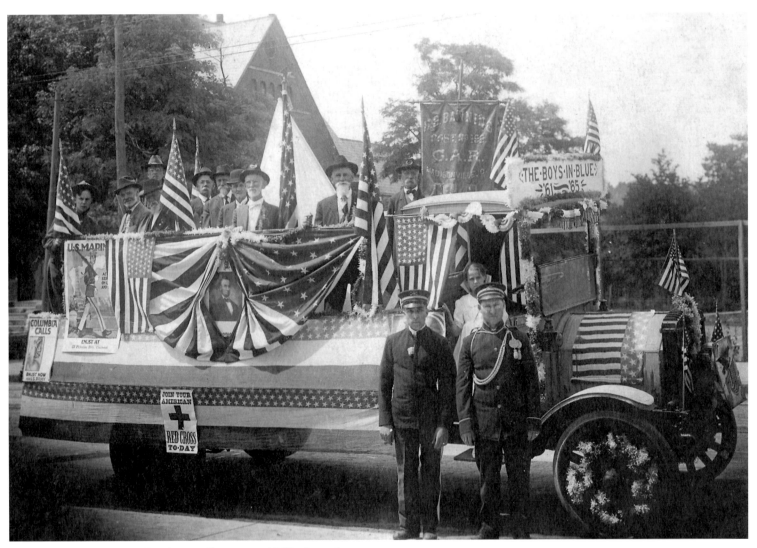

Veterans from Madisonville ride proudly in a World War I parade.

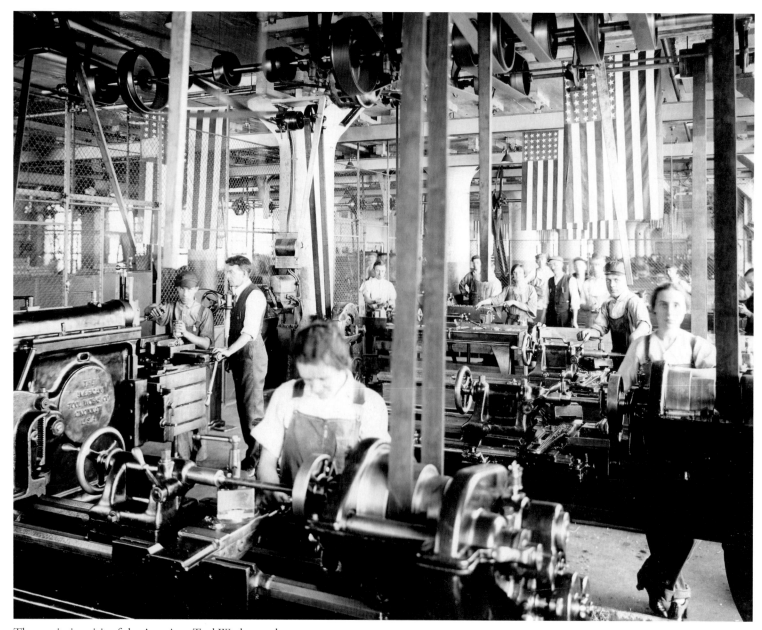

The patriotic spirit of the American Tool Works employees
during World War I is shown by the profuse decorations
which they supplied.

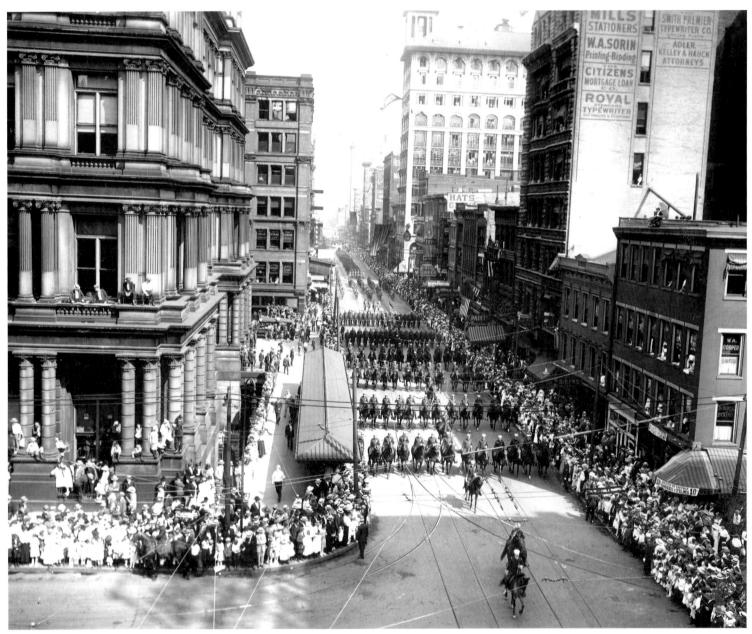

"Farewell Day" was observed August 23, 1917 when 3,000 Ohio National Guardsmen passed in review on Government Square on their way to service in the First World War. Tears mingled with cheers as over 1,000 Cincinnatians gathered to say good-bye as the soldiers boarded trains for southern training camps.

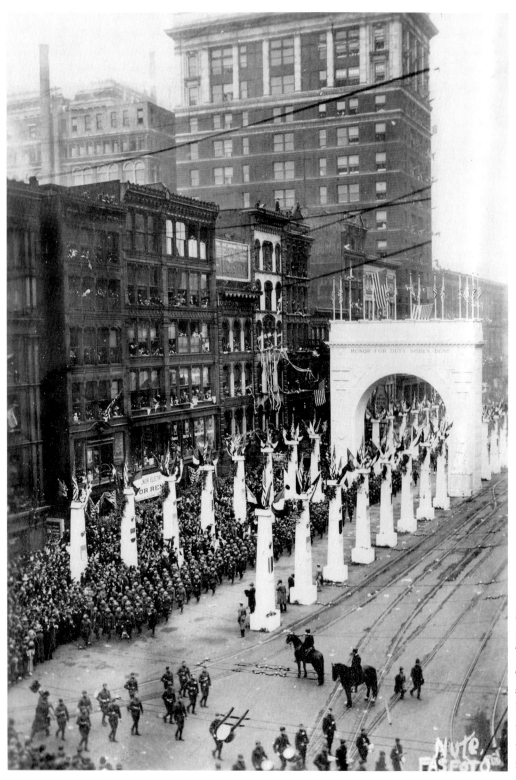

Soldiers returning from Europe following the war march beneath the majestic Arch of Triumph and through the Court of Honor on Government Square in April 1919. From atop the 48-foot high arch fly the flags of the United States and her allies. The pillars of the Court of Honor bear shields containing the names of the battles in which the soldiers fought.

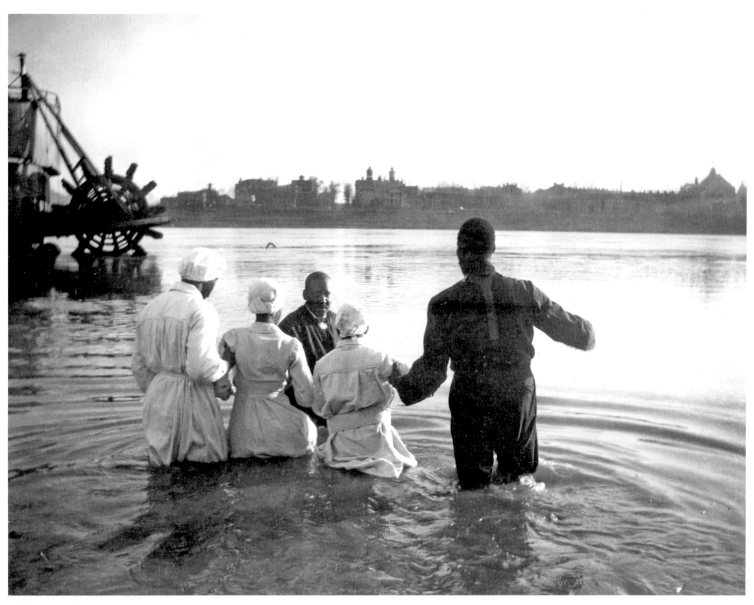

Ohio River baptism in 1919.

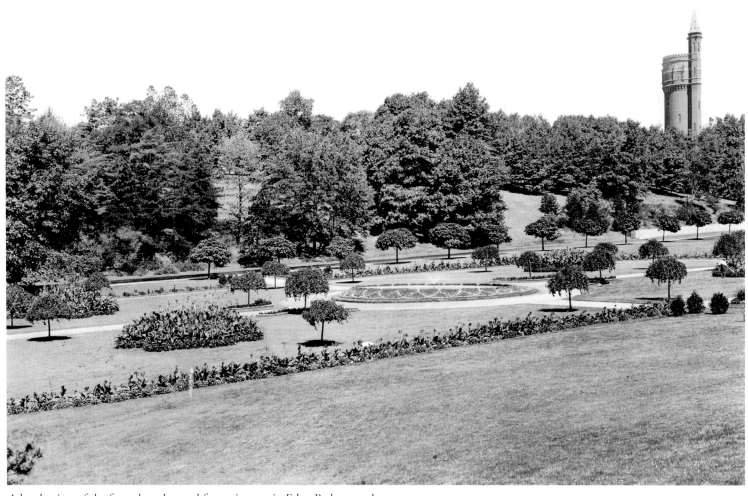

A lovely view of the formal garden and fountain seen in Eden Park around 1922. Built in 1894, the brick Water Tower in the distance was used as a pressure tank to supply water to Walnut Hills. During World War I the tower served as a guardhouse for infantry regiments encamped in the park.

FROM THE ROARING TWENTIES TO THE GREAT DEPRESSION

1921-1939

Inspired by the idealism of World War I, a youthful generation of Cincinnatians set out to remake their city in the 1920's. Architecturally, the decade saw the construction of some of the city's most important and enduring landmarks, including three Art Deco masterpieces—the Times Star building on the east, Union Terminal on the west and the Carew Tower in the center.

In the first half of the decade, youthful idealists gathered under the banner of the Charter Committee to rescue Cincinnati from three long decades of misrule. The 1924 Charter attempted to apply the principles of modern business management to city administration through the adoption of a city manager form of government, and within a decade Cincinnati transformed itself from the "worst governed" city in the United States to one of the best.

The great depression of the 1930's brought the expansive visions of the twenties to an abrupt end. At the peak of the depression unemployment in Cincinnati reached 30.4 percent, reflecting the national average. The onslaught of families who turned to private relief agencies strained local resources to the breaking point. Eventually, an array of federal New Deal programs stimulated major construction projects like Mt. Airy Forest and Greenhills, providing jobs and dignity to thousands.

Heavy rains on top of a melting snow pack in January 1937, brought a disastrous flood to the Ohio Valley. The nearly 80-foot flood waters not only submerged almost 45 square miles of Hamilton County, but they knocked out water and power service to people on top of Price Hill and Clifton Hill as well as those in the Mill Creek Valley.

As the 1930's drew to a close, war once again broke out in Europe. Within months military contracts spurred plant expansion and brought thousands back into the workforce.

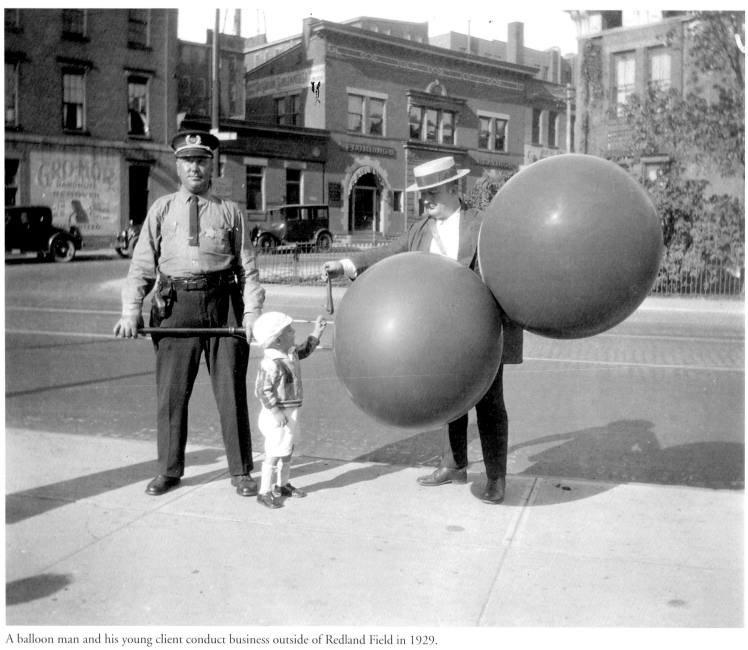

A balloon man and his young client conduct business outside of Redland Field in 1929.

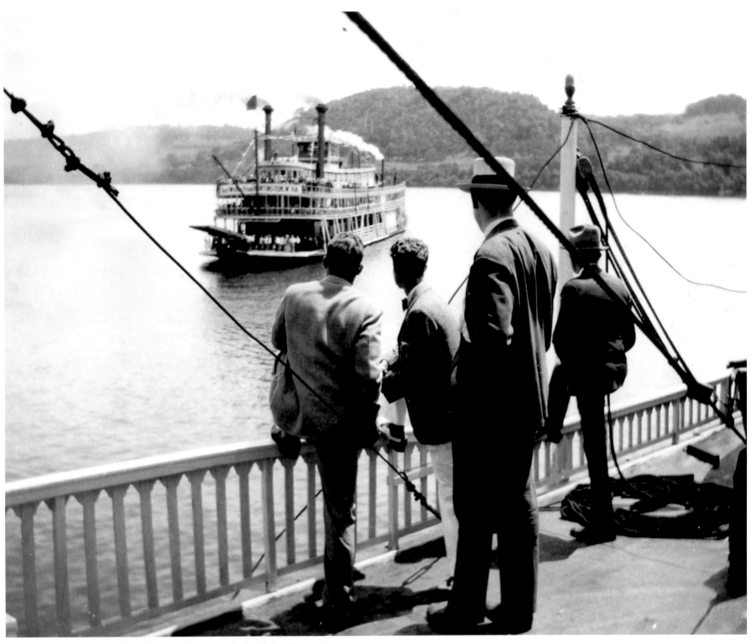

Looking across to the Tom Greene from the deck of the Betsy Ann
at the start of a race between the two boats in July, 1930.

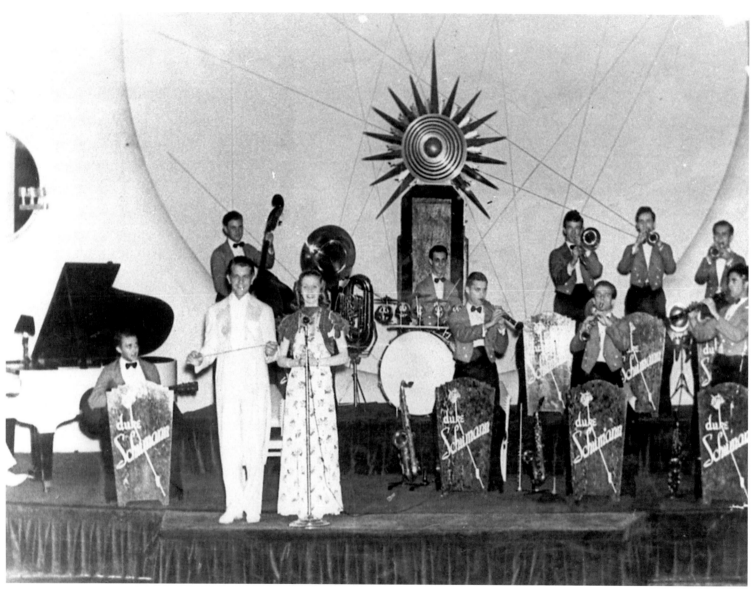

Cincinnati native Doris Day and Jerry Doherty with the Duke Schumann Band
perform at the Pavillon Caprice in the Netherland Plaza Hotel in 1938.

Horses are exercised along the oval track of the new Coney Island Race Course in 1925. A year later it was shut down for illegal gambling. It opened again in 1933 only to close again in 1935 due to the effects of the Depression and competition from the Latonia track. River Down's, Inc. took it over in 1936 and it has remained open ever since.

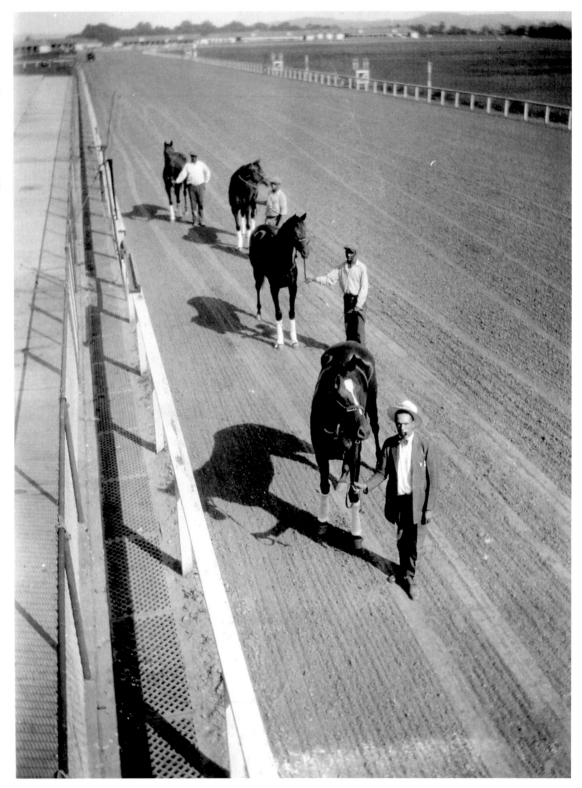

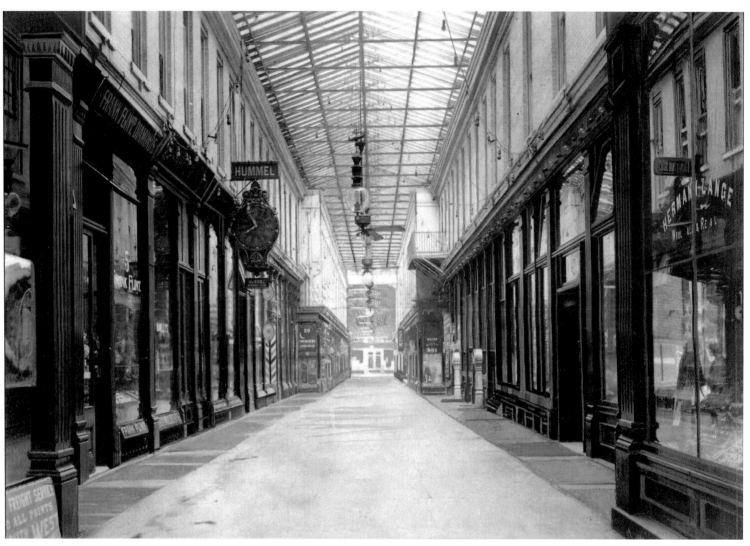

A two-story, glass covered arcade ran from Vine to Race Streets connecting the Carew Building and the Emery Hotel from 1889-1929 and housing many of the city's fine jewelers and other retail outlets. An arcade was retained when the Carew Tower was built.

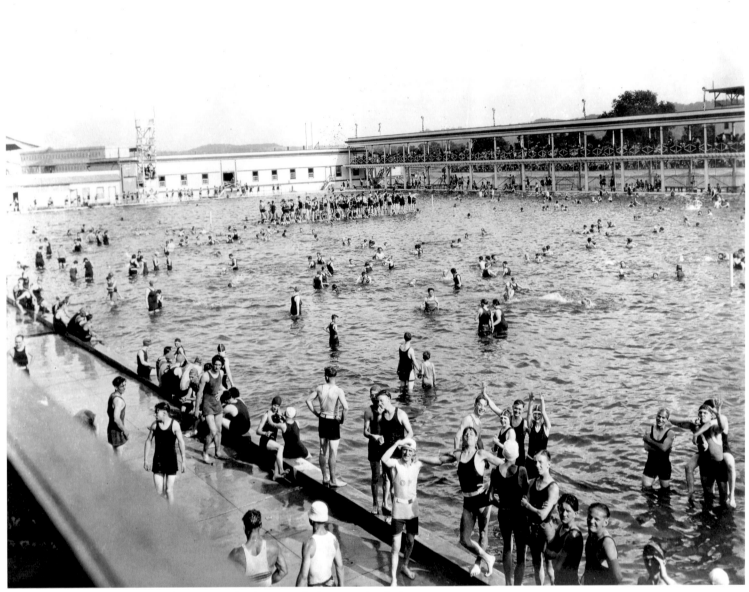

In 1926 a swimming pool opened at Coney Island. It was the largest recirculating water pool in the world, measuring 200 by 401 feet and holding 3.5 million gallons of water. An adult could swim with a rented suit and towel for 50 cents (child-25 cents). Suits and towels were "sterilized" between uses. It was first called Sunlite Pool in 1938.

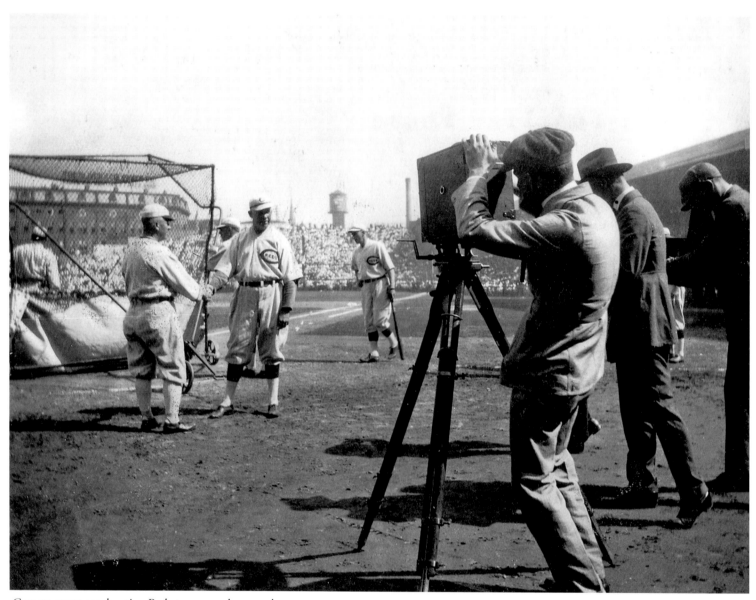

Camera crews are shooting Reds team members on the
playing field of Redland Field in 1932.

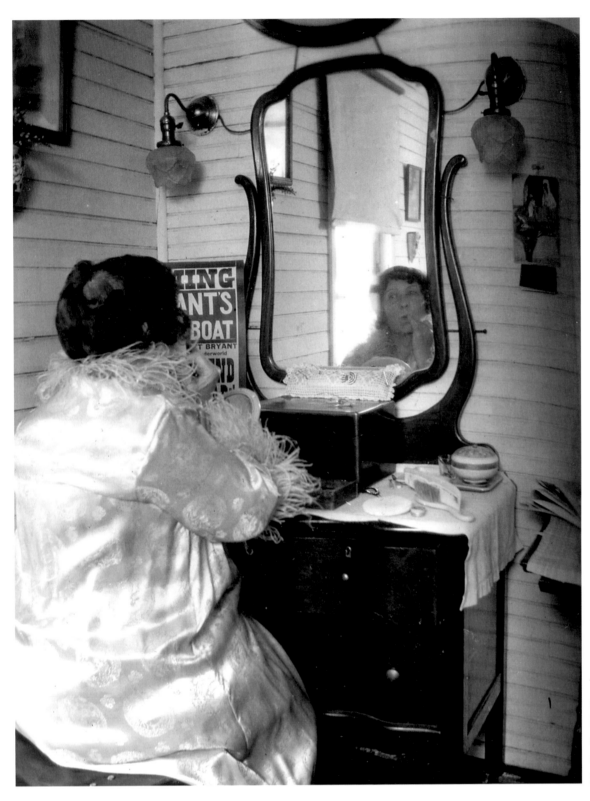

The Bryant Showboats plied the Ohio and Mississippi Rivers for nearly half a century. Here an actress applies her make-up prior to a performance in 1931.

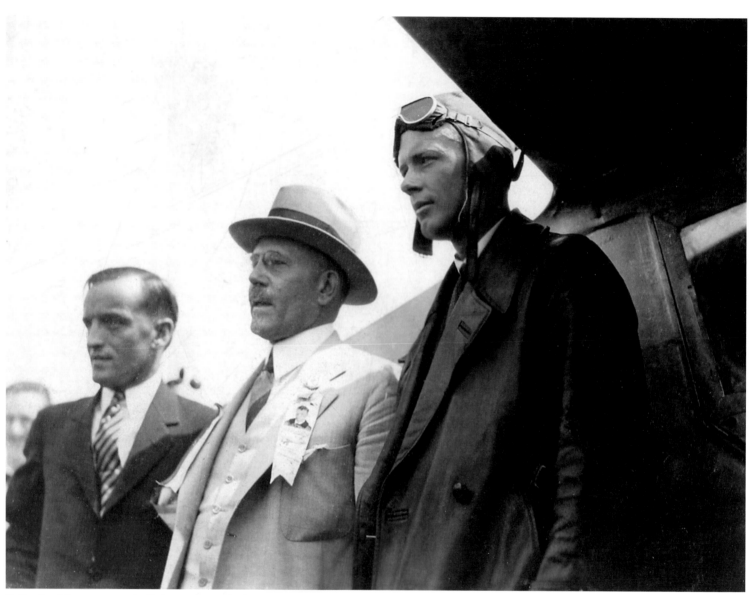

Following his non-stop solo flight to Paris, Charles A. Lindbergh visited
Cincinnati on August 6, 1927 as part of his tour of American cities to
promote aviation. "Lindy" was greeted by thousands of Cincinnatians,
eager to get a glimpse of the famed aviator and his equally famous "*Spirit
of St. Louis*" monoplane at Lunken Airport.

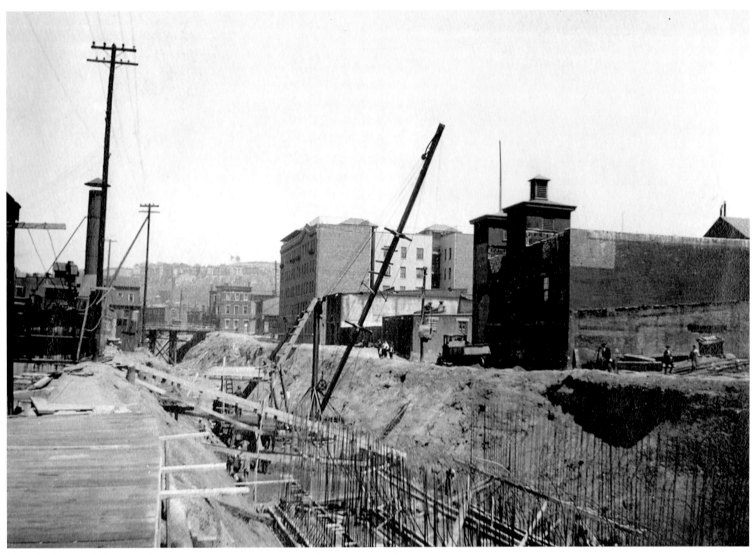

Tunnels for the city's new subway system were under construction at Plum and
Canal (Central Parkway) in 1921. Construction stopped in 1925 when funds
from a bond levy ran out. The project was abandoned in 1927 when no additional
funding could be obtained. Less than half of the 16-mile planned route was
completed. Only two miles of the underground facility remain today.

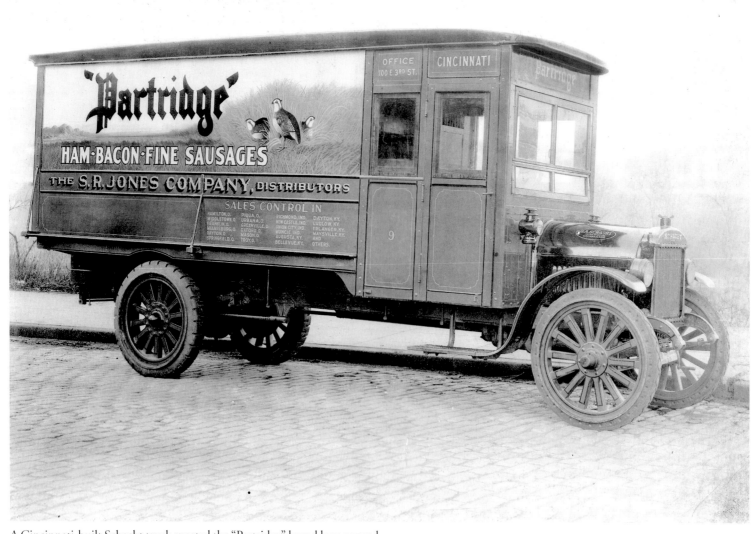

A Cincinnati-built Schacht truck sported the "Partridge" brand logo around 1927. The H.H. Meyer Packing Company chose the brand name because of the excellent qualities of the game bird.

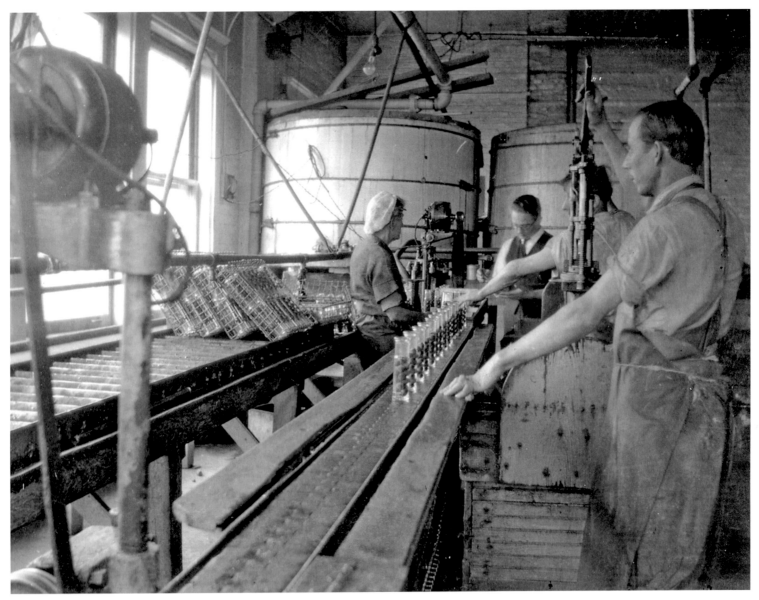

Cincinnati isn't generally known for olives, but these workers are packing
them for the Lippincott Company in 1923. The Lippincott Company
was nationally known from 1901-1942 for packing tomato products,
pickles, and preserves, as well as olives.

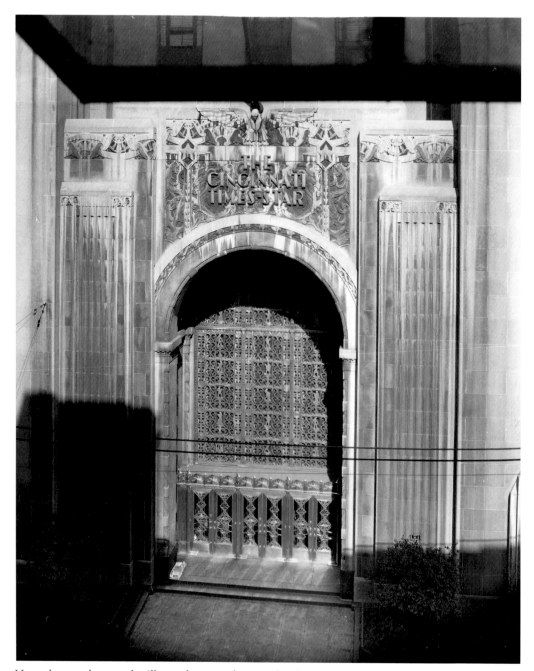

Heavy bronze doors and grilles under an eagle-topped arch
create an impressive entrance to the E. Eldridge Hannaford-
designed Cincinnati Times-Star Building. The granite
and stone art-deco landmark opened in 1933 at Elm and
Broadway.

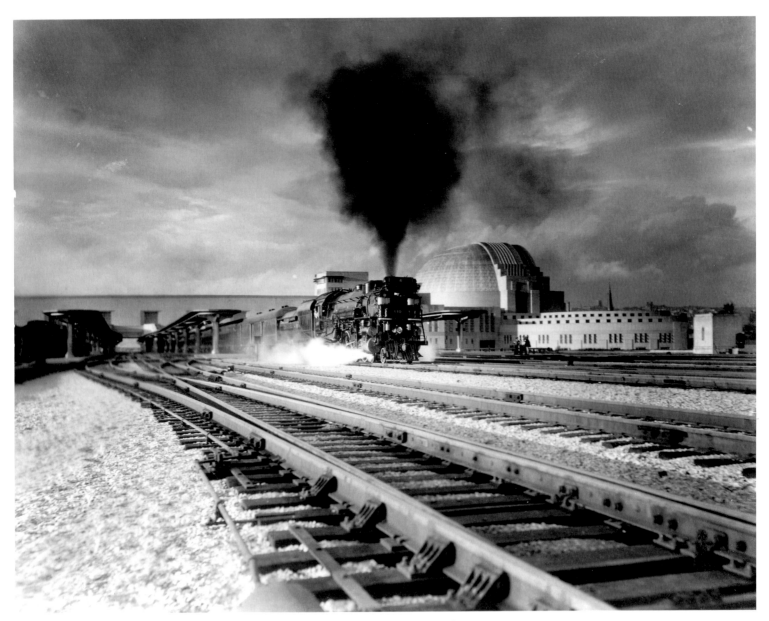

Chesapeake and Ohio's *George Washington*, one of the nation's first totally air-conditioned trains, is shown pulling out of Union Terminal bound for Washington, D.C. A version of it bearing the George Washington name, linked Cincinnati and Washington from 1932 until 1971 when the service was taken over by Amtrak.

An iceman makes deliveries to his customers in Mt. Auburn in 1932. By the 1940's electric refrigerators were replacing the iceman and his dripping blocks of ice.

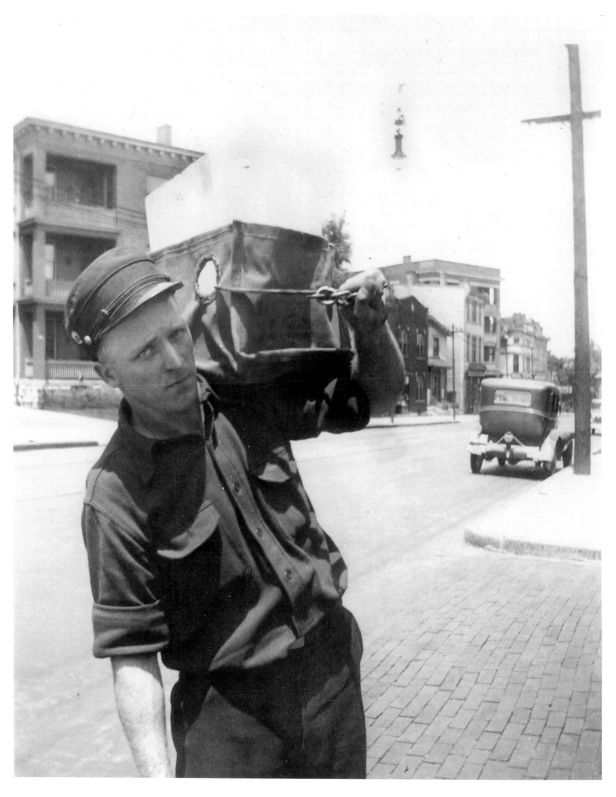

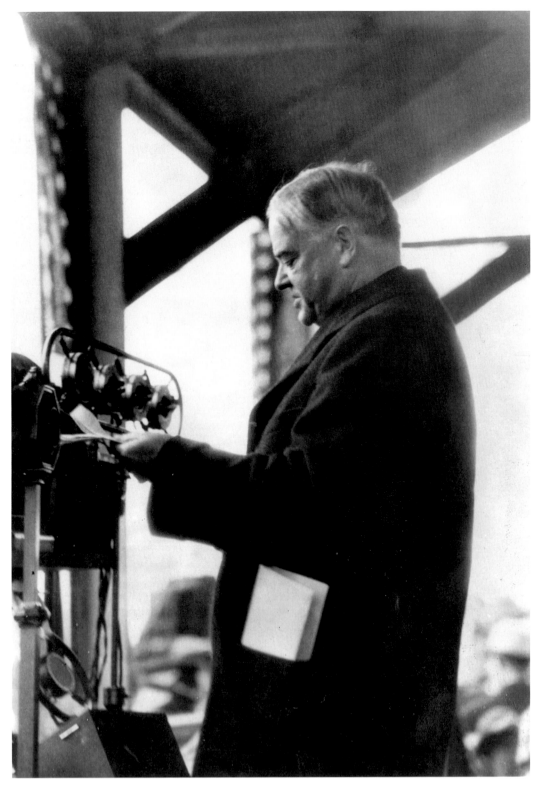

On October 22, 1929 President Herbert Hoover dedicated the Ohio River Memorial Monument with a speech broadcast over WLW radio. The obelisk commemorated the completion of the channel in the Ohio River that made it navigable year-round.

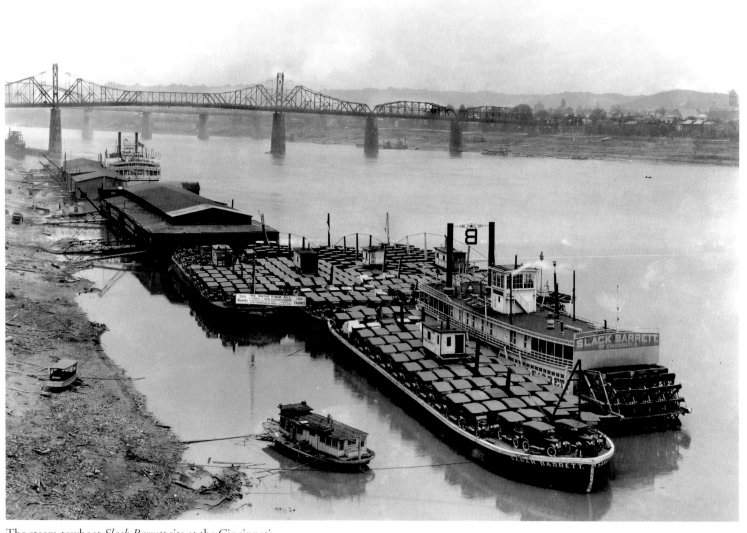

The steam towboat *Slack Barrett* sits at the Cincinnati
wharf with five barges of automobiles destined for the
Laurel Street Auto Laundry and Garage around 1920.

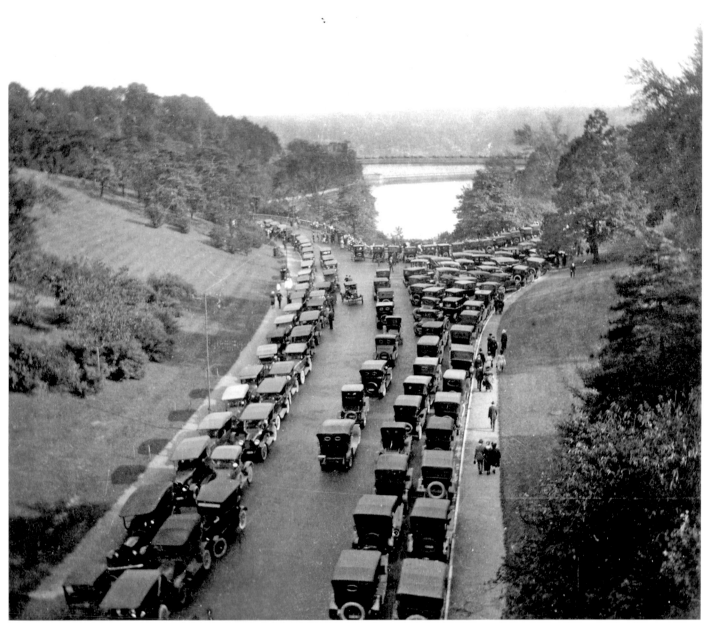

Cars are double-parked on Eden Park Drive as concert-goers attend the Caruso Memorial Concert in 1921.

The Display House in the Krohn Conservatory features six seasonal exhibits each year. A woman in her Easter finery admires the lilies in the 1933 Easter display.

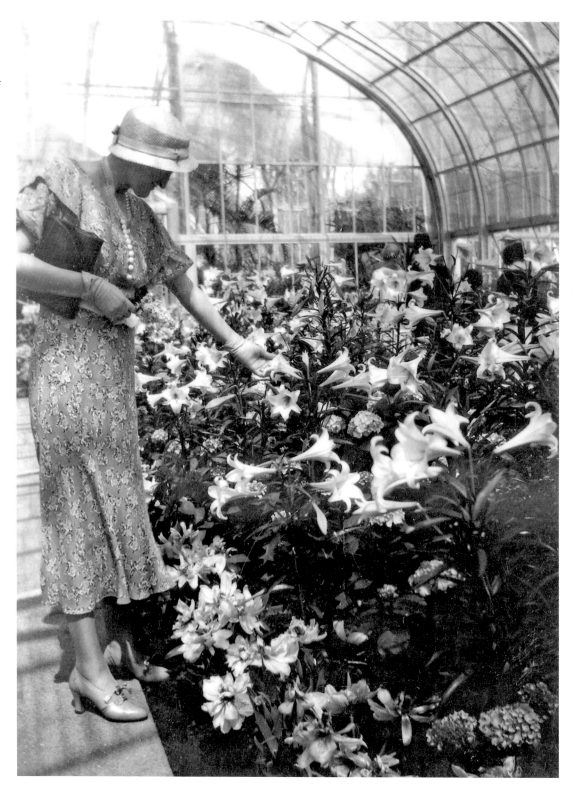

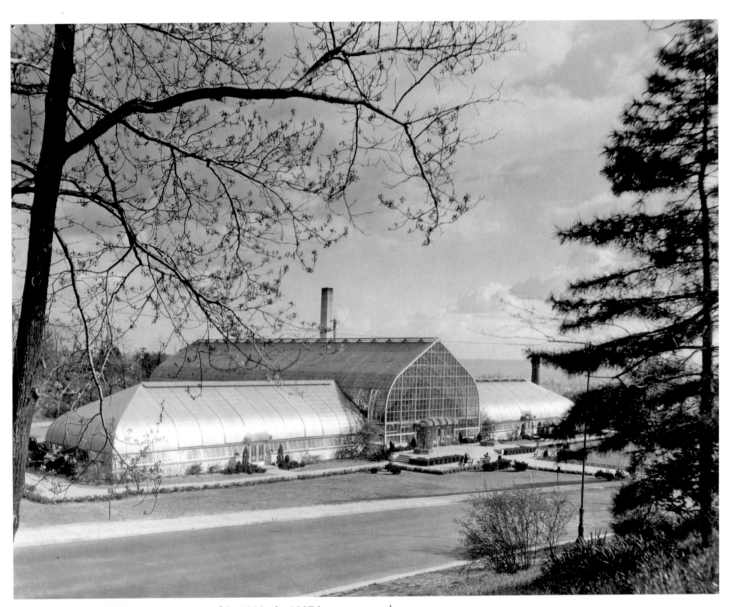

The new Eden Park Conservatory opened in 1933. In 1937 it was renamed the Irwin M. Krohn Conservatory to honor the President of the Board of Park Commissioners and long-time park board member.

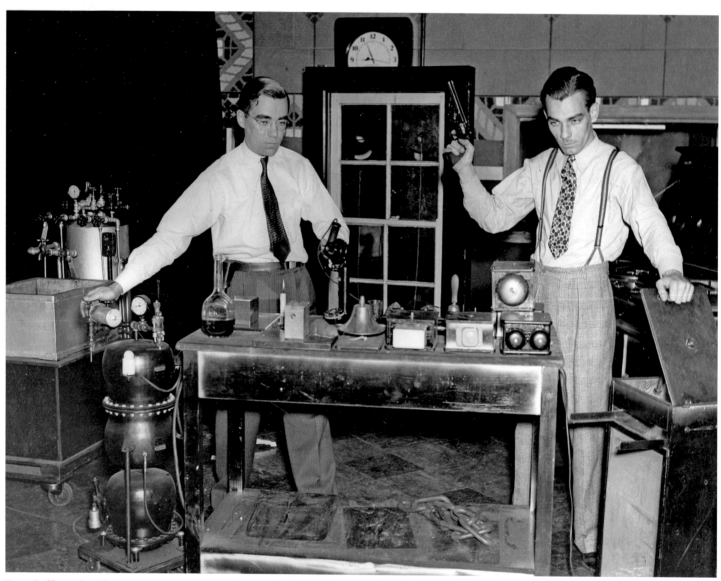

Sound effects played an important role in radio programs.
WLW had one of the largest and most complete sound
departments in the industry.

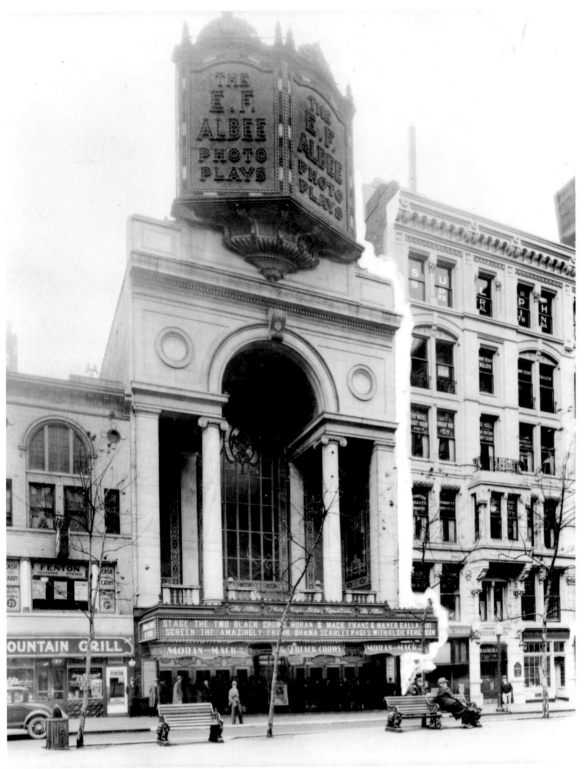

Theater-goers stand in line in 1930 to enter the Albee Theater. The Albee was popular because of its superb acoustics and clear view of the stage. When the theater was torn down in 1977 the classic Roman façade was saved and added to the Cincinnati Convention Center.

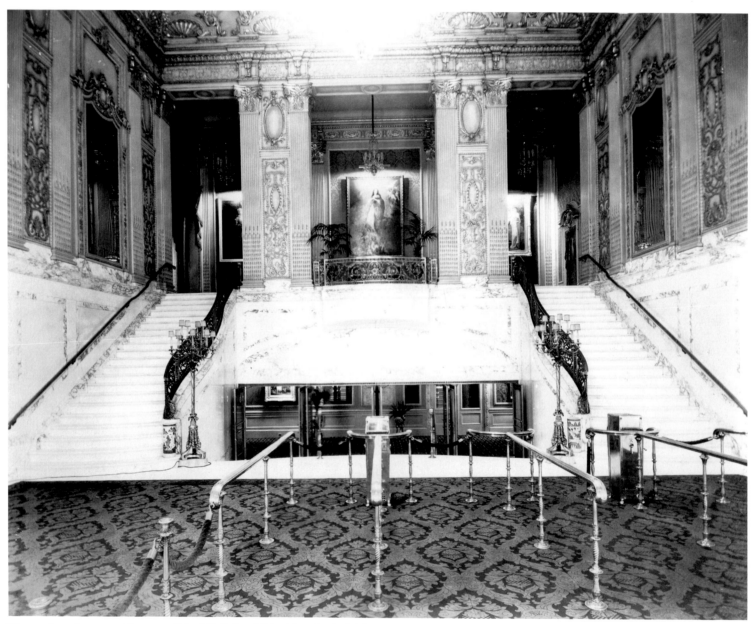

The opulent theater architecture of the 1920's is exhibited here in the lobby of the Albee Theater. Twin marble staircases led from the lobby to the mezzanine lined with original oil paintings and crystal chandeliers.

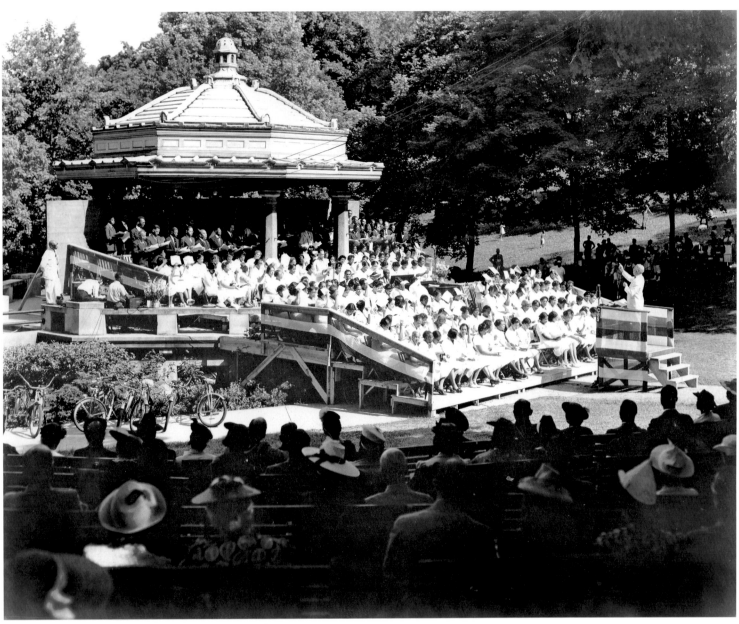

The annual Festival of Negro Music was sponsored by the Cincinnati Recreation Commission. The three hundred mixed voices were recruited from choirs, glee clubs and choruses around the city and are shown here at the festival in Eden Park in 1939.

The first professional night baseball game took place at Crosley Field on May 23, 1935 between the Reds and the Philadelphia Phillies. President Franklin D. Roosevelt "threw the switch" on the 632 lights remotely from the White House. Over 130,000 fans attended the seven night games that year.

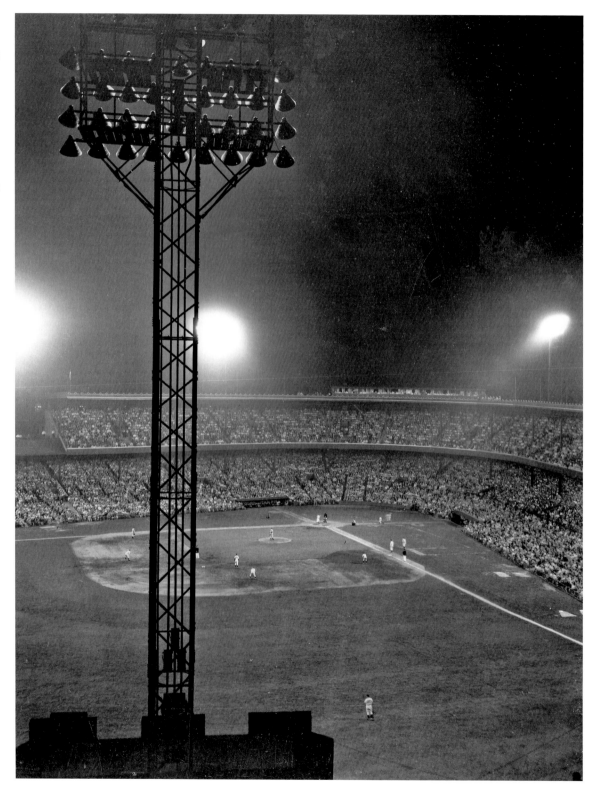

The Clifton Open Air School was started by Mrs. Helen Lotspeich. She was an enthusiast of fresh air and its presumed beneficial effects on health. For that reason there was no heat in the school and the windows were kept open. A new Lotspeich school, was built in 1930, which had heat but the windows were still kept open.

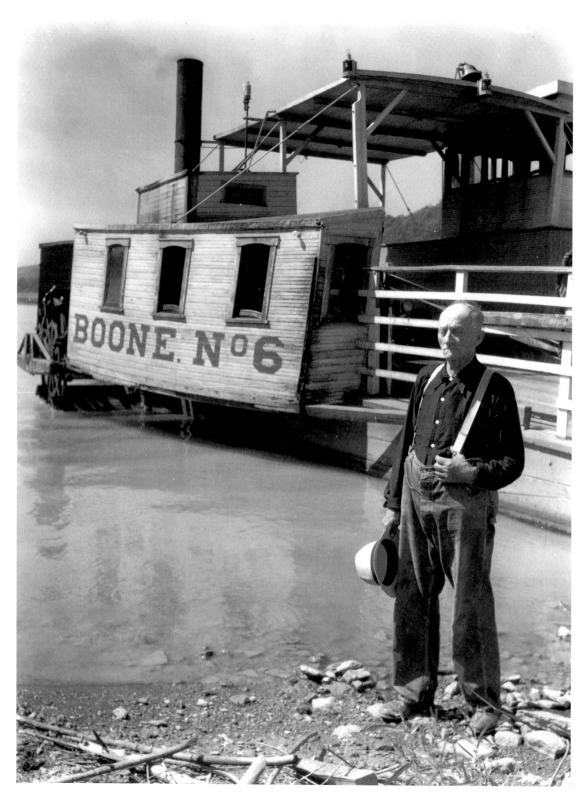

The *Boone No. 6* is one of a long line of ferries that have crossed the Ohio River at Anderson Ferry since 1817. This ferry was built in 1920.

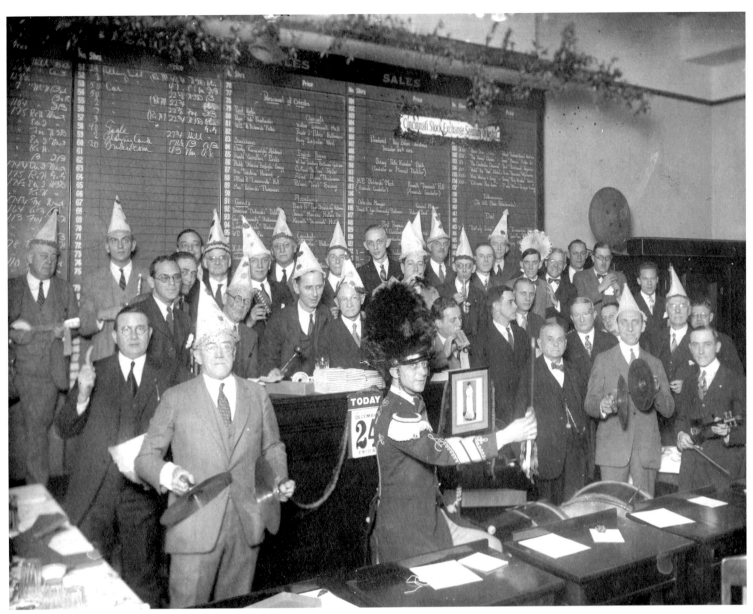

On Christmas Eve 1926, three years before the stock market crashed, Cincinnati Stock Exchange members celebrated by creating the "Seemfunny Orkestra" and performing a program of skits and songs.

Captain Frederick Way, Jr. stands watch in the pilothouse of the steamboat *Senator Cordill* around 1932. The *Senator Cordill* operated between Pittsburgh and Cincinnati in the early 1930's.

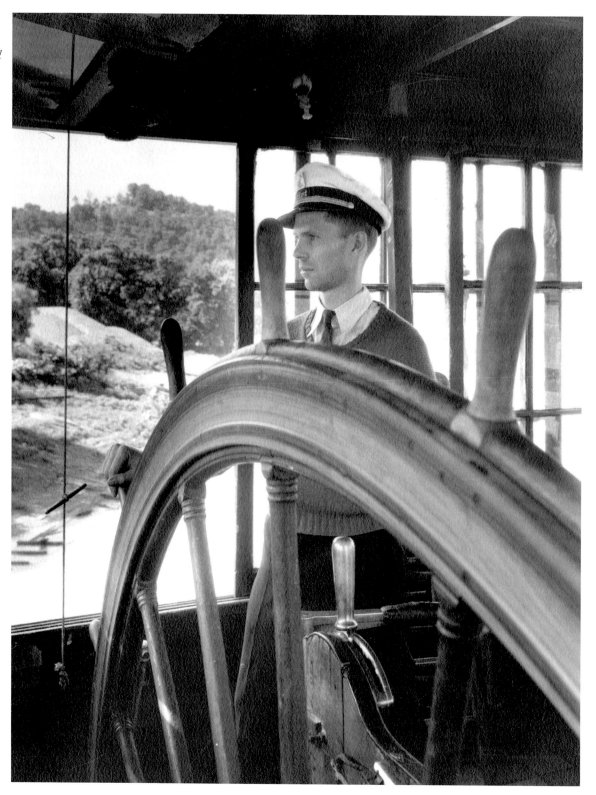

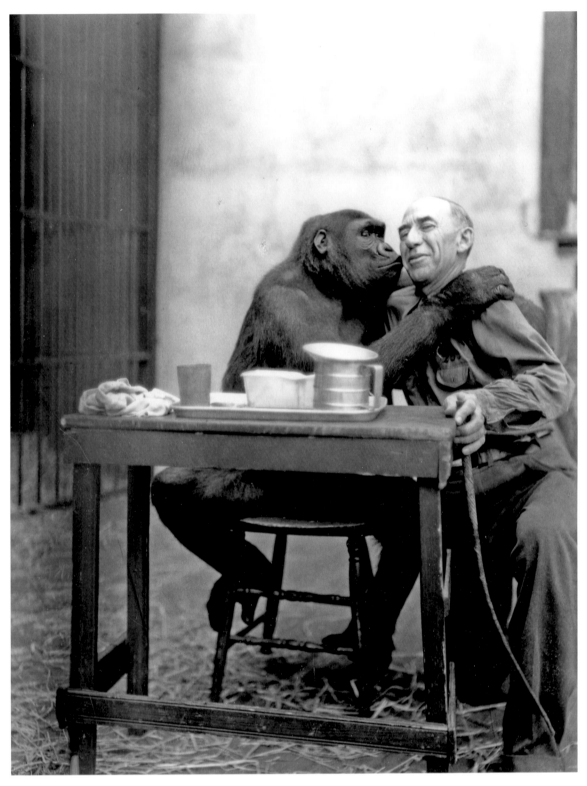

World-famous gorilla Susie and her trainer William Dressman at the Cincinnati Zoo in 1935. Susie, said to have been the first trained gorilla, came to America on the first trip of the Graf Zeppelin in 1929. She died in 1947.

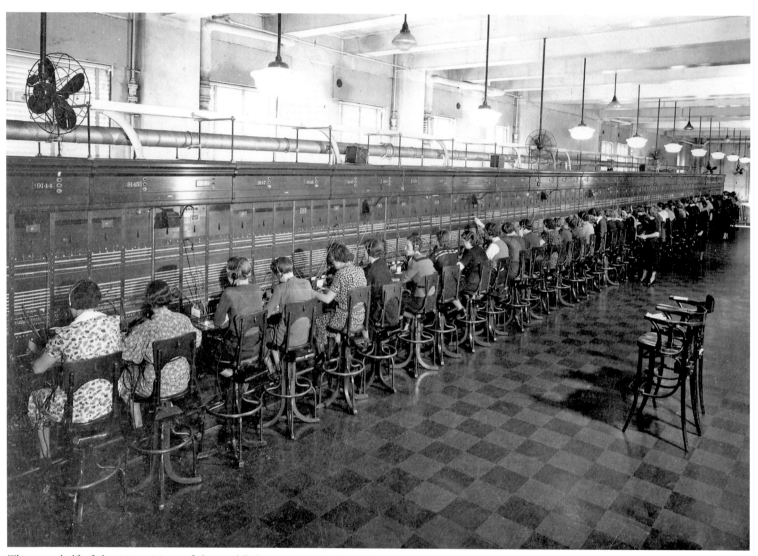

These are half of the 88 positions of the world's longest straight long-distance switchboard. On January 22, 1937 it handled a record 9,722 outgoing calls.

Noah's Ark was a "themed" fun house at Coney Island based on the popular Bible story. Opening in 1926, the ride rocked patrons back and forth on top of a man-made mountain.

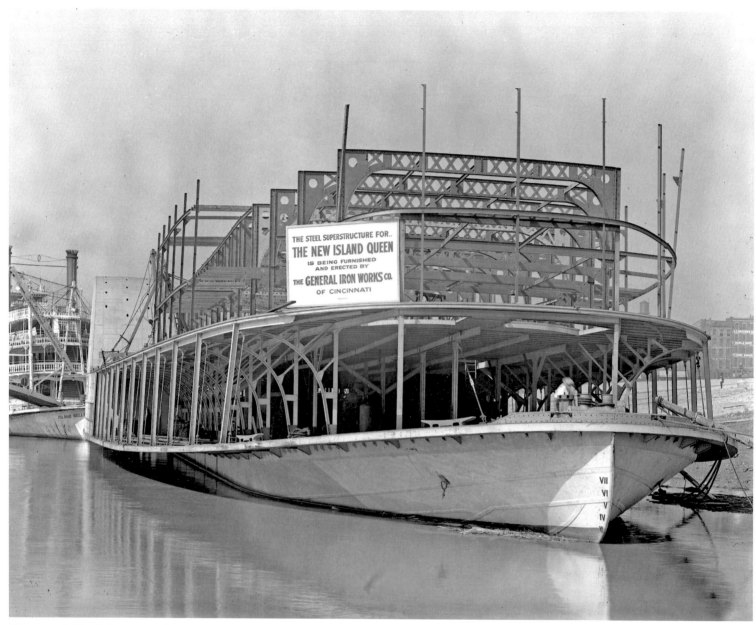

The second *Island Queen* is under construction at the Public Landing in 1924.
This excursion boat was completed and dedicated on April 18, 1925. During the
summers, the *Island Queen* carried passengers between the Public Landing and
Coney Island amusement park. During the off-season she made "tramp trips"
between Pittsburgh and New Orleans. On September 9, 1947 the *Island Queen*
exploded and burned at Pittsburgh.

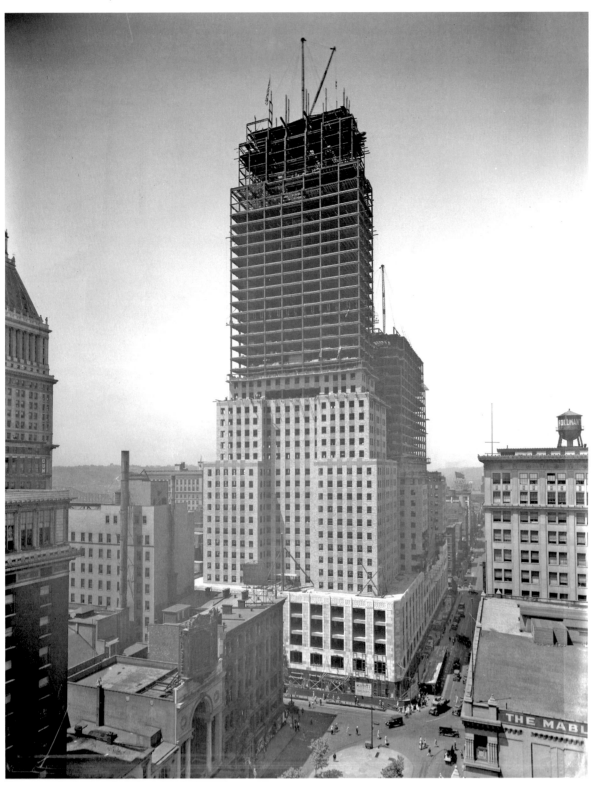

The city's tallest skyscraper, the Carew Tower, is under construction in 1930. This 48-story building and the adjoining Netherland Plaza Hotel were completed in less than nine months.

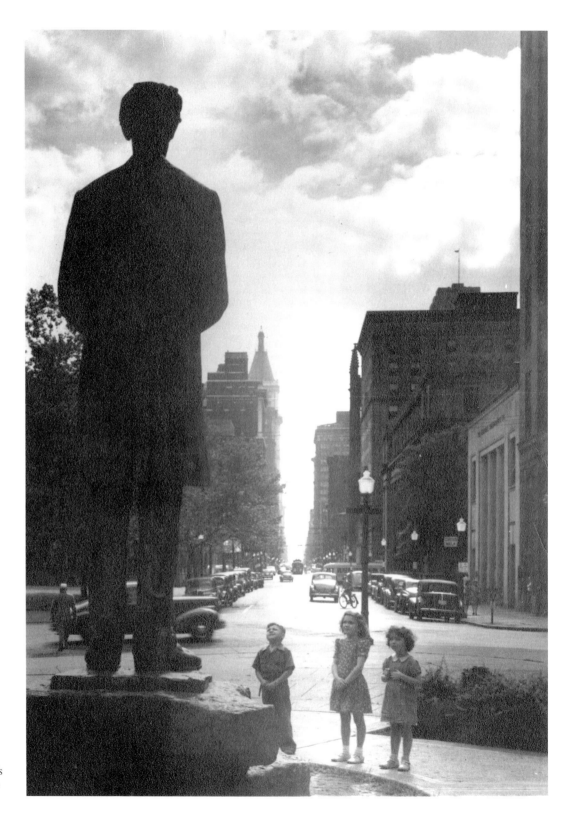

Children look up in awe at the statue of Abraham Lincoln in Lytle Park. The bronze statue, created by George G. Barnard, initially caused some controversy because president Lincoln's son, Robert Todd, found it "uncouth."

132

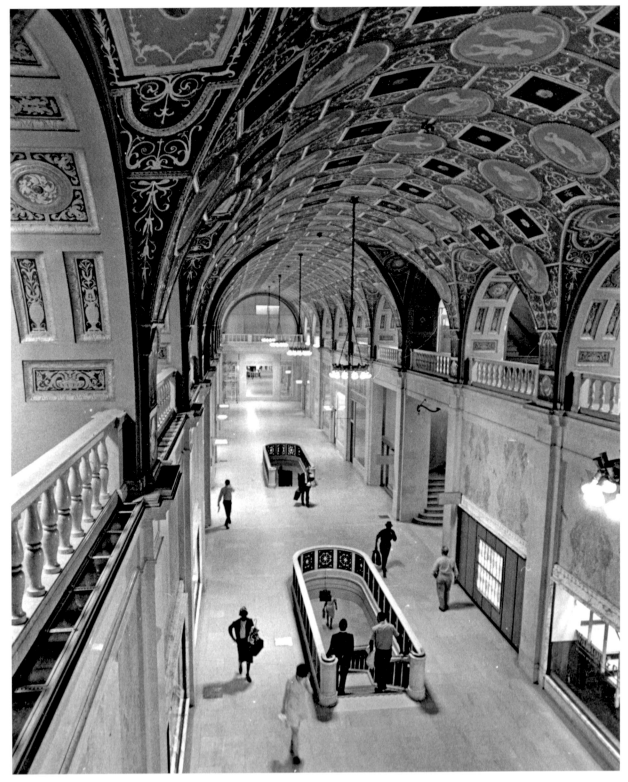

"Gateway to the South," the Dixie Terminal was built in 1921 and functioned as a terminus for buses and streetcars between Cincinnati and Northern Kentucky. Designed in the Italian Renaissance style, the terminal's interior arcade combines beauty and function.

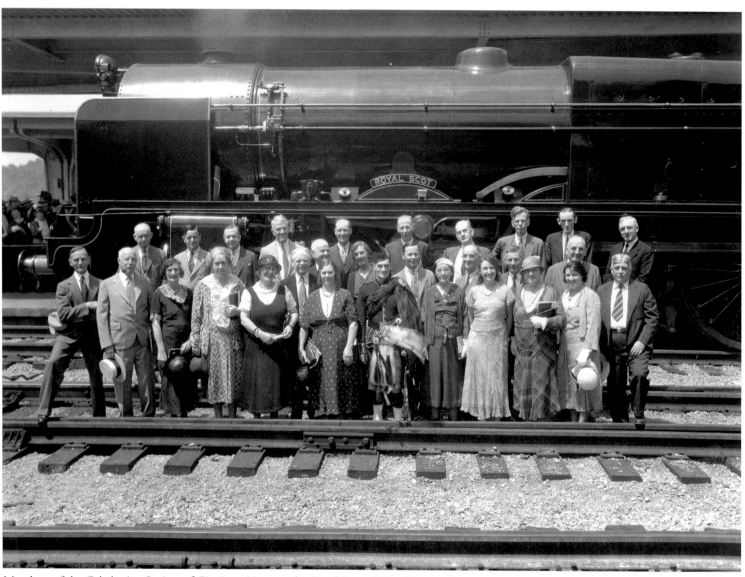

Members of the Caledonian Society of Cincinnati inspect the *Royal Scot* at Union Terminal on May 24, 1933. Transported overseas from Great Britain, this locomotive of the London, Midland & Scottish Railway was en route to Chicago to be placed on exhibit at the Century of Progress Exposition. The Caledonian Society was organized in 1827 to annually celebrate the birthday of Scotland's patron saint, Saint Andrew, and to also provide funds for needy Scottish immigrants coming to Cincinnati.

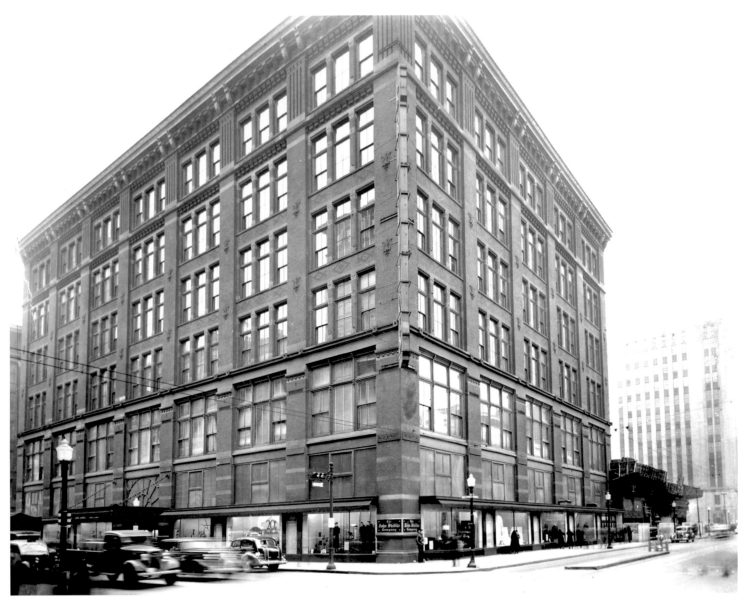

The John Shillito Company at Seventh and Race Streets as it looked just prior to its "face-lift" in 1937. Modernization of this department store included a nine-story addition, air-conditioning and a new facade.

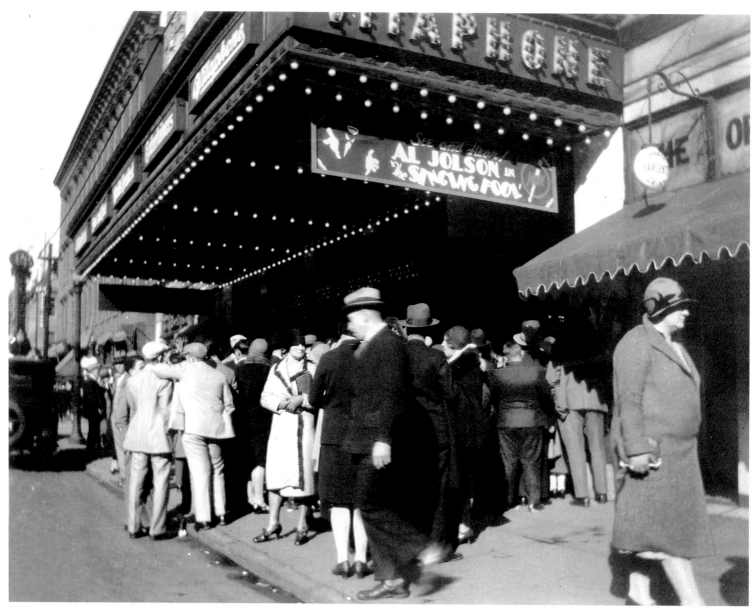

Theatergoers line up to see Al Jolson in his second feature film *The Singing Fool* at the
Capitol Theater in 1928. The Capitol was equipped with the new Vitaphone sound system.
With this system the soundtrack was recorded on a separate phonograph record that had
to be synchronized with the film portion of the movie when it was projected on the screen.
Vitaphone was eventually replaced with sound-on-film technology.

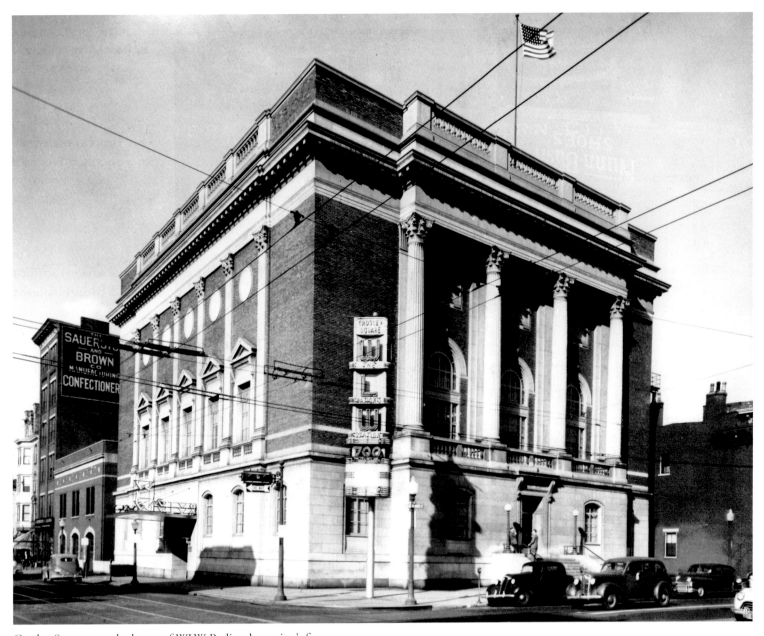

Crosley Square was the home of WLW Radio, the nation's first 50,000 watt commercial broadcasting station to operate on a regular schedule in 1928. From then on it was known as "The Nation's Station."

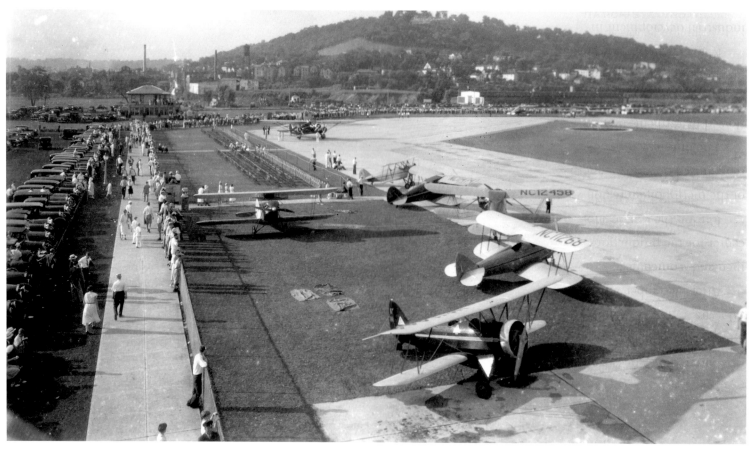

Ohio-made Waco biplanes and a Stinson Tri-Motor grace the ramp at Lunken Airport during a public event in the early 1930's. The original administration building is visible at left, replaced by a new building in 1937.

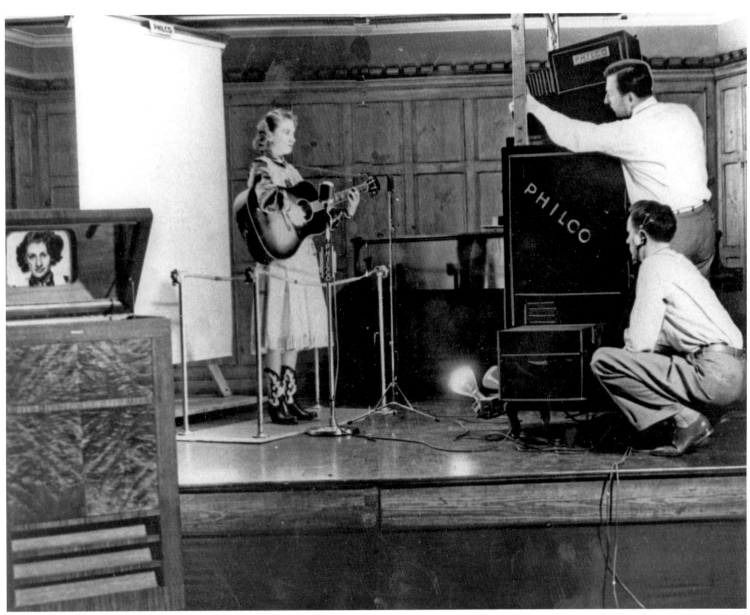

In 1939 the future of television was uncertain. In a demonstration of the new media, WLW singer Helen Diller, broadcast in front of a curtain. A microphone picked up her voice while her image was seen on a receiver.

Impressive-looking doormen in their silk top hats greet guests of the Netherland Plaza Hotel in 1933.

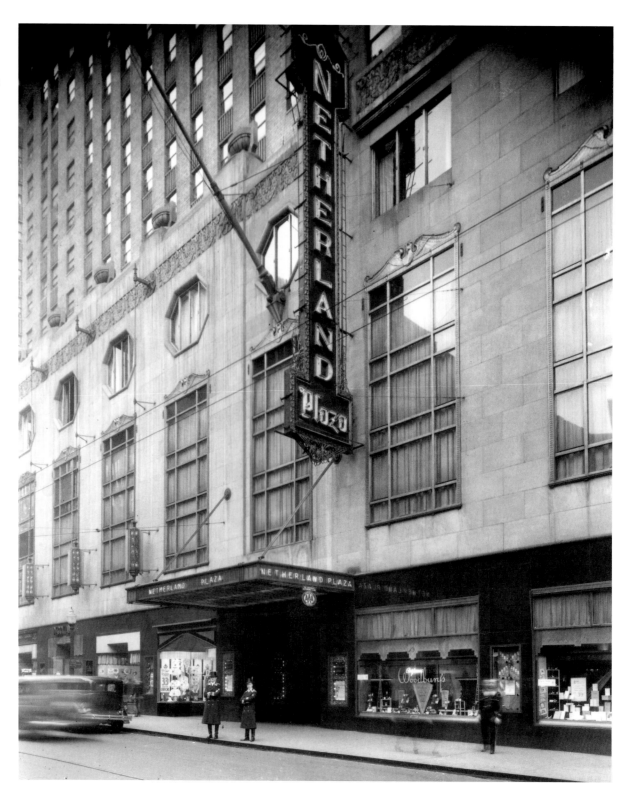

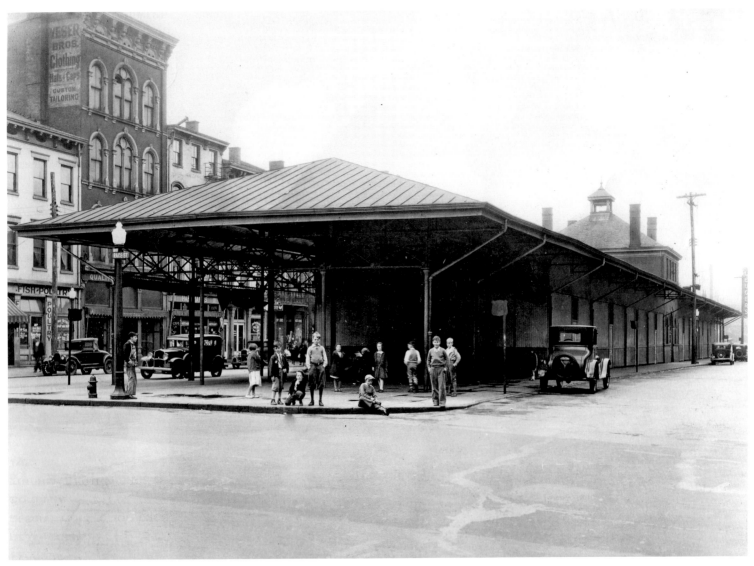

Children linger beneath the roof of Findlay Market in 1935. Named
after civic and military leader James Findlay, this market began providing
fresh produce and meat to the residents of Over-the-Rhine in the 1850's.
Before there were supermarkets, people stocked their pantries at open-air
markets in the old world tradition.

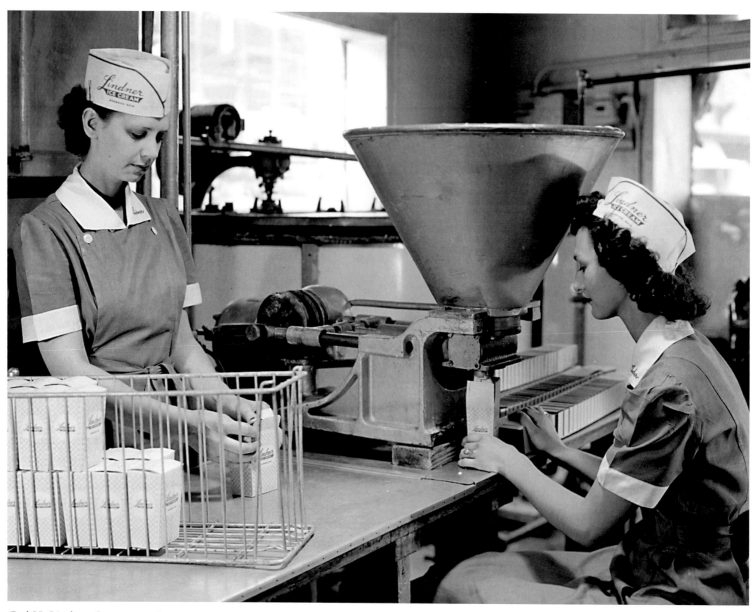

Carl H. Lindner, Sr. came to Cincinnati in 1931 and started the Lindner
Brothers Ice Cream Company. He is credited with introducing the
"triple-dip" ice cream cone to this area. He sold his interest in that
company and in 1940 started the first United Dairy Farmers store.

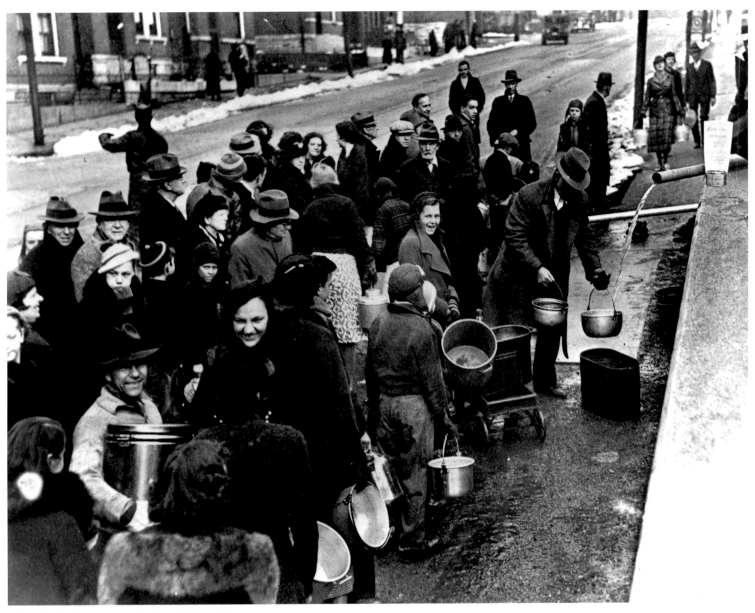

After the flood waters receded in 1937, residents
of Clifton Avenue stood in line for fresh water.
The water still had to be boiled before drinking.

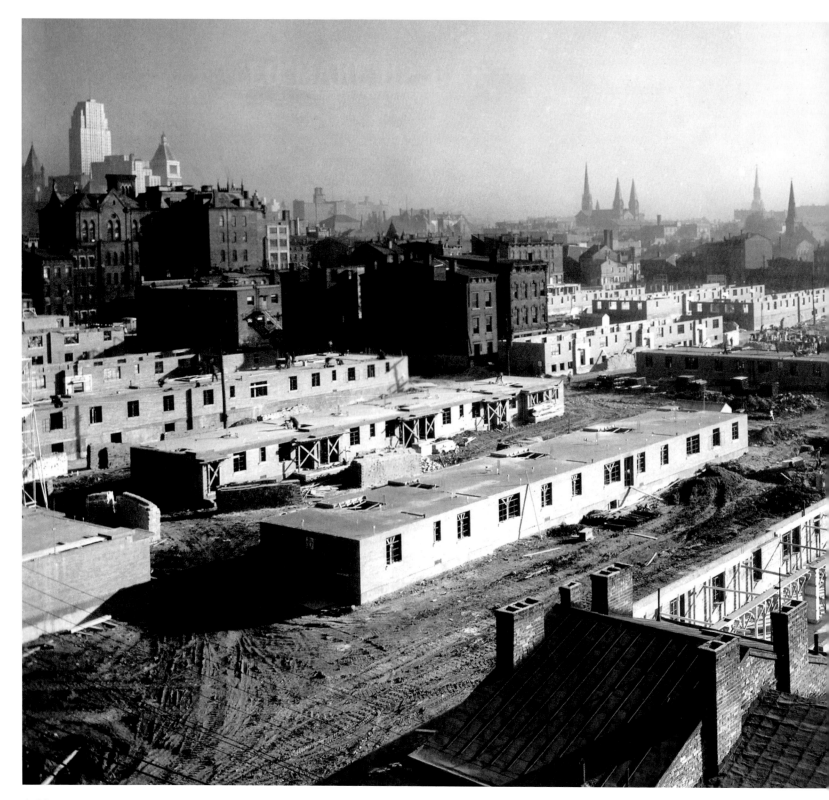

144

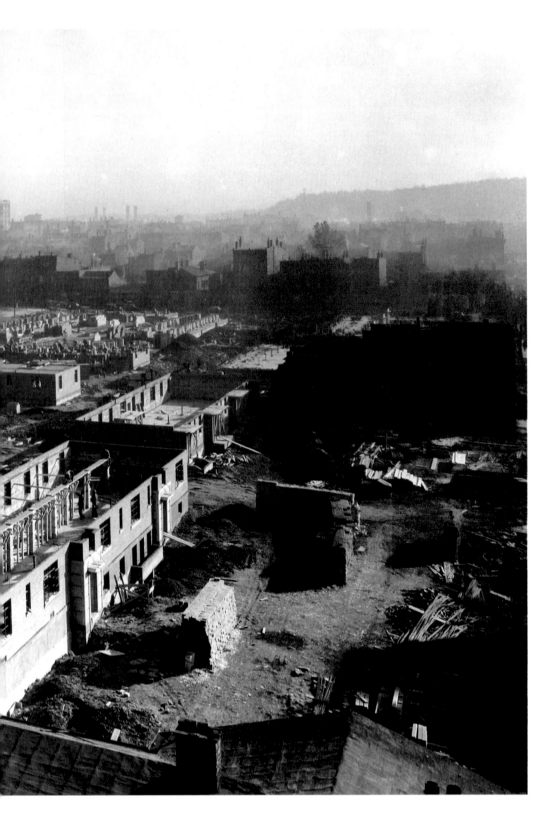

In the 1930's the Public Works Administration made money available for construction of new housing for the poor. Laurel Homes, completed in 1938, was the first federally funded housing project in Cincinnati. Initially it housed mostly low-income white families but additional units were added later for black families.

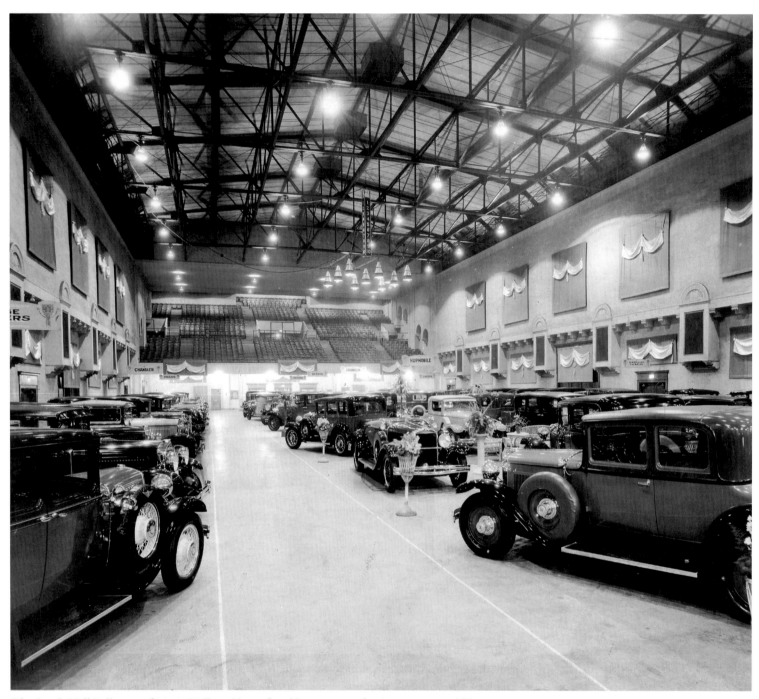

The South Hall Ballroom of Music Hall could comfortably seat 1,800 for dinner or it could be transformed into an exposition center. The wide aisles, good lighting, and drive-in entrances provided a suitable showplace for these 1920's automobiles. Music Hall served as a convention and exposition facility until the construction of the Convention Center in 1967.

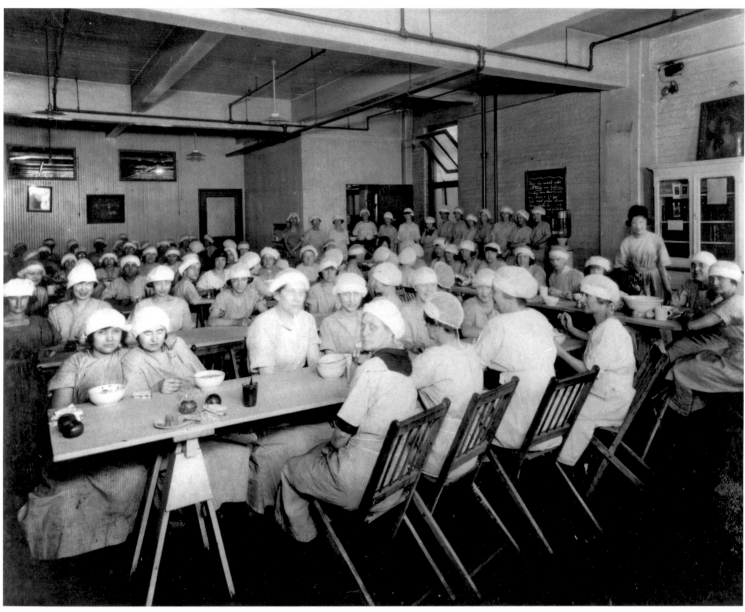

The women of Strietmann Biscuit Company take a lunch break
from making crackers and cookies in the 1920's.

This was a source photo for the U.S. Playing Card Company industrial mural, one of fourteen Winold Reiss murals depicting area businesses and workers that hung in the Union Terminal concourse. A woman printer is shown in the 1930's photograph but she doesn't appear in the finished mural.

FROM WORLD WAR TO THE EMERGENCE OF THE MODERN CITY

1940 – 1960'S

Battered by a decade of depression, with war already raging in Europe and tensions mounting in the Pacific, Cincinnatians in 1940 could not have foreseen how world events and local choices would transform their city over the next 30 years.

After December 7, 1941, Cincinnatians mobilized to meet the demands of yet another world war. Thousands of local men and women heeded the call to serve their country both in uniform and on the homefront, making Cincinnati a vital center for the production of machine tools.

During the war, local leaders set in motion a comprehensive planning process that helped guide the transformation of the metropolitan region after the war. The plan included a local expressway system, a new airport, and visions for a reorganized downtown and a revitalized riverfront.

The unforeseen rise of suburban shopping malls undermined the vitality of retail in the central business district and slowed investment. Not until 1964 did the city develop an effective revitalization plan for the district, which finally sparked construction of a new Fountain Square, a Federal Reserve Bank, a convention center, and hotels and office buildings in the heart of the region.

Many changes came at a substantial social cost. When the city began clearing the West End for expressways and industrial development in 1960, thousands of black residents were uprooted. Long-standing patterns of defacto segregation in neighborhoods and workplaces created tensions. Combined with the rise of the national Civil Rights movement, dissatisfaction mounted until it exploded in riots during the "hot" summers of 1967 and 1968.

The 1960's ended with a new, more unified view of the city, marked by a renewed interest in the vitality of the downtown as well as the city's neighborhoods.

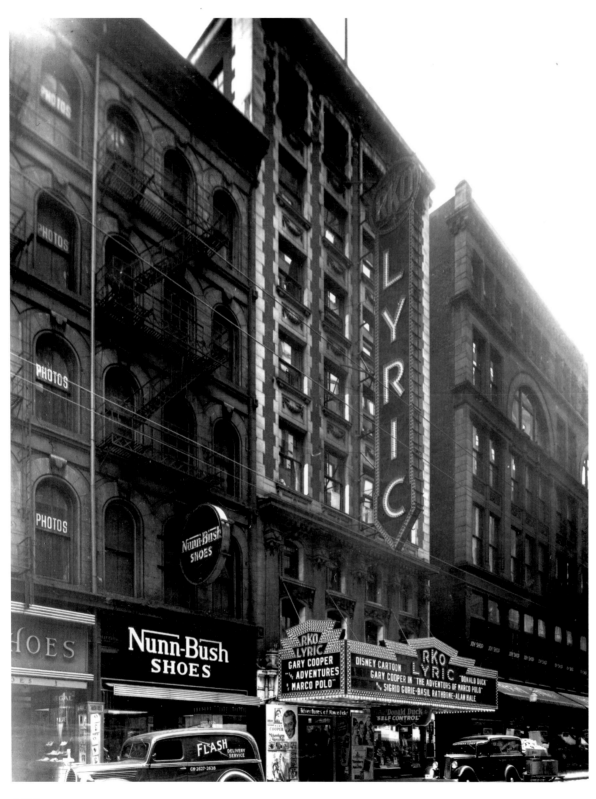

The latest Gary Cooper film and Donald Duck cartoon entice customers to patronize the Lyric Theater in 1938. When the Lyric first opened on Vine Street in 1906, quality stage productions were performed there. The theater was converted into a movie house shortly after World War I. The popularity of drive-in theaters and television led to the Lyric's demise in 1952.

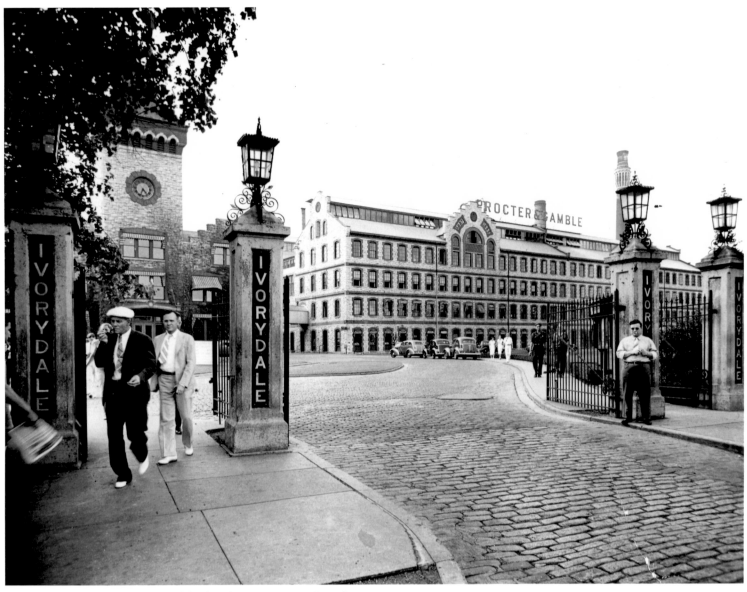

Construction on the original Ivorydale plant began in 1885. Over the years
this manufacturing complex grew to contain 213 buildings over 61 acres
and included a fire department, dining rooms, and recreational facilities.

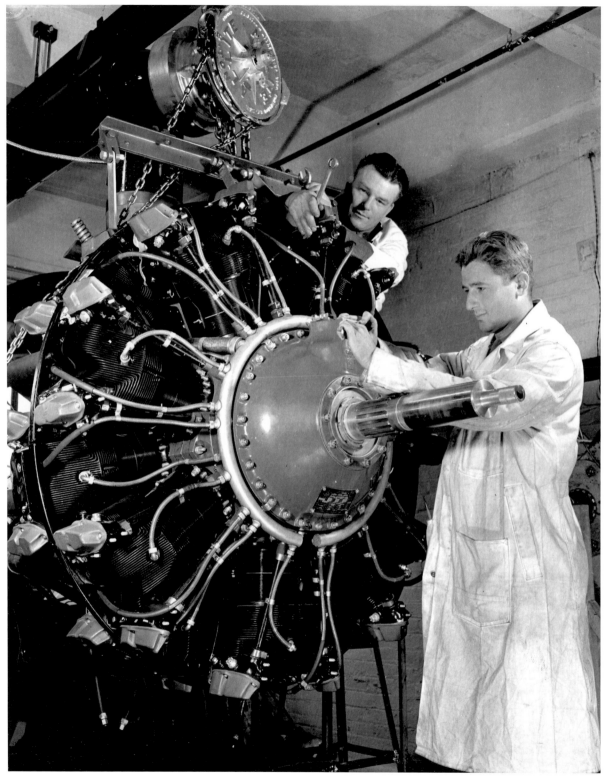

In 1941 the Wright Aeronautical Corporation opened an enormous aircraft engine plant north of Cincinnati. Students were trained in engine testing and assembly on the air-cooled Cyclone 14 engine they produced.

Cincinnati-made machine tools were essential to the National Defense program during World War II and the Korean War. Here a precision hydraulic universal grinding machine is finishing a machine tool part at Cincinnati Milling Machine, the largest producer of machine tools in the United States.

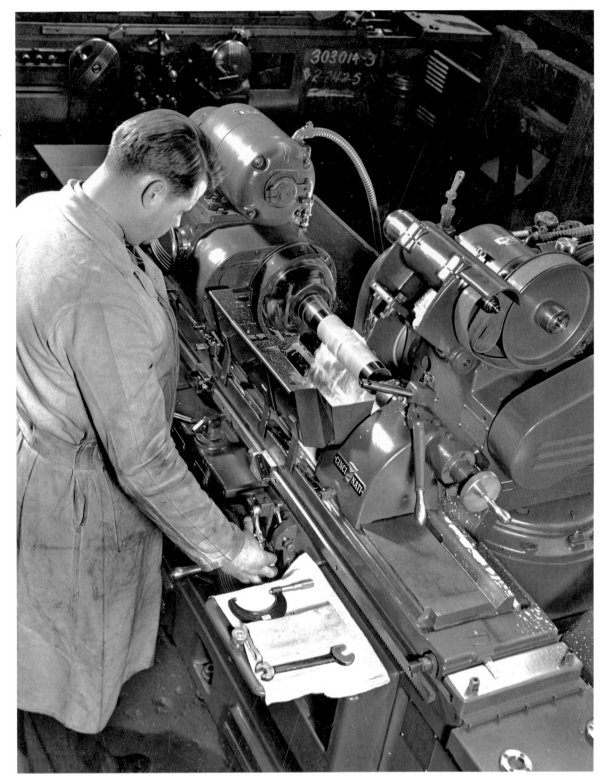

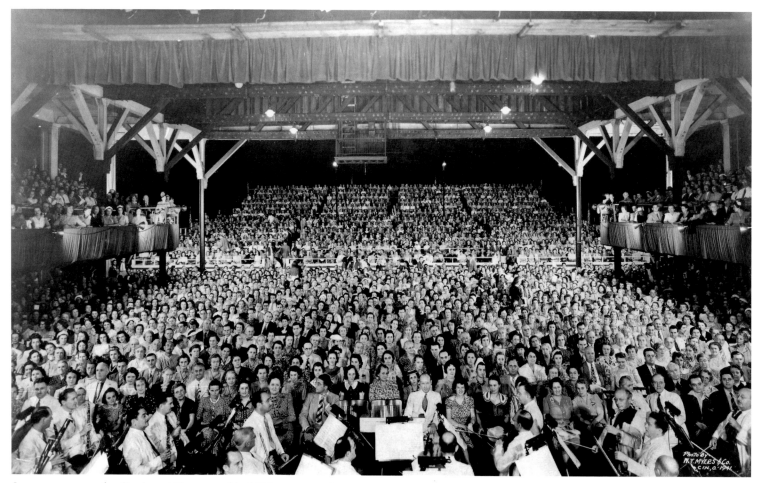

Summer opera at the Cincinnati Zoo started in 1920 as an experiment
to revitalize the arts after World War I. Crowds like this one in 1941
jammed the pavilion for over 50 years to hear the dulcet tones of rising
stars like Beverly Sills, Rise Stevens, Placido Domingo and Ezio Pinza.

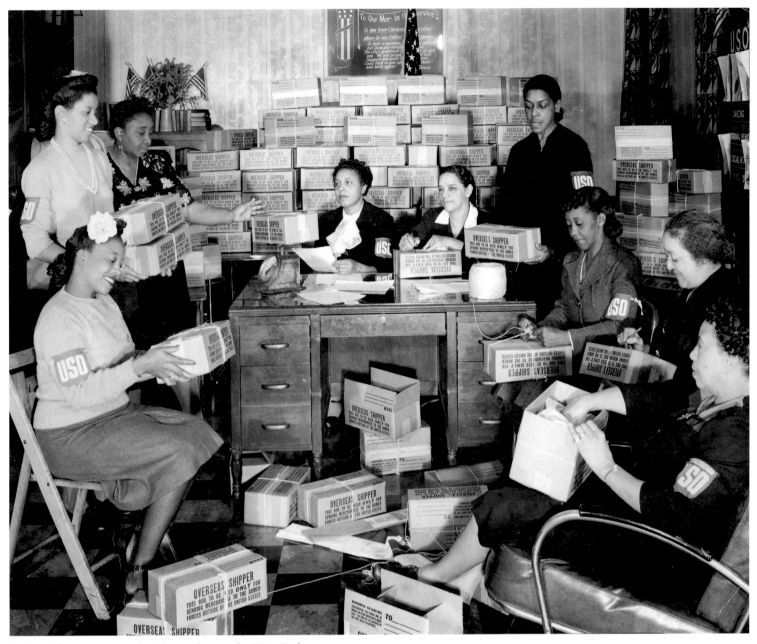

These African American U.S.O. workers in the West End were part
of a group responsible for packing over 300 boxes of supplies to be
sent to military service personnel overseas in 1944.

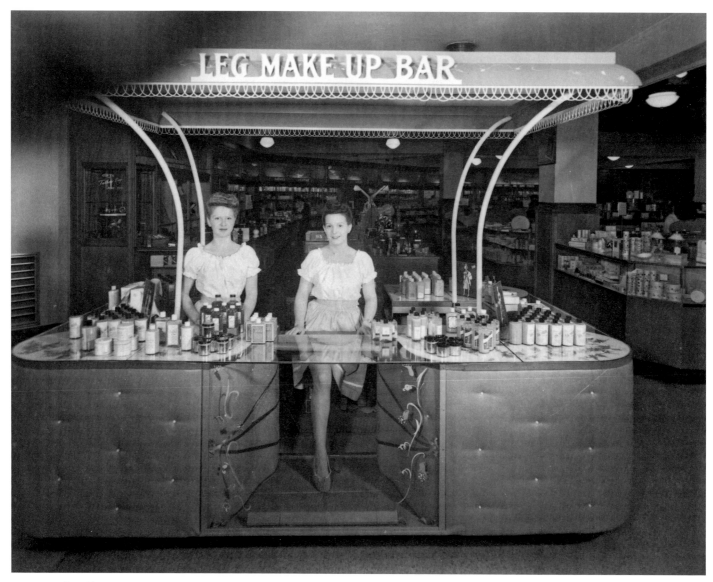

Americans faced limited supplies of many items during World War II. When silk and nylon were needed for military products such as parachutes, women had to resort to leg make-up to create the look of stockings.

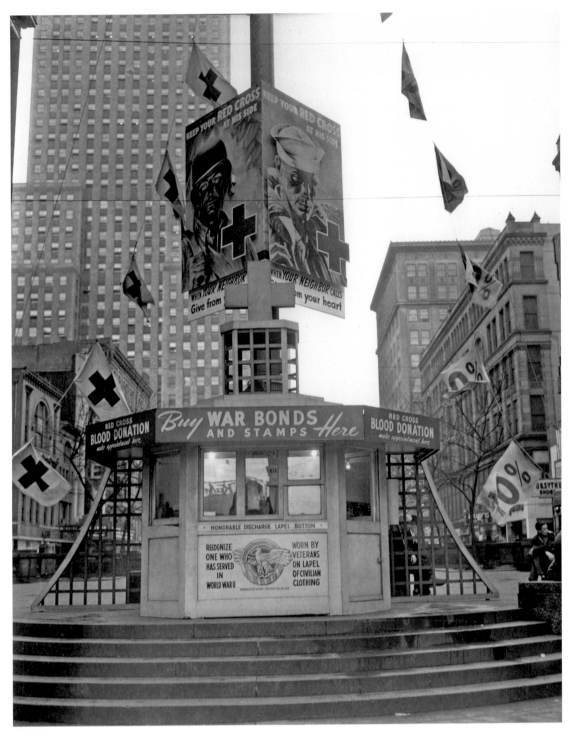

The Hamilton County War Savings Committee gathered volunteers and donated materials to erect a "bond pier" at the Vine St. end of Fountain Square. Representatives from civic, fraternal and social groups sold war bonds from the pier throughout the war.

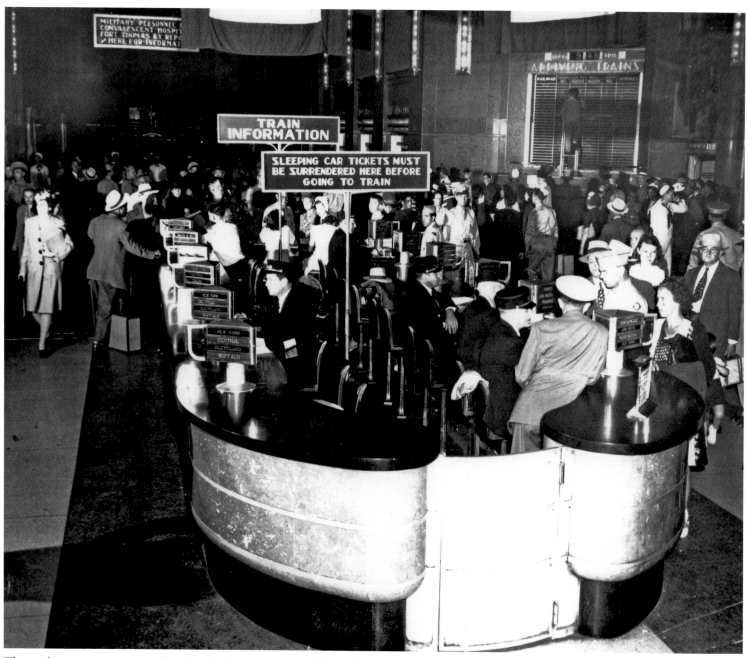

The need to move war personnel and restrictions on auto travel boosted passenger travel on the railroads during World War II. In 1944 an estimated 34,000 people traveled through Union Terminal each day.

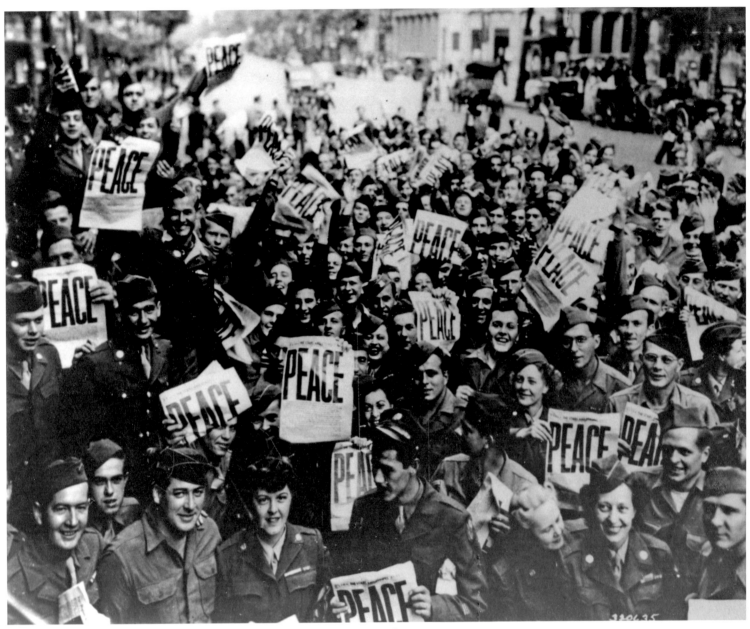

Euphoria swept over Cincinnati after President Truman announced the end of
hostilities with Japan in 1945. Following the announcement, a crowd of 15,000
gathered on Fountain Square to celebrate the end of World War II.

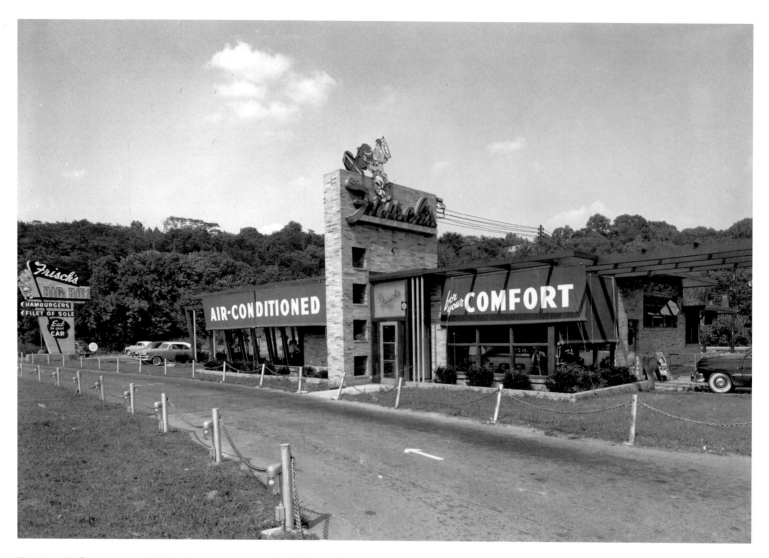

Cincinnati's first year-round drive-in restaurant was Frisch's mainliner, opened
in 1939. The first Big Boy Restaurant opened in 1947 when Dave Frisch
introduced the double-decker "Big Boy" hamburger as well as expanded curb
service. Drive-in service was phased out in 1985.

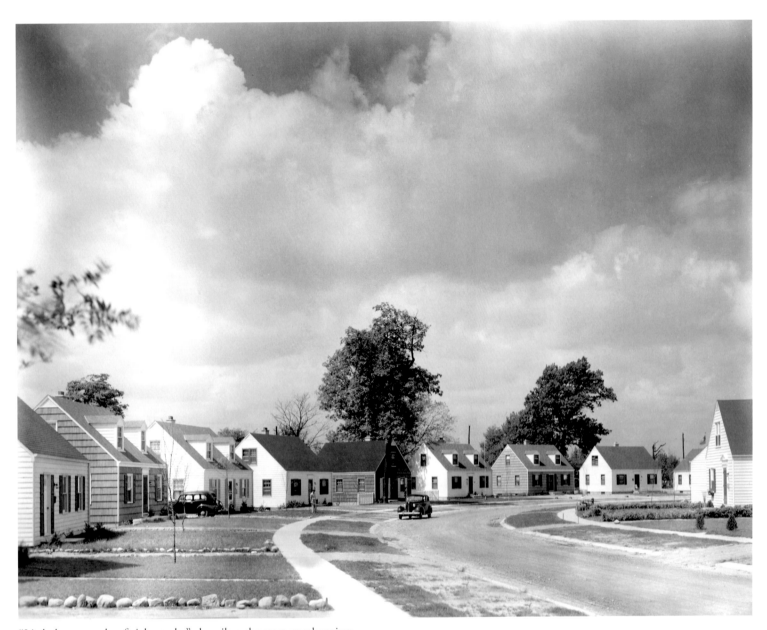

"Little boxes made of ticky-tacky" describes the post-war housing boom of the late 1940's and early 1950's. The baby boom couples armed with affordable mortgages and automobile availability led to a growing demand for single family homes.

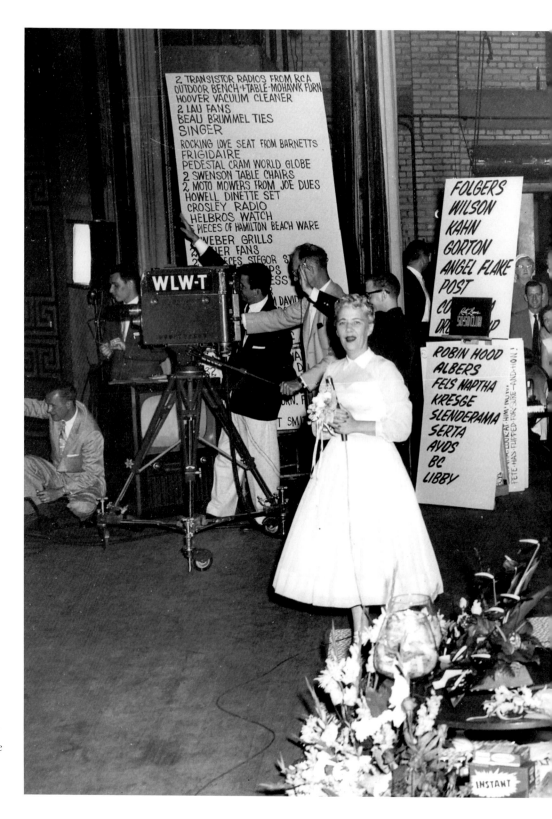

The Fifty-Fifty Club, with star Ruth Lyons, was one of the most popular daytime television shows in the 1950's and early 60's. In 1957 it became the first local program to be broadcast in color.

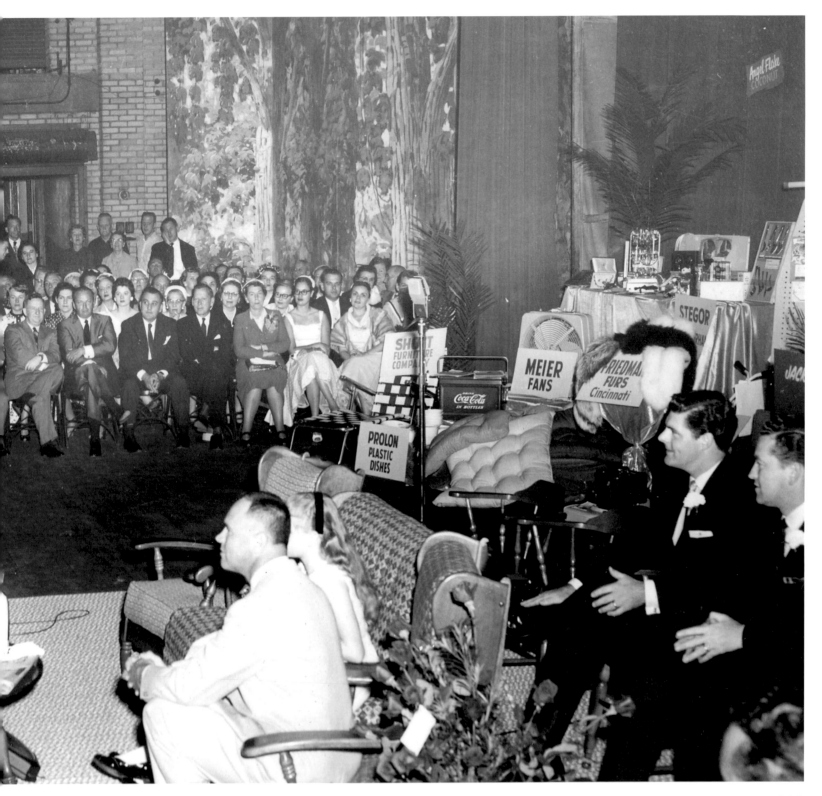

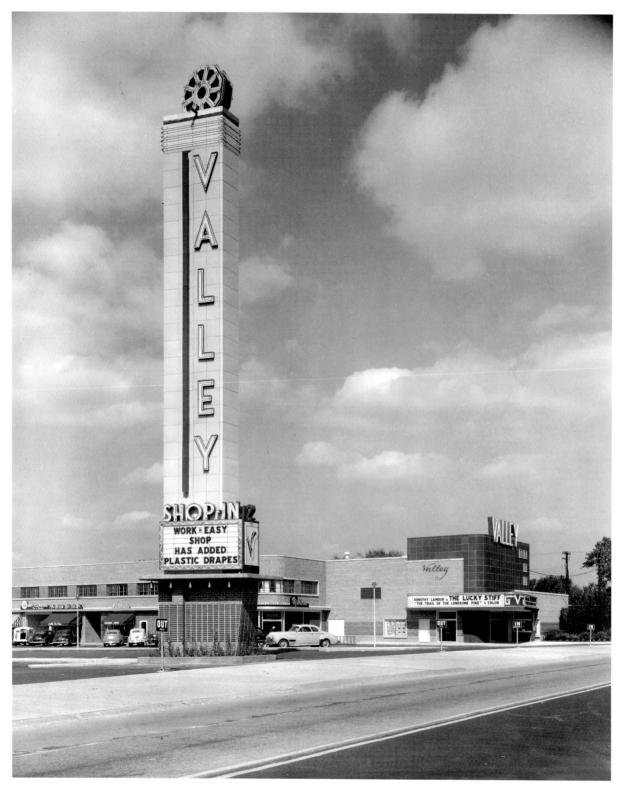

In the 1940's retail development began to follow automobile traffic routes rather than streetcar lines. In 1949 the Valley Shop-In was opened on Reading Road. It consisted of a strip of fourteen stores, a theater, and parking for 550 cars.

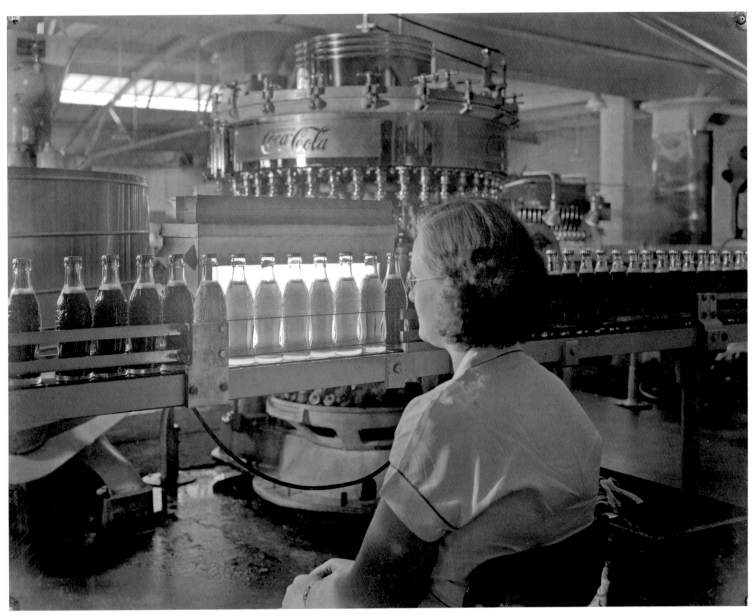

An inspector scrutinizes bottles of Coca-Cola in the 1940's as they
pass in front of a piercing light. In the final step of production,
each bottle had to meet exacting standards.

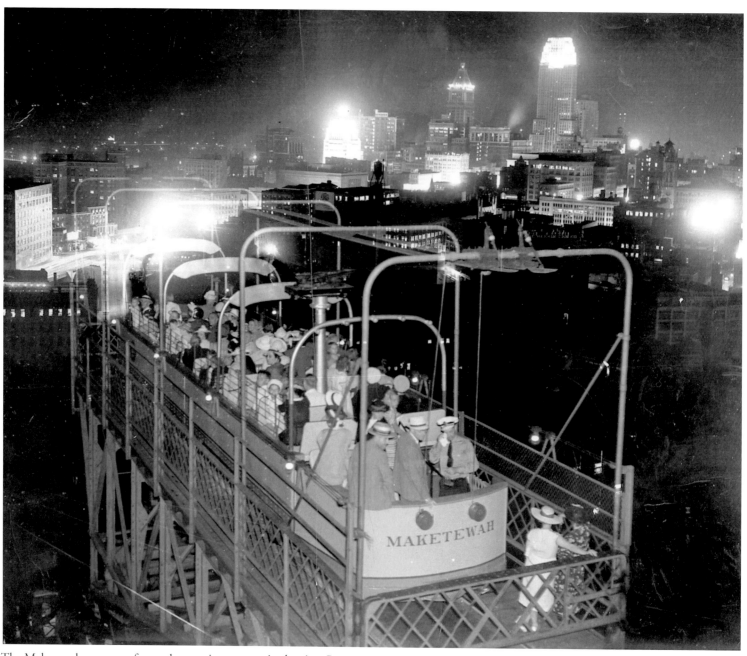

The Maketewah was one of several open air streetcars in the city. Passengers enjoy the fresh air and city lights from the Mt. Adams Incline in the 1940's.

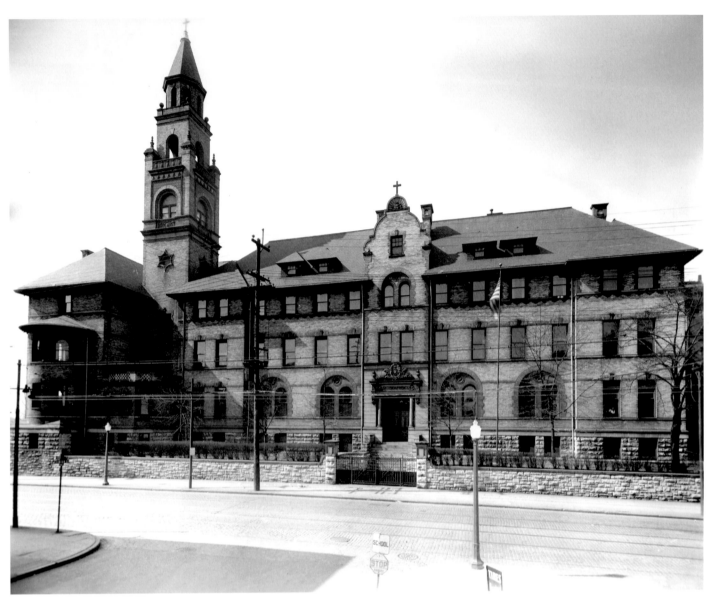

The Convent and School of the Sisters of Mercy on Western Avenue was designed by the architectural firm of Samuel Hannaford and Sons in 1885. Today it is home to the Job Corps Center, which offers academic and vocational training to men and women from low-income families. It is shown as it appeared in 1946.

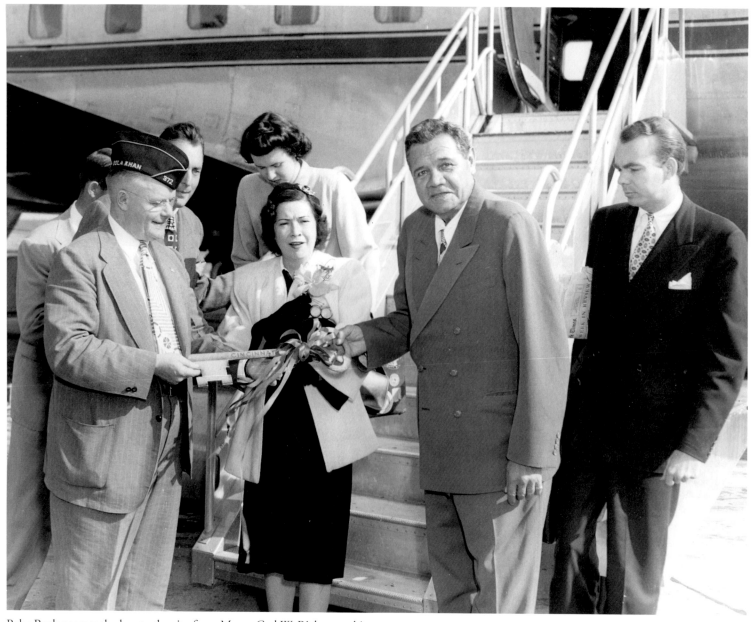

Babe Ruth accepts the key to the city from Mayor Carl W. Rich upon his arrival in Cincinnati in 1947 to attend the All-Star game. Ruth died the following year.

Throngs of shoppers jam the aisles of Shilllito's on November 29, 1948 taking advantage of the store's first 9:00 PM closing time.

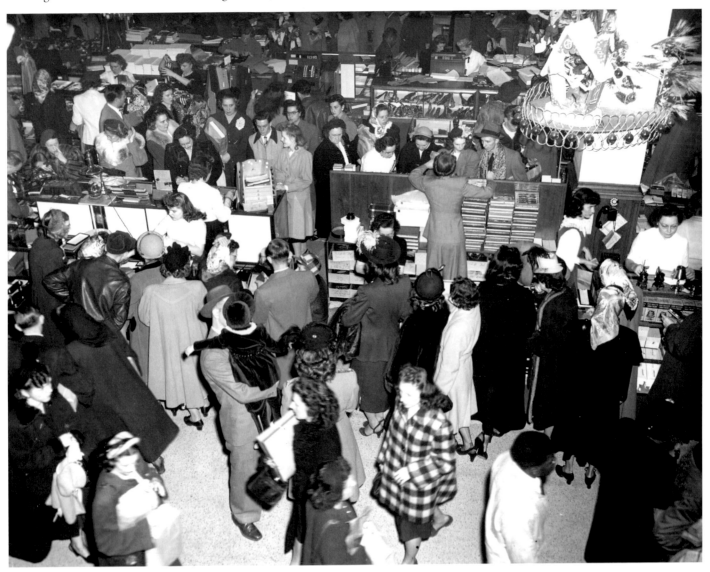

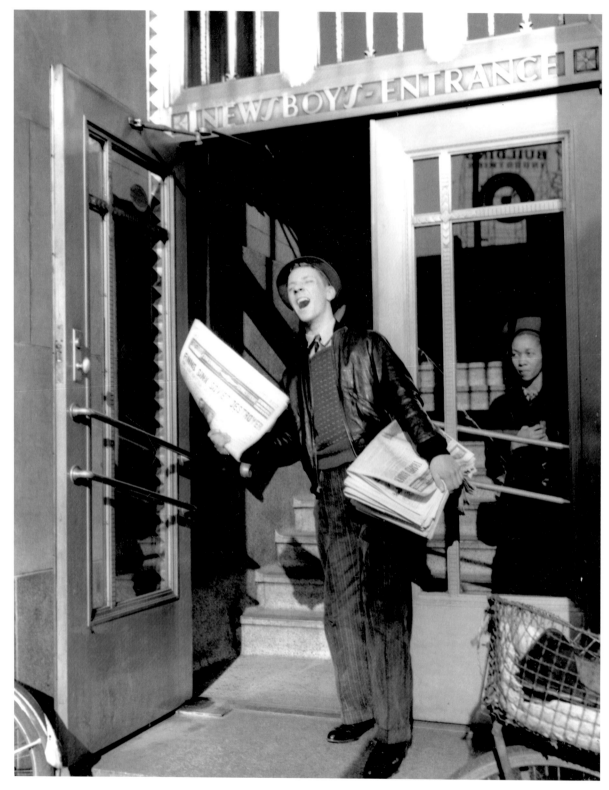

A newsboy shouts out war related headlines at the newsboy's entrance to the Cincinnati Times-Star Building in the 1940's.

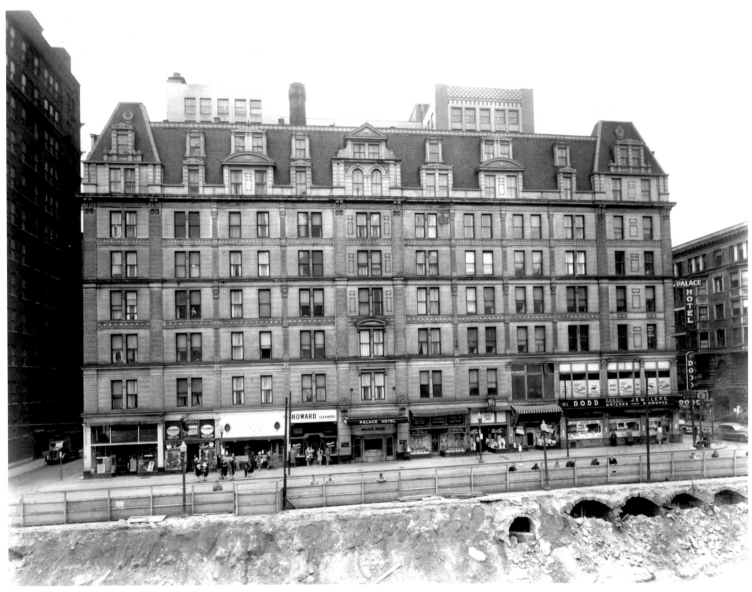

The Palace Hotel built in 1882 was designed by local architect Samuel Hannaford. Renamed the Cincinnatian in 1951, it was the first hotel in the country to have hydraulic elevators and incandescent lights.

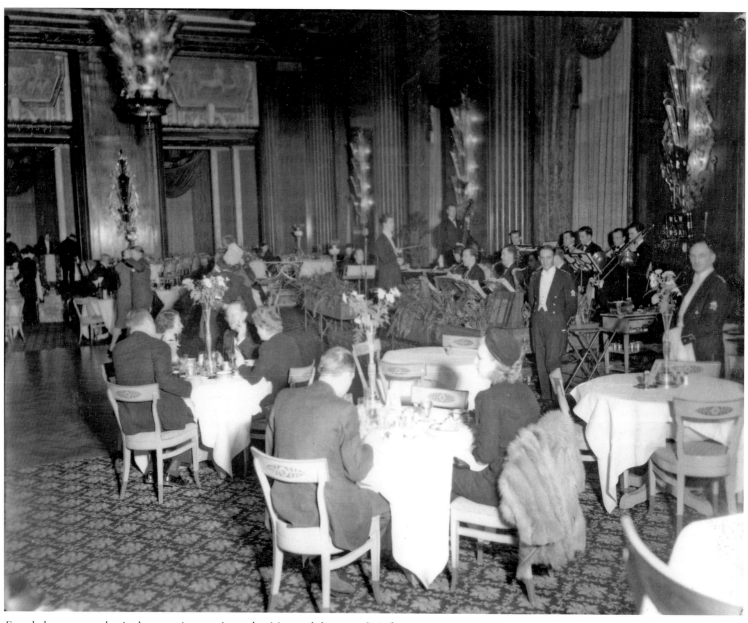

Fur-clad women and suited men enjoy continental cuisine and dance to their favorite
music in the Restaurant Continentale of the Netherland Plaza Hotel in the 1940's.

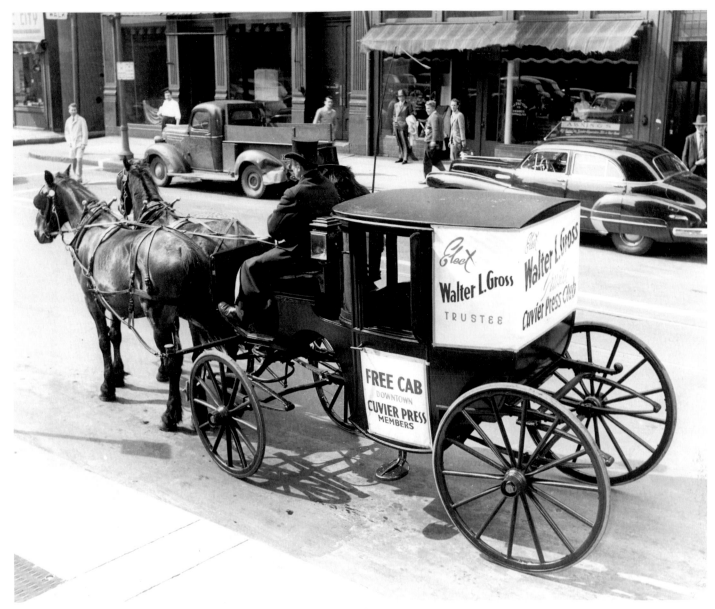

Walter L. Gross, a candidate for trustee of the Cuvier Press Club in 1947, solicits votes by offering club members free, two horse-power cab rides between the club and downtown hotels.

Before DVD's and videotapes, mom and dad would bundle kids in their pajamas, pack soft drinks and popcorn and head for the drive-in movies. The Woodlawn Drive-In, built in 1947, was the second one in Cincinnati. In addition to the movie it featured a cafeteria, repair service for cars, and a playground for children.

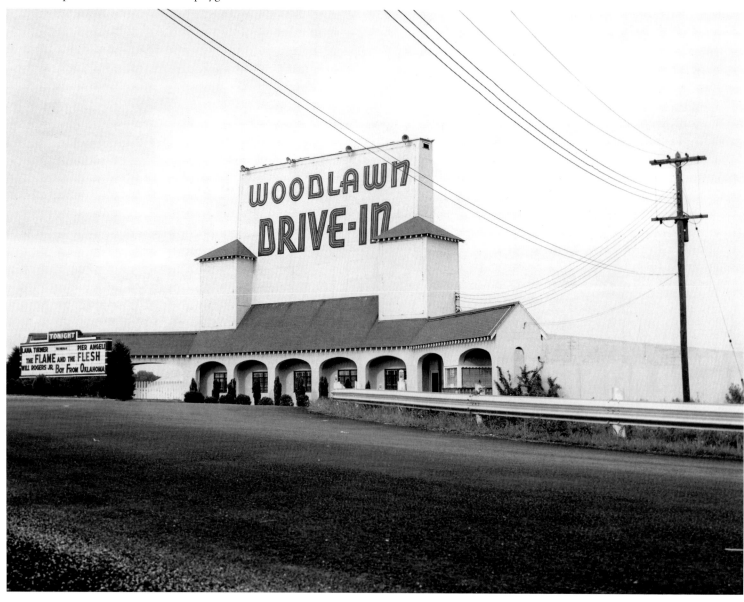

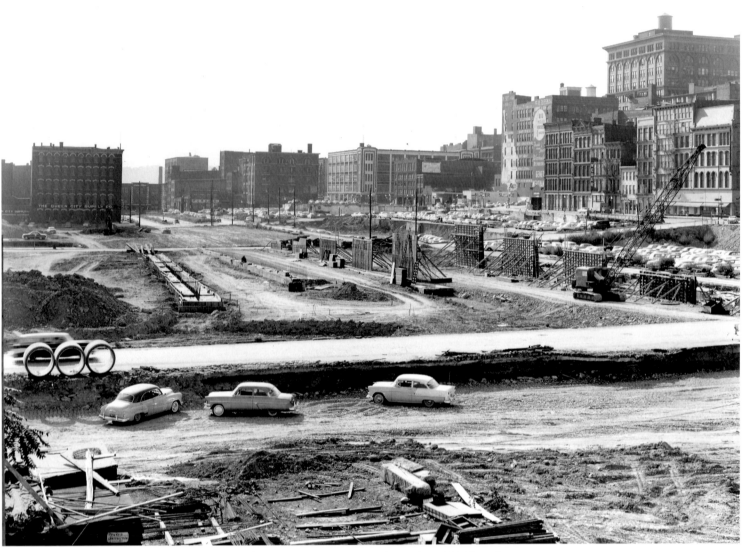

The Third Street Distributor, now called Fort Washington Way, was proposed as early as 1925 in order to distribute traffic around the central business district. Work did not get started until passage of the Federal Highway Act of 1956. It opened in June of 1961.

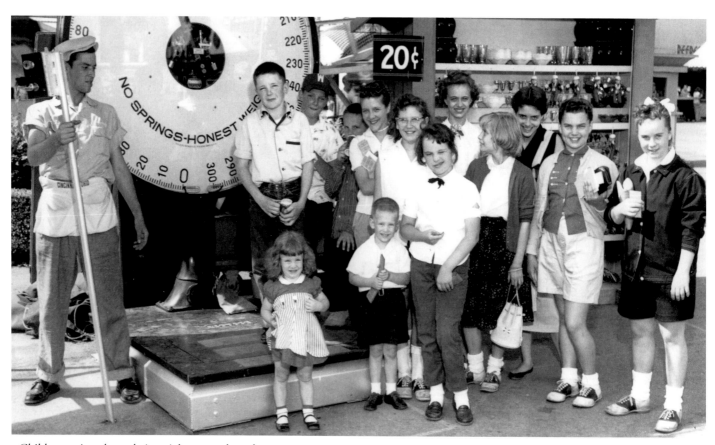

Children wait to have their weight guessed on the
Mall at Coney Island in the 1950's.

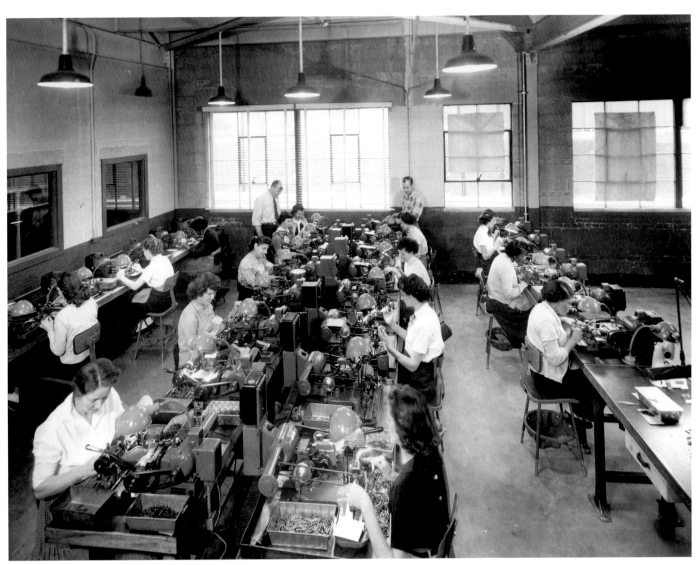

The Gruen Watch Company was founded in 1874 and introduced such innovations as the stem-wound watch, the thin pocket watch, and the curved movement wristwatch. The steady hands of these skilled women work with the intricate watch parts in 1954.

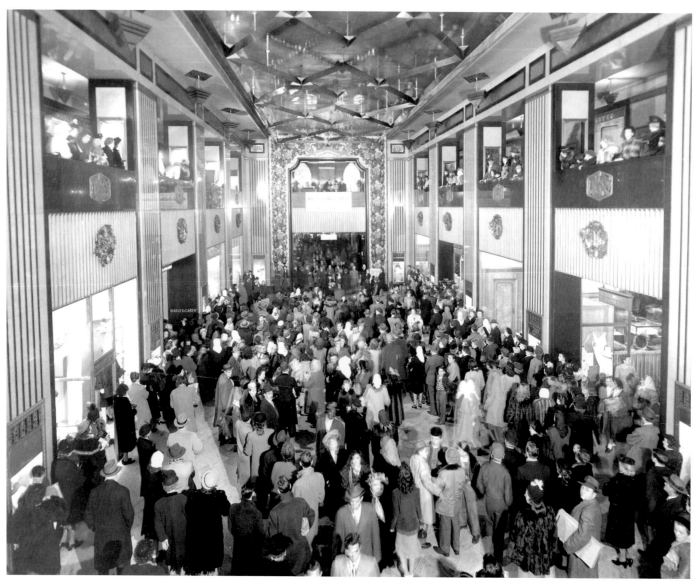

Christmas shoppers take a break to listen to the Mabley
Christmas Carolers in the arcade of the Mabley & Carew
Department Store in the early 1950's.

Known as the *Cincinnati Cobra*, Ezzard Charles became the World Heavyweight Boxing Champion by defeating Joe Louis in 1950. In 1951 he lost the title to Jersey Joe Walcott.

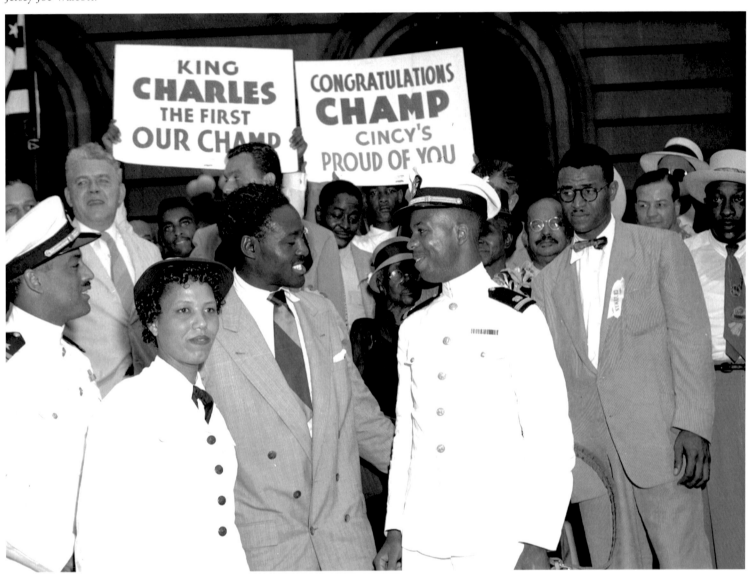

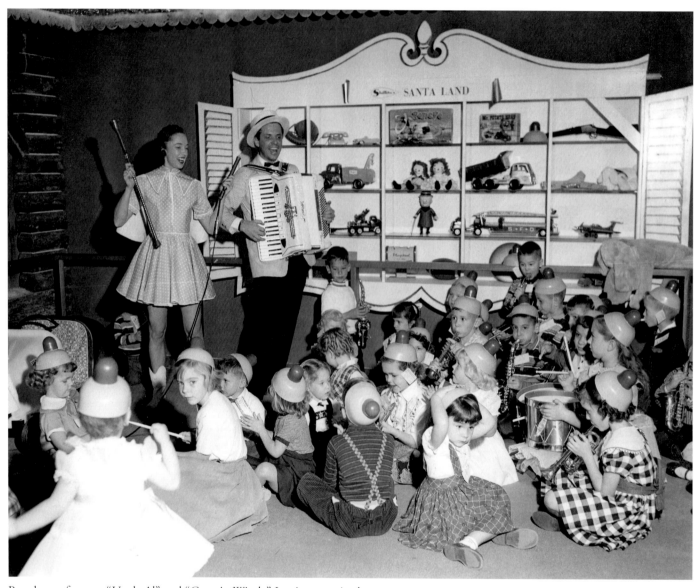

Popular performers "Uncle Al" and "Captain Windy" Lewis entertain the children in Santa Land at Shillitos in 1958.

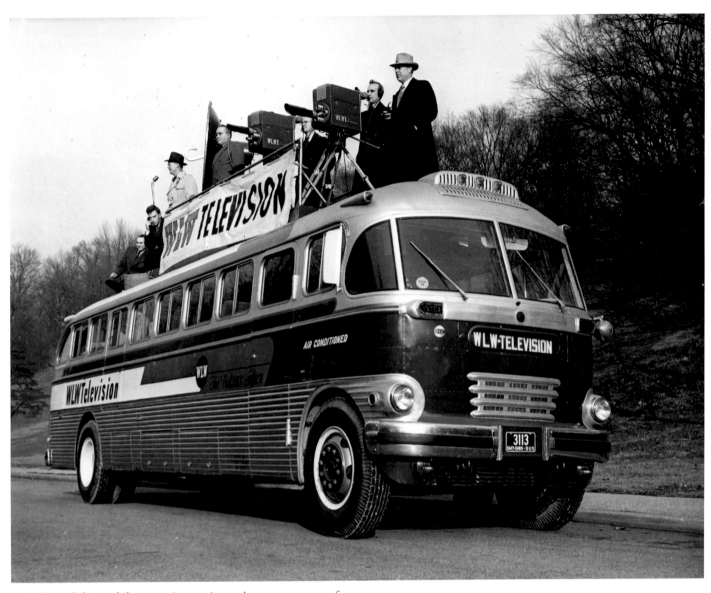

WLWT used this mobile transmitter unit to telecast events away from the studio in the 1950's. The event was then relayed by microwave to the transmitter for re-transmission to the television public.

The "Great Hall" of the Netherland Plaza Hotel, an Art Deco
masterpiece, is seen here in 1951. Built in the 1930's, its
opulence helped to offset the dreariness of the Depression.

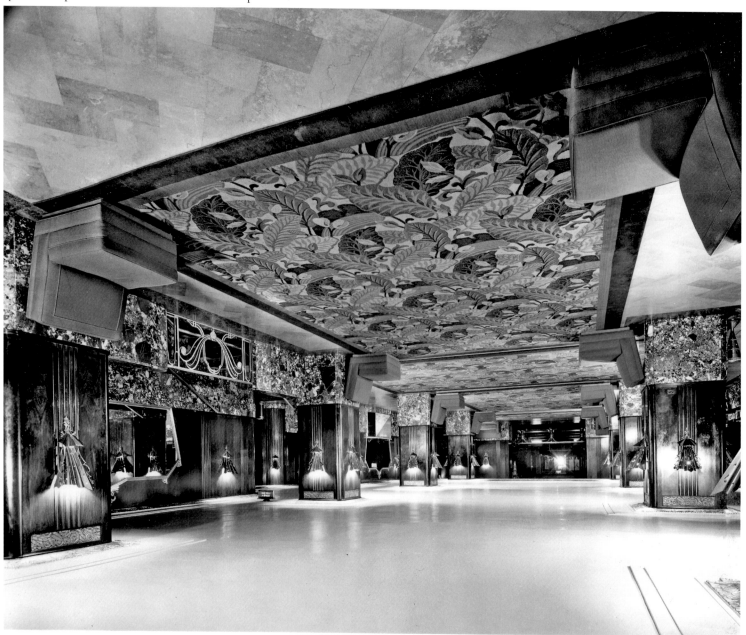

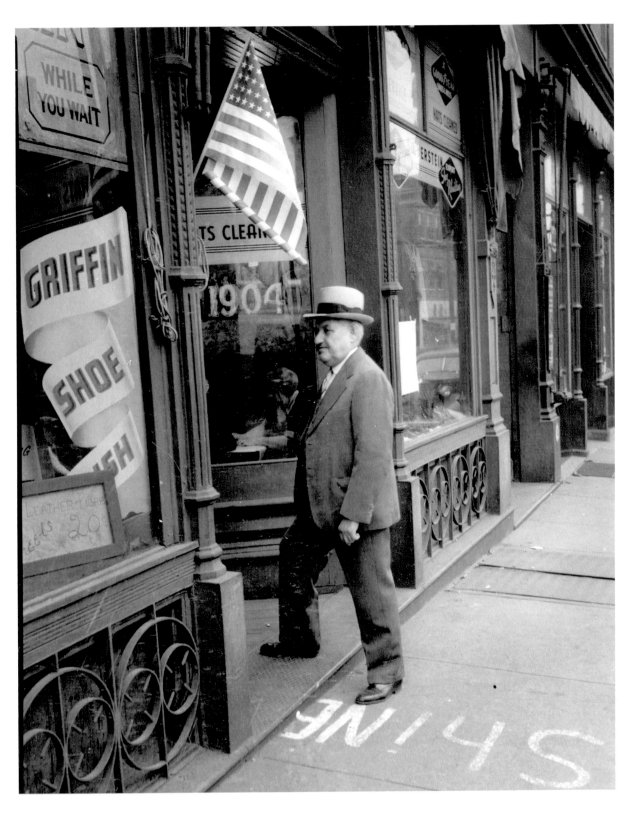

A customer enters
Silverstein Shoe Repair
Shop at 1904 Vine Street
in Over-The Rhine.

Books were shelved in alcoves at the Public Library of Cincinnati and Hamilton County in the early 1950's. Designed by local architect James W. McLaughlin, this library building was dedicated in 1874. The building was razed after a more modern facility was built at 800 Vine Street in 1955.

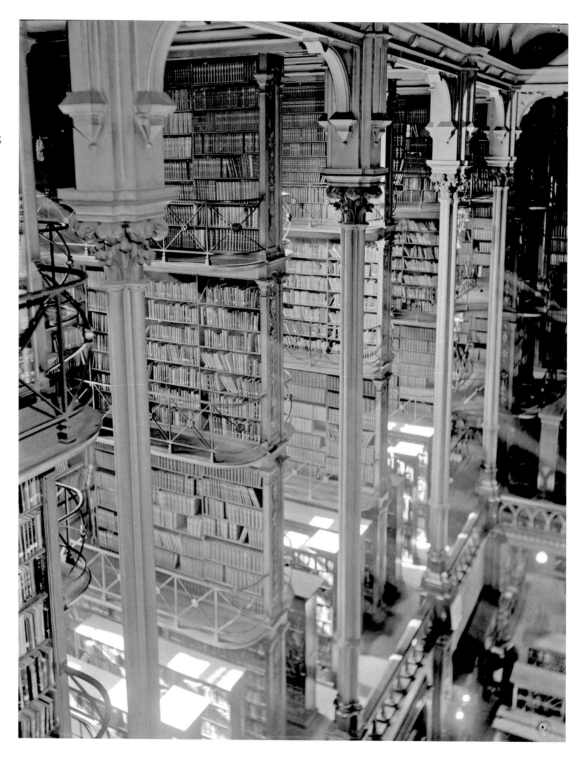

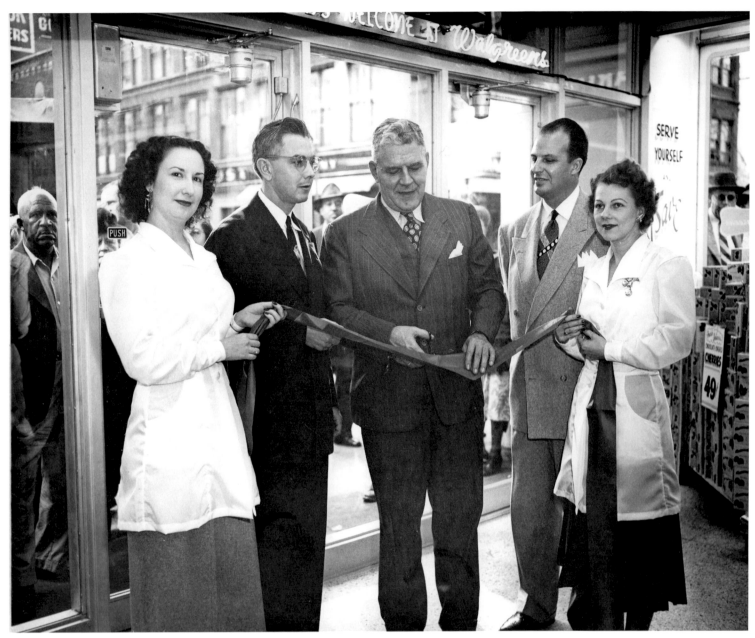

Mayor Albert D. Cash cuts the ribbon on October 30, 1950 to open the largest self-service Walgreen's Drug Store built to date.

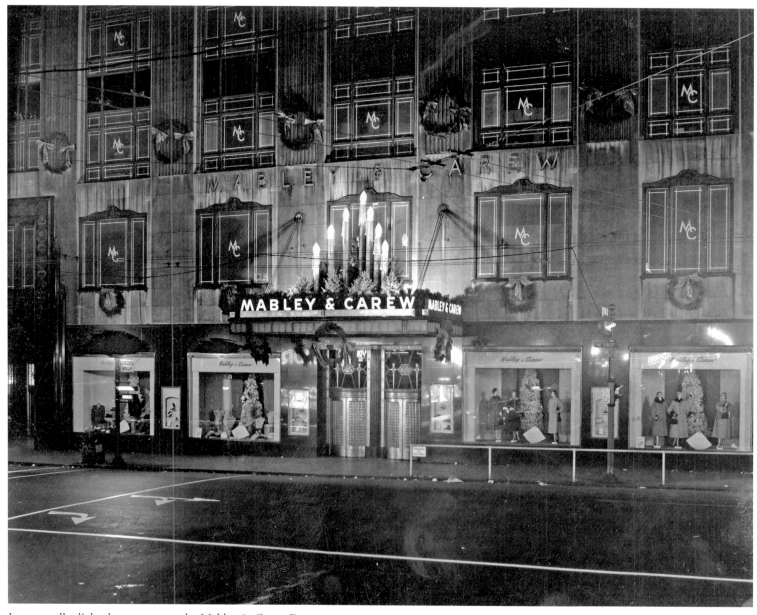

Large candles light the entrance to the Mabley & Carew Department
Store during the 1952 Christmas season.

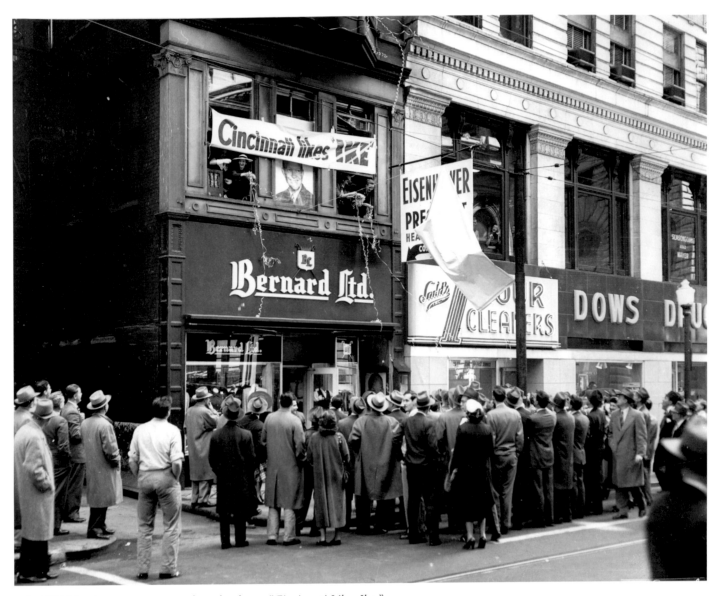

In 1952 Eisenhower supporters adopt the slogan "Cincinnati Likes Ike."
The Eisenhower for President headquarters opened on the second floor of
412 Vine Street in April.

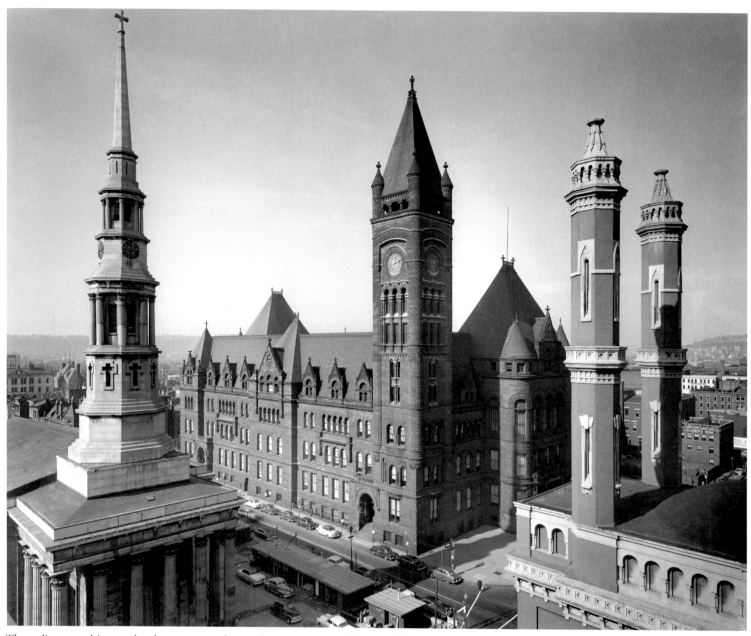

Three diverse architectural styles come together at the intersection of Plum and Eighth Streets in 1953. To the left is the steeple of the Greek Revival St. Peter in Chains Cathedral (1845). Center is the Richardsonian Romanesque City Hall (1893). On the right are the minarets of the Byzantine-Moorish Plum Street Temple (1866).

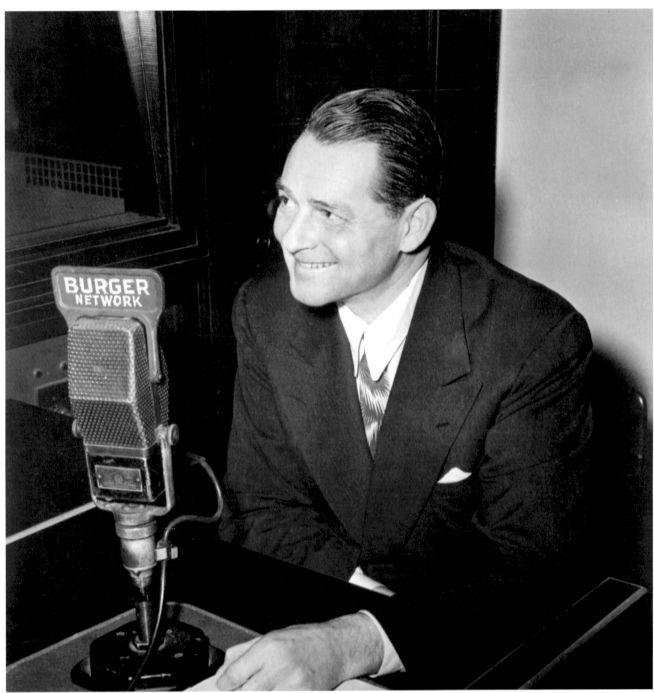

Former New York Yankee Hall-of Fame pitcher, and veteran broadcaster Waite
Hoyt was as known for his rain-delay stories as for his play-by-play announcing
from 1942-1966.

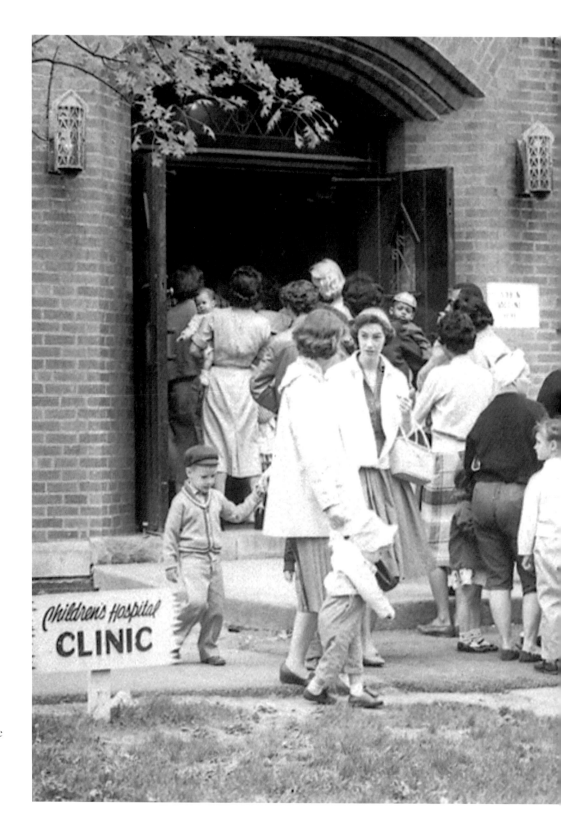

Thousands of Cincinnati children lined up at doctor's offices, clinics and hospitals to receive the Sabin live-virus polio vaccine on "Polio Sunday", April 24, 1960. Dr. Sabin did his research at Cincinnati Children's Hospital.

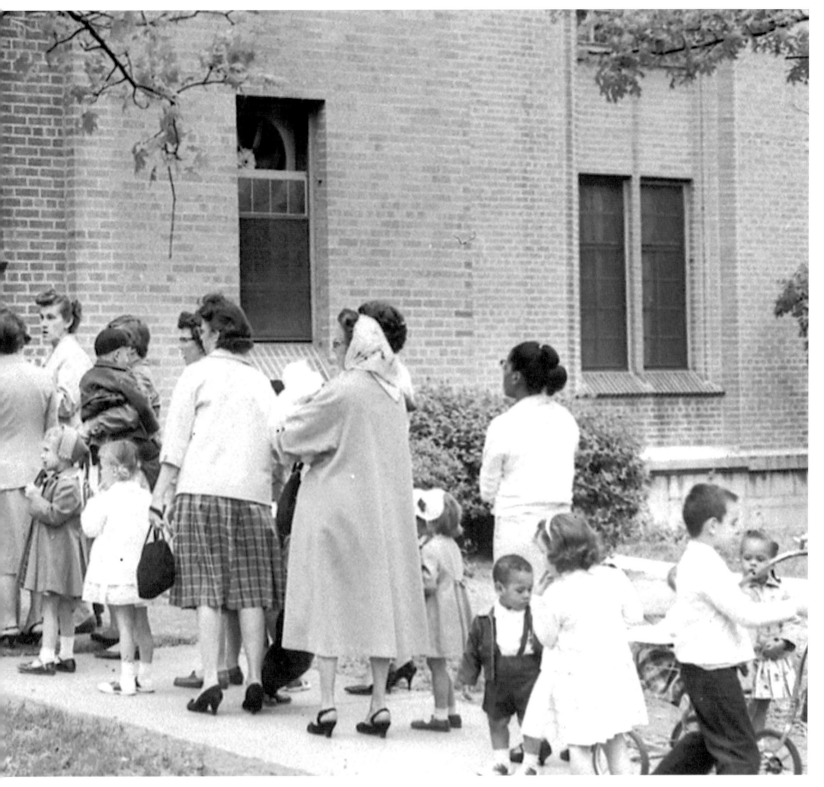

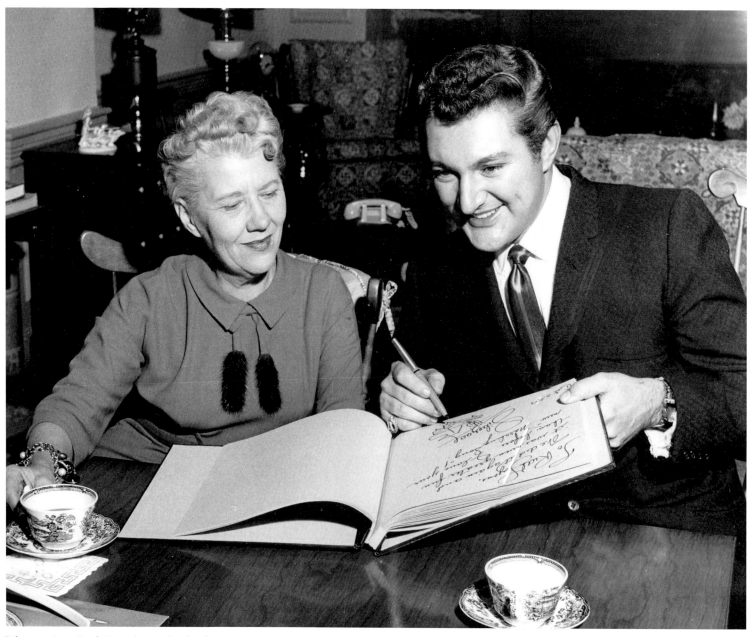

Liberace signs Ruth Lyons' guest book after an appearance
on the *Fifty-Fifty Club* in 1959.

NOTES ON THE PHOTOGRAPHS

All Photos are from the general and special photograph
collections of Cincinnati Museum Center.

II
TYLER DAVIDSON FOUNTAIN
GENERAL PHOTO COLLECTION

VI
BRIGHTON BICYCLE CLUB
GENERAL PHOTO COLLECTION

X
COVINGTON & CINCINNATI
SUSPENSION BRIDGE
GENERAL PHOTO COLLECTION

02
SIXTH STREET
GENERAL PHOTO COLLECTION
MARKETS-SIXTH STREET
(OVERSIZED)

03
"CINCINNATI ZOUAVES"
GENERAL PHOTO COLLECTION
WARS-CIVIL WAR
B-91-143

04
"LADIES SQUARE"
GENERAL PHOTO COLLECTION
STREET-4TH STREET
B-82-030

05
THE LAST HORSE-DRAWN STREETCAR
SPECIAL COLLECTION #296-1009
ROMBACH AND GROENE

06
EMPLOYEES AT PROCTER AND
GAMBLE COMPANY
GENERAL PHOTO COLLECTION
BUSINESS & INDUSTRY-PROCTER &
GAMBLE (OFFICE INTERIORS)

07
FOURTH AND RACE STREETS
SPECIAL COLLECTION #27-104
WINDISCH

08
OAKLEY RACE TRACK
SPECIAL COLLECTION #296-891
ROMBACH & GROENE

10
TEMPLE COURT
SPECIAL COLLECTION #27-291
WINDISCH

11
GUTHRIE GRAYS
SPECIAL COLLECTION #59
WARS-CIVIL WAR

12
1884 COURTHOUSE RIOT
SPECIAL COLLECTION

193

68
First National Bank Building
General Photo Collection
Banks-First National
B-82-047

69
West Carrollton
Special Collection #27
Windisch
B-01-227

70
Hughes High School
General Photo Collection

71
Moving out of the Fifth National
Bank
General Photo Collection
Banks-Fifth-Third

72
Sycamore fire
Photo Postcards
Fires

73
Garfield Cafe at Eighth and Vine
Streets.
General Photo Collection
Restaurants
B-87-036

74
Eden Park
Special Collection #59
Parks-Eden

75
Electric vehicle
General Photo Collection

76
Redland Field
Special Collection #296-220
Rombach & Groene

77
Ice cream vendor
Special Collection #116
Koch
Occupations
116-25d-4595

78
Highland Avenue Streetcar
Special Collection #116
Koch
116-123c-3881

79
U.S. Mail delivery vehicles
General Photo Collection
Buildings, Federal-Post Office
B-84-075

80
Reservoir in Eden Park
Special Collection #116
Koch
Parks-Eden
116-138b-2415

81
Ed Coyne
General Photo Collection
Zoo

82
High-water streetcars
Special Collection #58
Transportation-Streetcars,
Electric

83
Society of Red Men
General Photo Collection
Clubs
B-87-088

84
Canal Street
General Photo Collections
Rivers & Waterways-Canals
(Miami and Erie)
B-85-775

85
convict ship Success
Eversull

105
BRYANT SHOWBOATS
MSS
K76
v. 37

106
CHARLES A. LINDBERGH
GENERAL PHOTO COLLECTION
TRANSPORTATION-AVIATION

107
TUNNELS AT PLUM AND CANAL
GENERAL PHOTO COLLECTION
TRANSPORTATION-AVIATION

108
SCHACHT TRUCK
SPECIAL COLLECTION #32
KELLY AUTO BODY

109
LIPPINCOTT COMPANY
SPECIAL COLLECTION #116
KOCH
BUSINESS & INDUSTRY
116-108B-2086

110
CINCINNATI TIMES-STAR BUILDING
SPECIAL COLLECTION #309
BETZ-MARSH
10834

111
CHESAPEAKE AND OHIO'S GEORGE
WASHINGTON
SPECIAL COLLECTION #21
BRIOL
21-4211

112
ICEMAN
GENERAL PHOTO COLLECTION
BUSINESS & INDUSTRY

113
PRESIDENT HERBERT HOOVER
DEDICATING THE OHIO RIVER
MEMORIAL
GENERAL PHOTO COLLECTION
HOOVER, HERBERT
B-79-179

114
STEAM TOWBOAT SLACK BARRETT
GENERAL PHOTO COLLECTION
TRANSPORTATION-STEAMBOATS
(SLACK BARRETT)
B-76-056

115
CONCERT GOERS AT CARUSO
MEMORIAL CONCERT
SPECIAL COLLECTION #116
PARKS-EDEN
116-69B-1618

116
DISPLAY HOUSE IN THE KROHN
CONSERVATORY
SPECIAL COLLECTION #116
KOCH
PARKS-EDEN
116-42D-5000

117
EDEN PARK CONSERVATORY
SPECIAL COLLECTION #21
BRIOL
21-3073

118
SOUND EFFECTS CREW AT WLW
GENERAL PHOTO COLLECTION
RADIO & TELEVISION
WLW-SOUND EFFECTS

119
ALBEE THEATER
GENERAL PHOTO COLLECTION
THEATERS-ALBEE
B-87-129

120
LOBBY OF THE ALBEE THEATER
GENERAL PHOTO COLLECTION
THEATERS-ALBEE
B-89-020

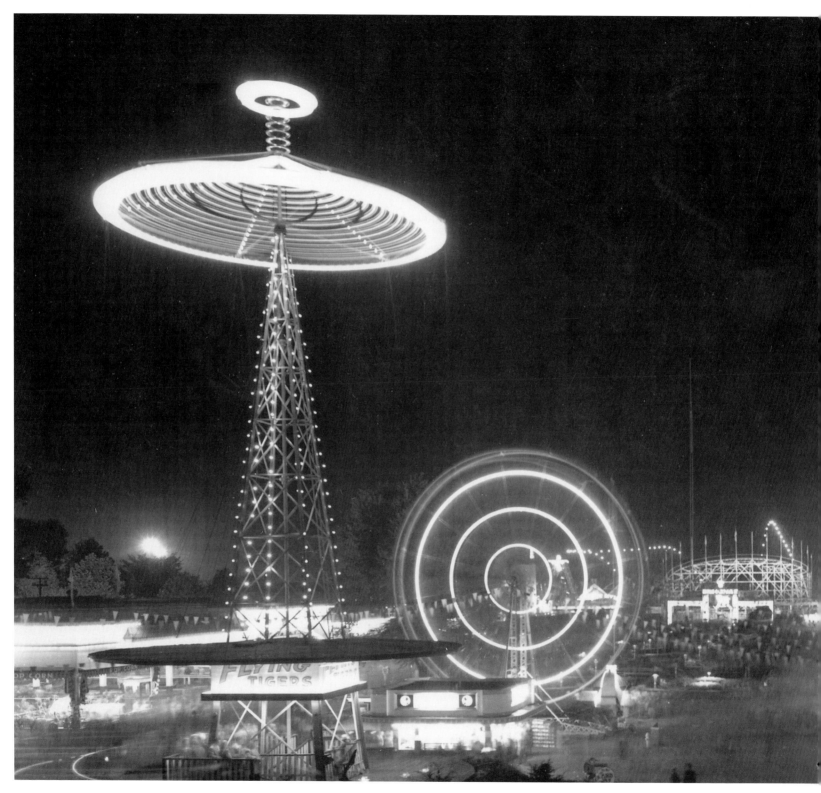

The bright lights of the rides contrast with the dark summer sky at Coney Island in the 1940's.

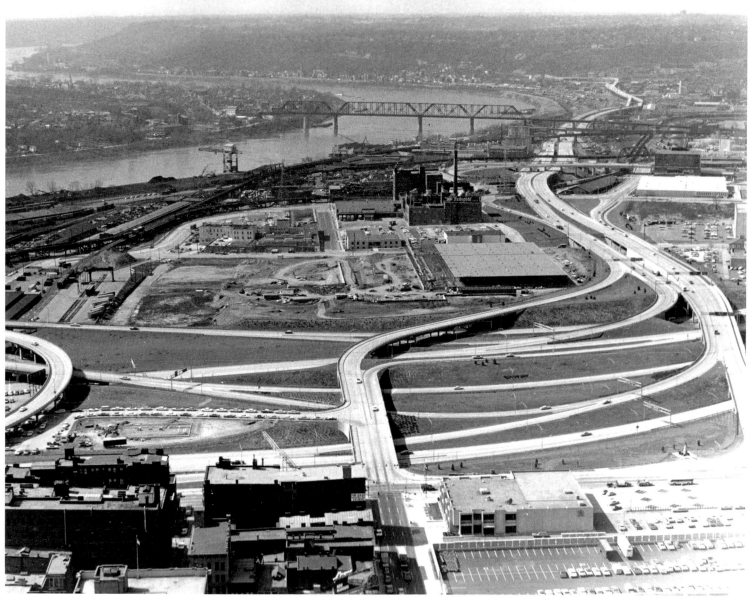

The "Millcreek Expressway," later to become I-75, was started after World War II north of the city and included the Wright-Lockland Highway as part of the expressway that would ultimately connect Florida and Canada. The section including the Fifth Street ramp downtown was completed in the early 1960's.